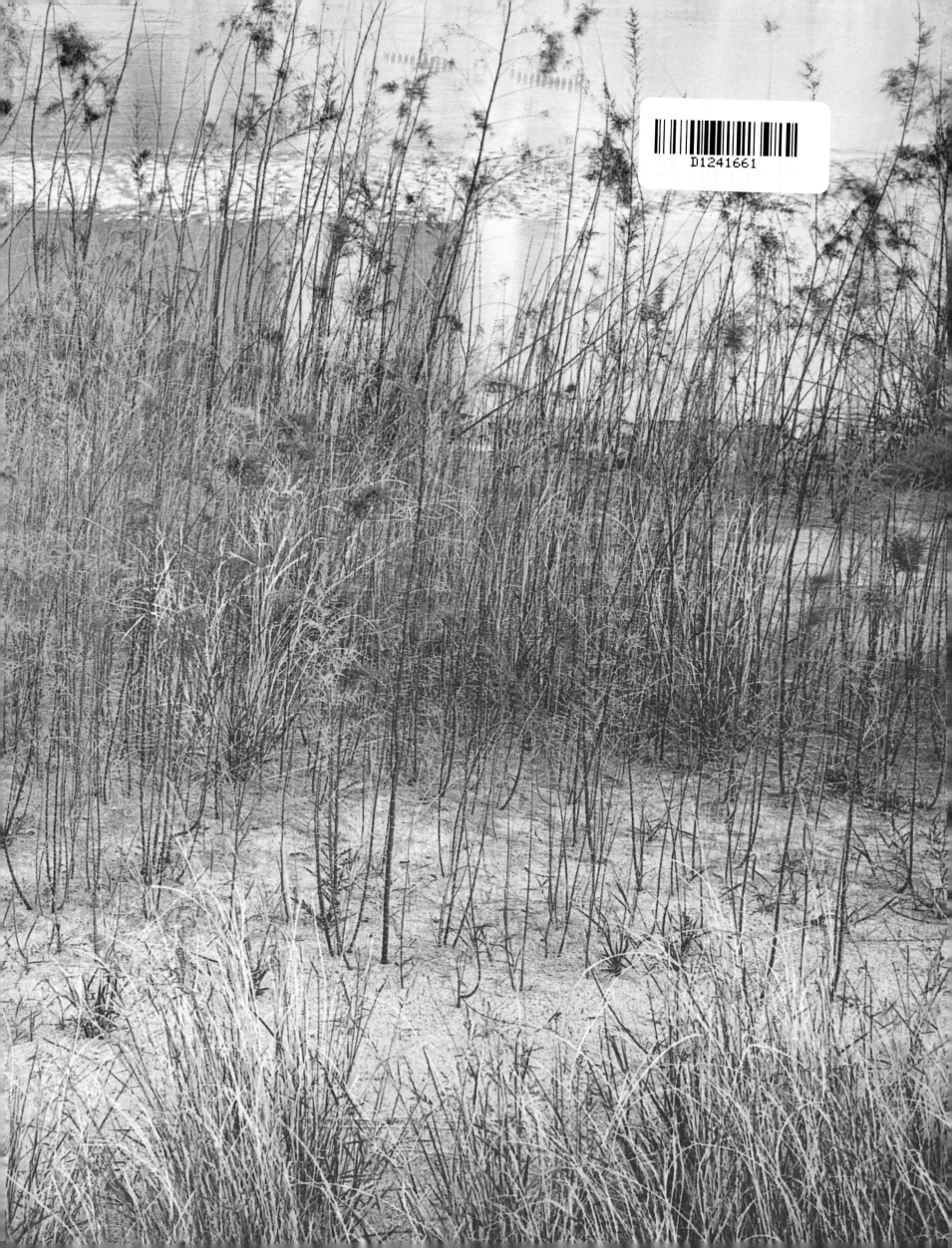

ELIOT PORTER

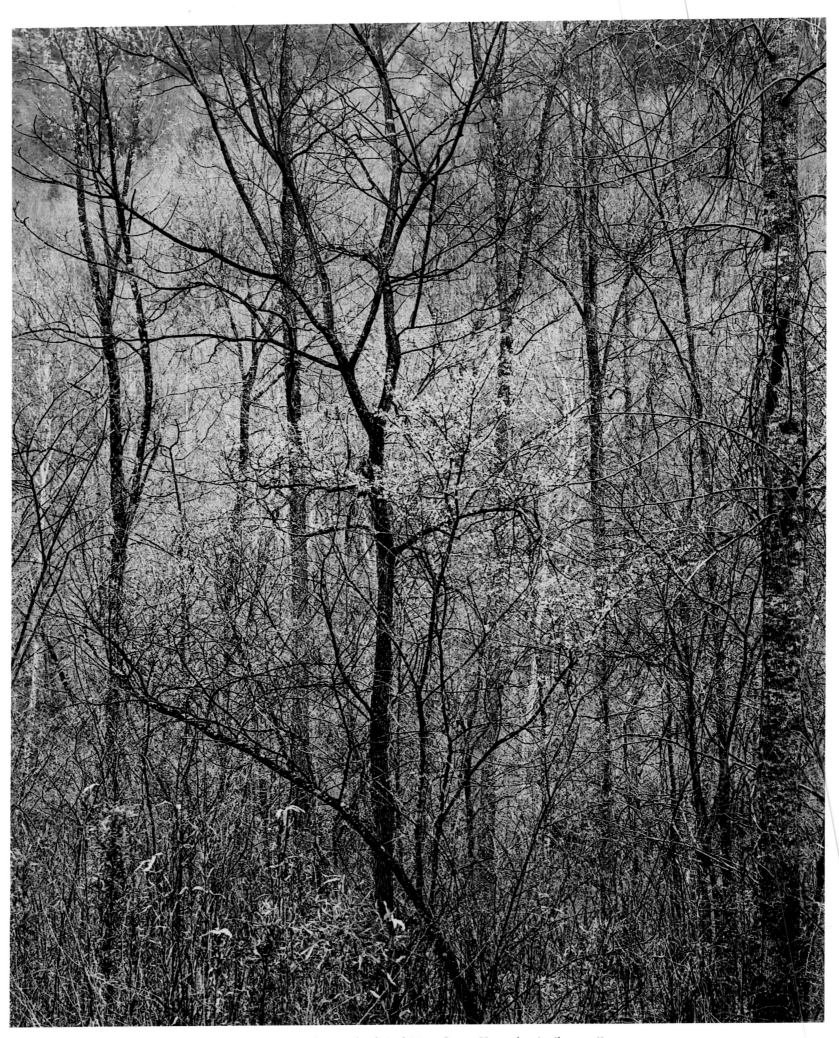

Redbud trees in bottom land, Red River Gorge, Kentucky, April 17, 1968

ELIOT PORTER
The Color of Wildness

ESSAYS BY

JOHN ROHRBACH

REBECCA SOLNIT

MEMOIR BY

JONATHAN PORTER

APERTURE

IN ASSOCIATION WITH THE

AMON CARTER MUSEUM

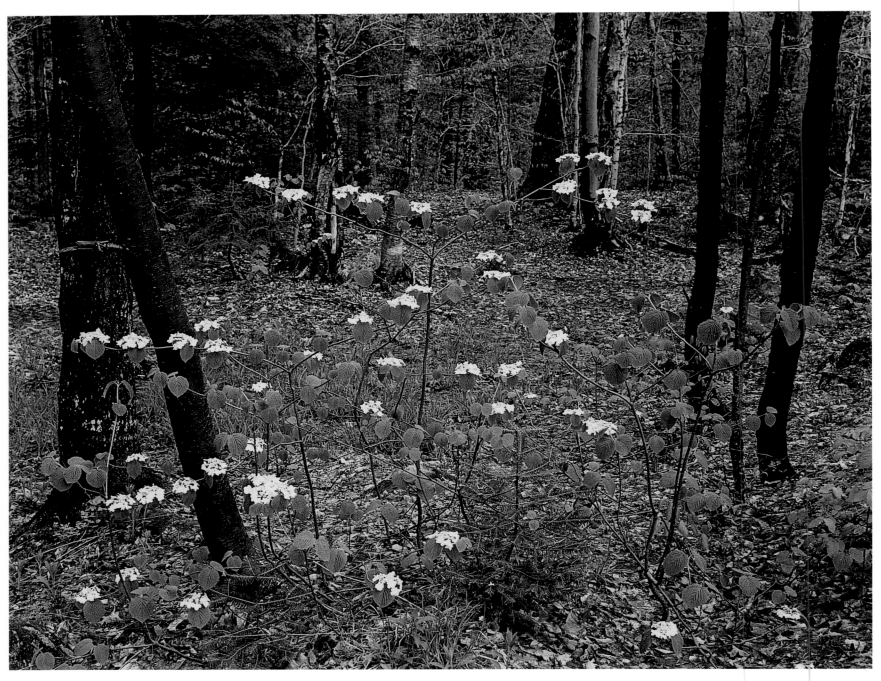

Hobble bush, Blue Mountain Lake, Adirondack Mountains, New York, May 15, 1964

CONTENTS

6

FOREWORD

8

PLATES

91

Envisioning the World in Color

JOHN ROHRBACH

113

Every Corner Is Alive:
Eliot Porter as an Environmentalist and an Artist

REBECCA SOLNIT

133

A Memoir of My Father

JONATHAN PORTER

138

ELIOT PORTER: A CHRONOLOGY

142

NOTES

149

ACKNOWLEDGMENTS

FOREWORD

Shortly after its inception more than forty years ago, the Amon Carter Museum began its history as a repository of American photography with the modest acquisition of a few photographs by Dorothea Lange (1895–1965). Over the ensuing years, the museum worked actively to acquire individual prints and larger groups of works toward establishing one of the major collections of its kind, now comprising more than 230,000 objects. Today, this collection reflects the varied interests and dedicated mission of the museum itself. The full panorama of American photography, from its beginnings to the present day, is represented, and the documentation and interpretation of the American West is a central feature.

These broad holdings can be divided into three parts. More than thirty thousand works constitute the fine art collection, which includes some of the greatest achievements by American photographers. Another seventeen thousand works are more historical in nature, though no less important, and document various aspects of our nation's cultural history. A third group, numbering more than 185,000 works, is made up of archival and monographic collections. This group includes the estate holdings of several significant American photographers, including Laura Gilpin (1891–1979) and Eliot Porter (1901–1990).

Gilpin, one of the finest pictorial art photographers of her generation, achieved a lasting reputation as a preeminent photographer of the Southwest, with special emphasis on the Navajo. The Amon Carter Museum's first director, Mitchell A. Wilder (1913–1979), was a close friend of the photographer and urged her to give her estate to the museum. In 1979 Gilpin complied with a bequest of twenty-seven thousand negatives and more than twenty thousand prints. At that time, the museum's ongoing commitment to American photography, coupled with its strong dedication to carefully preserve and actively study the works themselves, encouraged other photographers to consider the museum as a suitable home for their life's work. In 1984 Eliot Porter, one of America's greatest photographers of nature in color, promised to give the museum his extensive archives, which included more than 106,000 prints, transparencies, negatives, separations, and matrices. "In giving the collection to the Amon Carter," Porter stated at the time, "I wanted to be assured that it will stay together and be preserved. And I wanted it to be used."

This volume and its accompanying exhibition are evidence of the Amon Carter Museum's strong commitment to exploring and sharing Eliot Porter's important contributions to American photography. The museum wishes to express its deepest gratitude to the members of Dr. Porter's family for their ongoing friendship and support. Once the Porter gift was made, the museum's first task was to catalogue, house, and research the objects themselves. Key support for the endeavor was provided by a generous grant from the Andrew W. Mellon Foundation, which enabled the museum to hire Dr. John Rohrbach as curator and project manager for this formidable task.

Throughout its history, the Amon Carter Museum has sought to publish studies on American art and artists that reflect the highest standards of scholarship. The hope is that this volume, the result of more than eight years of research, will continue that tradition and serve as a persuasive endorsement of Eliot Porter's artistic genius.

—Rick Stewart, Director
Amon Carter Museum, Fort Worth, Texas

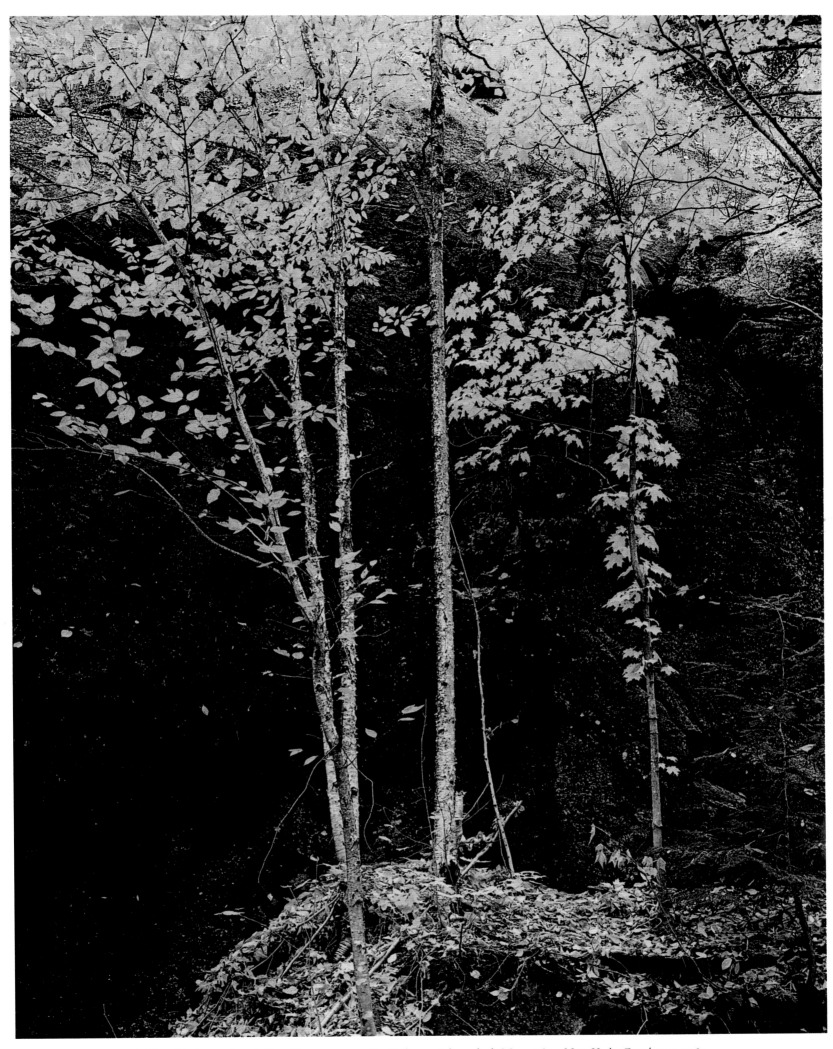

Yellow birches and rock face, Route 73, near St. Huberts, Adirondack Mountains, New York, October 7, 1963

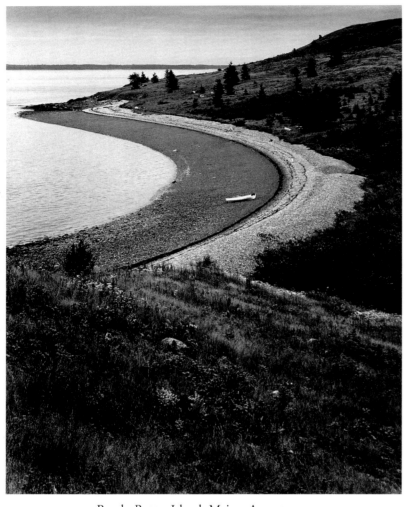

Beach, Butter Island, Maine, August 1937

. . . I must thank you for having given me the opportunity to live with your spirit in the form of those photographs that for three weeks were on our walls, —And "our" includes yours.—Some of your photographs are the first I have ever seen which made me feel: "There is my own spirit"—quite an unbelievable experience for one like myself.

—Alfred Stieglitz to Eliot Porter, January 21, 1939

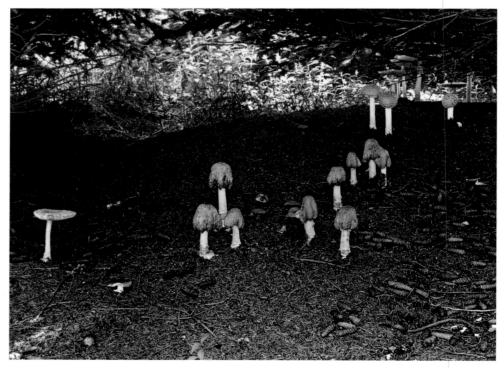

Amanitas, Little Spruce Head Island, Maine, Summer 1937

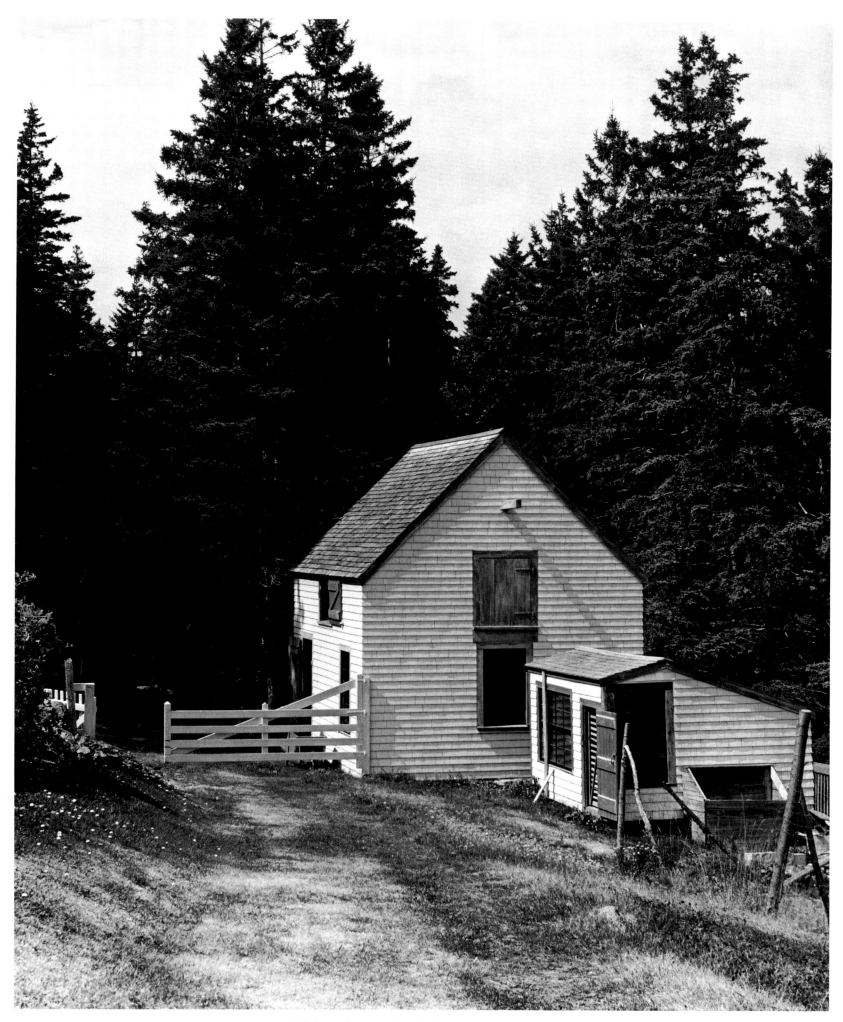

Lighthouse barn, Eagle Island, Maine, Summer 1937

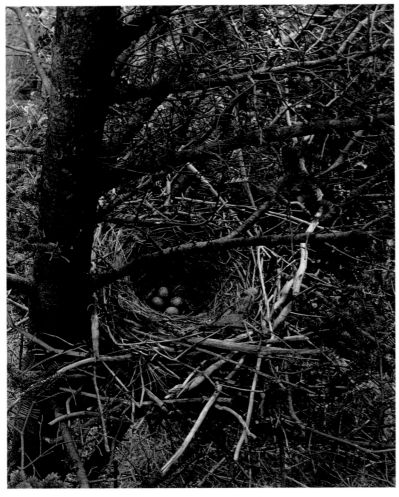

Crow's nest in tree, Maine, May 1938

With a portfolio of black and white photographs, I went to Houghton Mifflin to see if they would be interested in publishing a book of bird photographs. . . . I was courteously received by the editor-in-chief, who advised me that to be a success a photographic bird book should be in color. I accepted the challenge, though it seemed like a terrific undertaking with uncountable years of work. —ELIOT PORTER

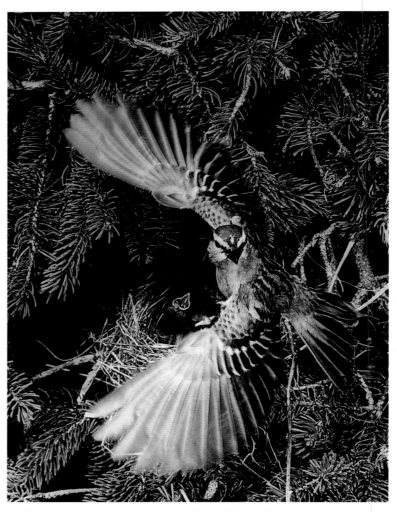

Chipping sparrow, Great Spruce Head Island, Maine, June 19, 1971

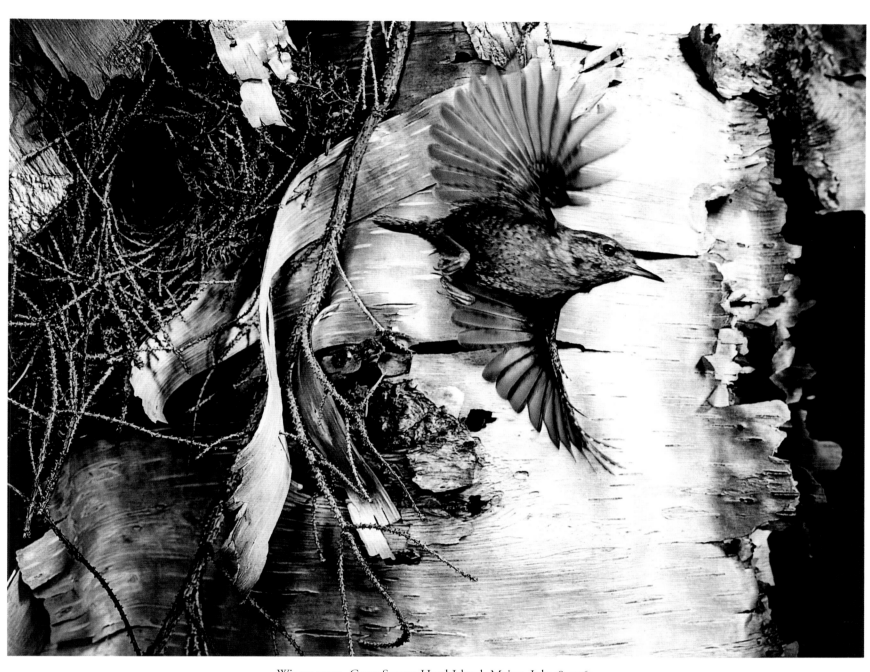

Winter wren, Great Spruce Head Island, Maine, July 18, 1960

People were often startled by the relationships revealed in my color photographs; sometimes they were incredulous, other times delighted, but never indifferent. The disbelievers are most often those who have been preconditioned to a stereotype of nature, not blind but unreceptive to the portrayal of unusual and exotic aspects. Nature to them presents a bland and expressionless face except during her violent extremes; her subtle fleeting moods escape their notice. For me the stereotype is the least interesting aspect of nature, and the one I most often reject as a color subject. The wide blue sky, the big landscape, the mountain scene, the comprehensive views—these I believe are best portrayed in black and white.

The relationships that are all-important for me in nature photography are best illustrated in my close studies. Close is a relative term; it may refer to a spot of lichen or a reflecting pool in the sand, or more broadly in a larger connotation to a sheer cliff or a grove of trees. But in either case the photograph is an abstraction of nature—a fragment isolated from a greater implied whole, missed but imagined, a connection which assists in holding the viewer's attention. The comprehensive, explicit view lacks more often than not this compelling quality. The relationships that interest me are both biological and aesthetic, ecological in the broadest sense; interactions between living things and the physical environment, which includes rock, water, and ambient light.

The recording of these interactions stimulates the most dispute in my photography. Depending on its quality, ambient light produces remarkable and not always readily appreciated effects on the subject. In certain situations this light will be heavily loaded with blue from the sky, which will be manifest in blue highlights on smooth reflective surfaces even though an overall blue cast to the shadows is neutralized by reflection of light from other parts of the environment. These blue highlights are especially noticeable in shaded locations on the upper shiny surfaces of leaves, on moving water, and on the oxides formed on smooth rock surfaces called desert varnish. The most severe criticism of my photographs has been directed at the recording of these phenomena, particularly at the portrayal of vegetation with a blue overcast. Blue rock reflections have also received a fair share of dogmatically expressed disbelief by people who claim to have been to the same places. By exploring these relationships in my photographs, I hoped that people would see beyond what they had been conditioned to see, to perceive the subtle and intricate interrelationships that shape the natural world. —E. P.

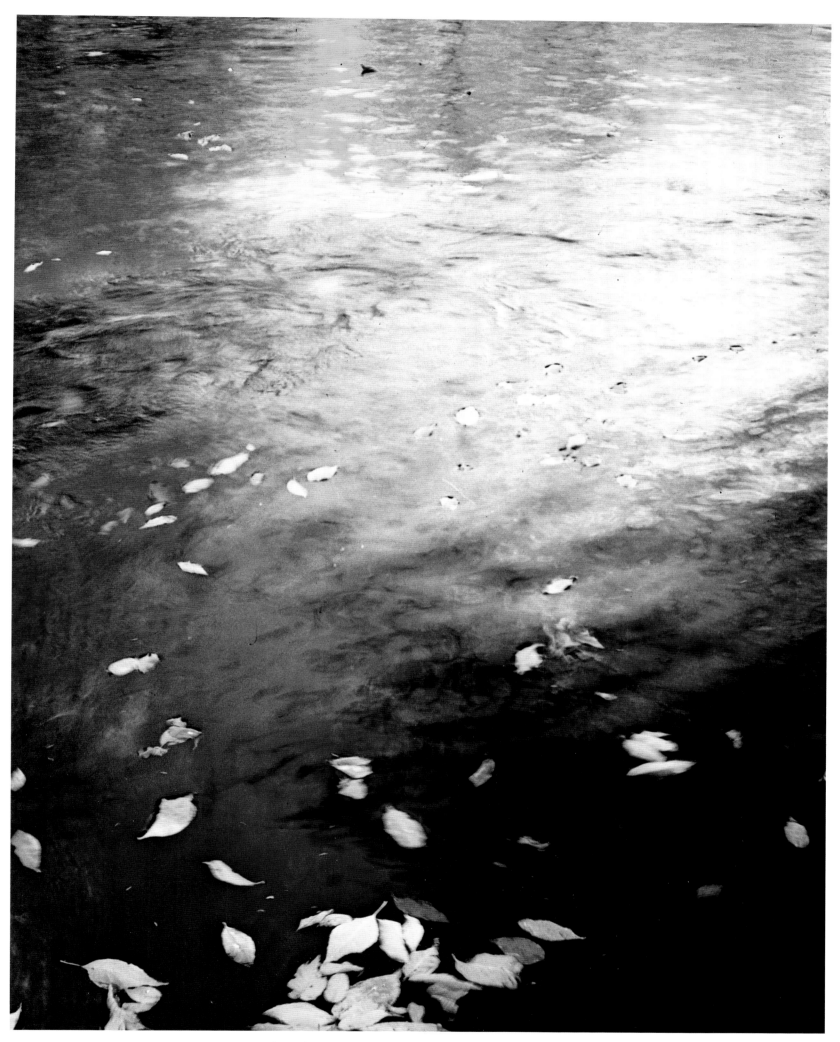

Pool in a brook, Pond Brook, New Hampshire, October 4, 1953

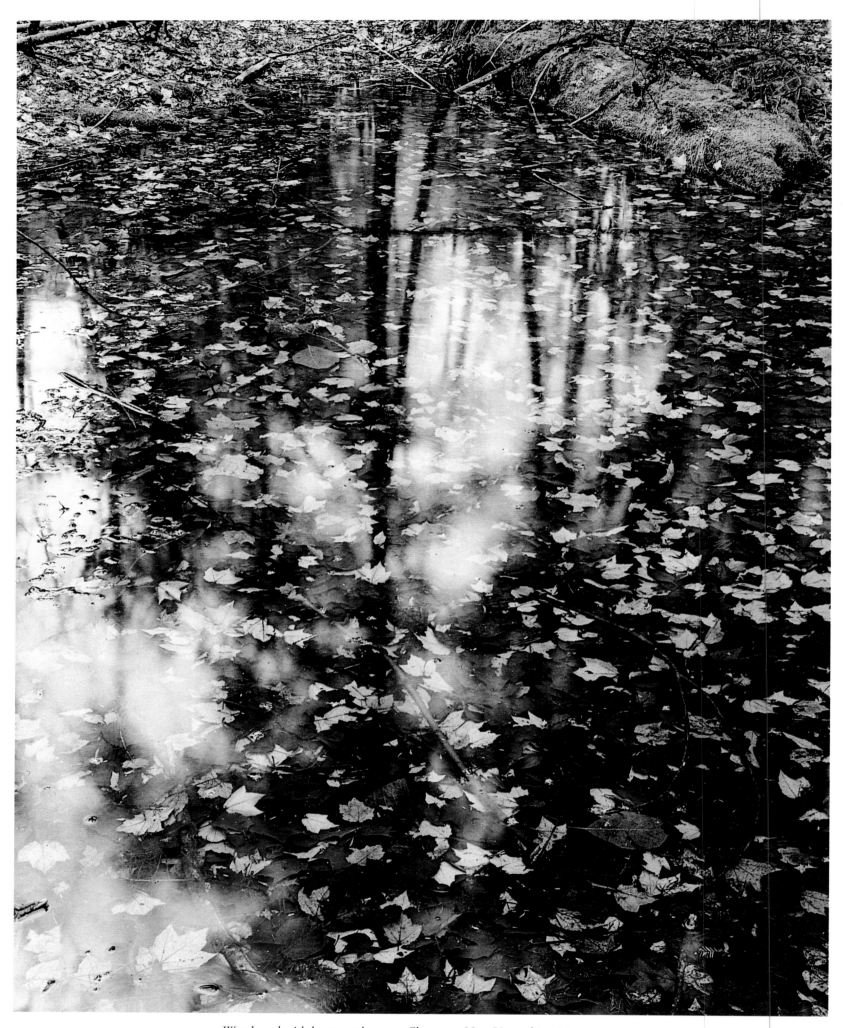

Wood pool with leaves on bottom, Chocorua, New Hampshire, May 7, 1961

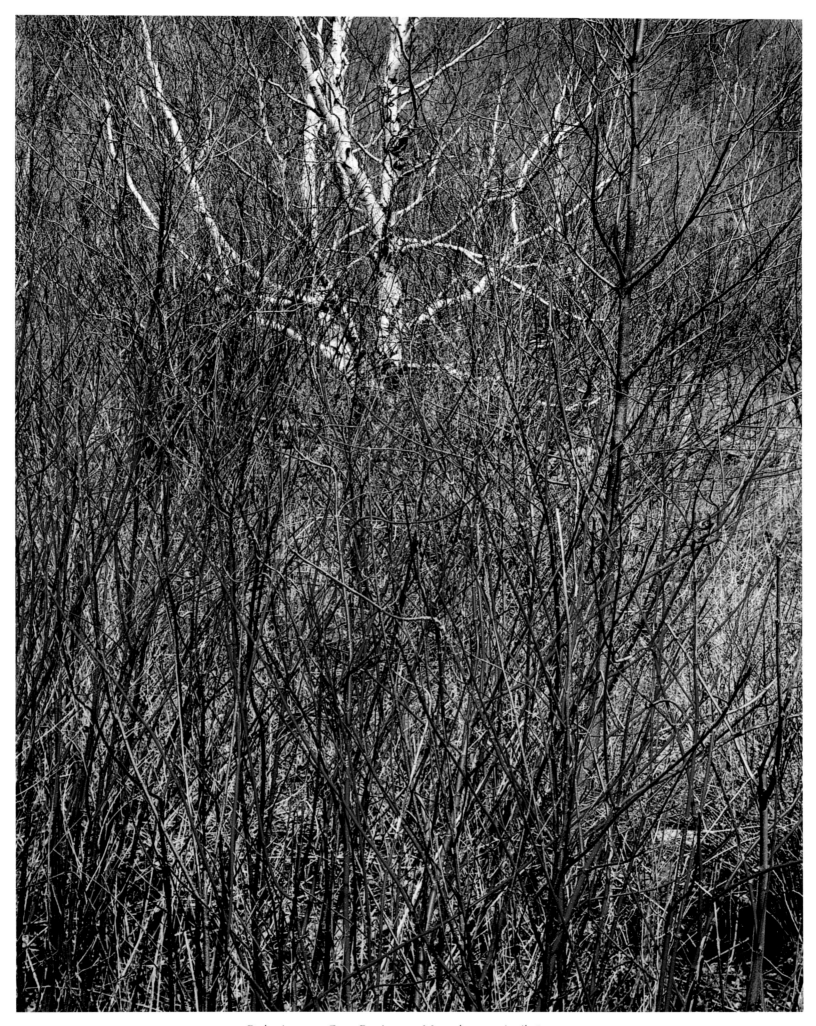

Red osier, near Great Barrington, Massachusetts, April 18, 1957

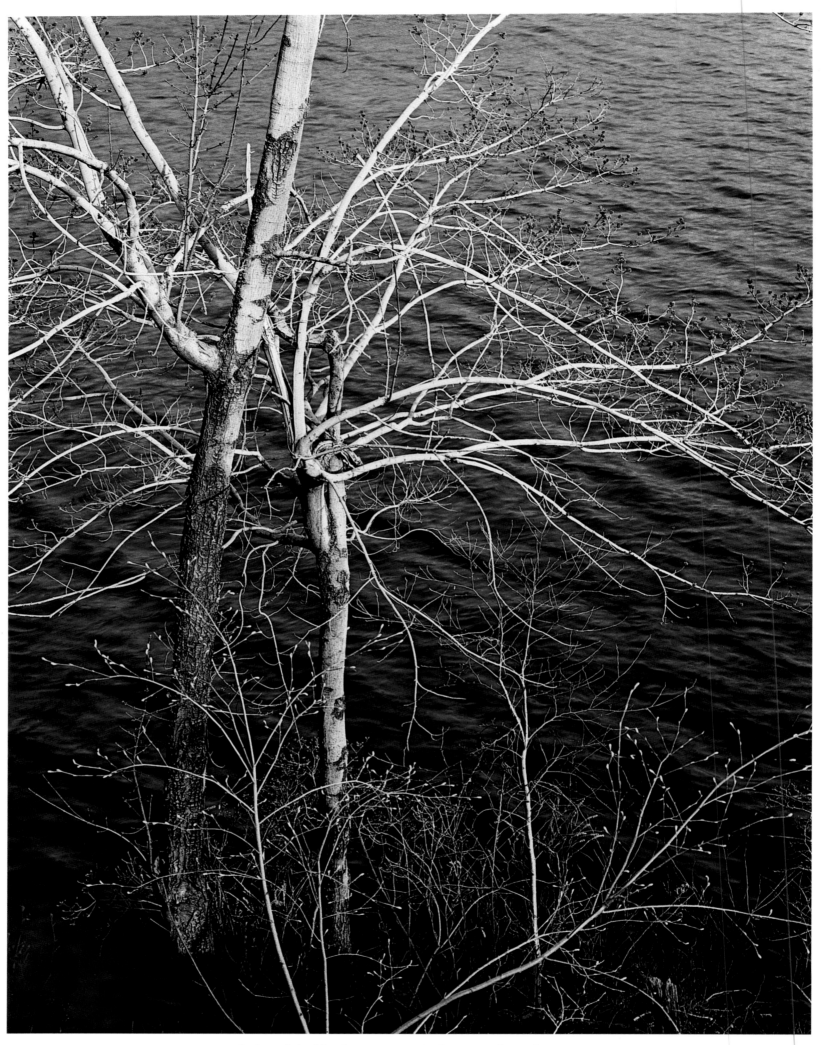

Red maple by lake, Bear Mountain Park, New York, April 11, 1957

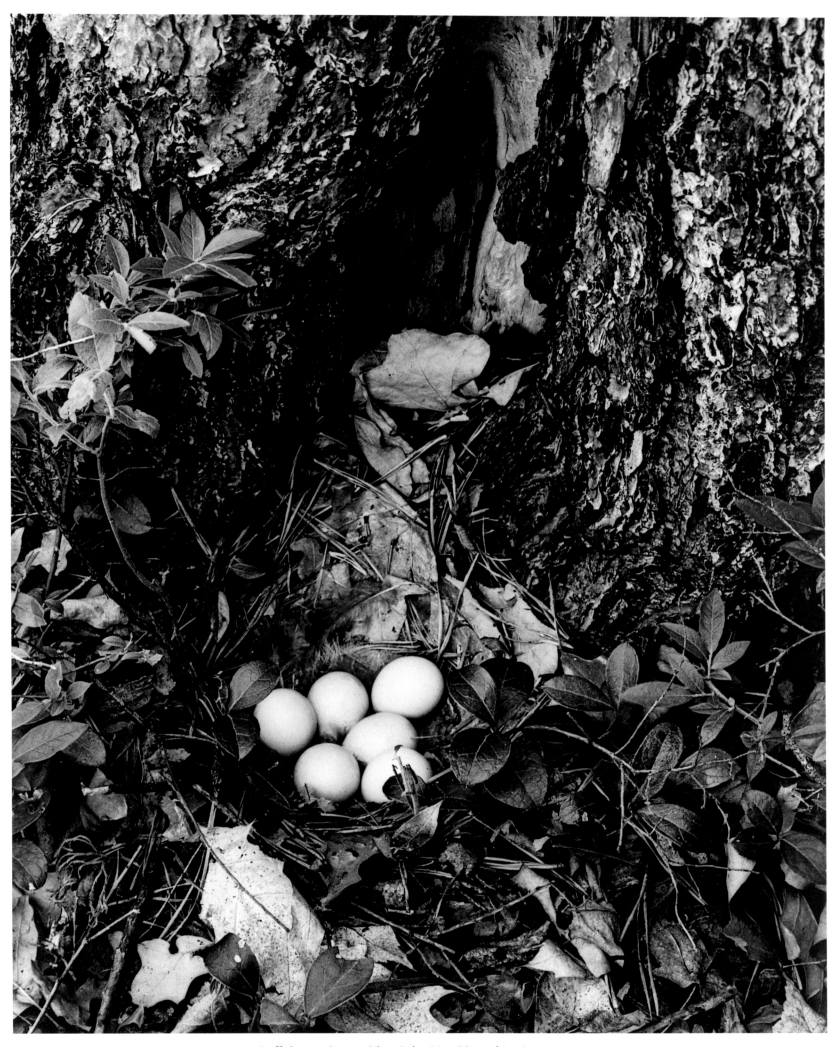

Ruffed grouse's nest, Silver Lake, New Hampshire, June 3, 1953

Floating leaves and reflections, Aspen, Colorado, October 3, 1951

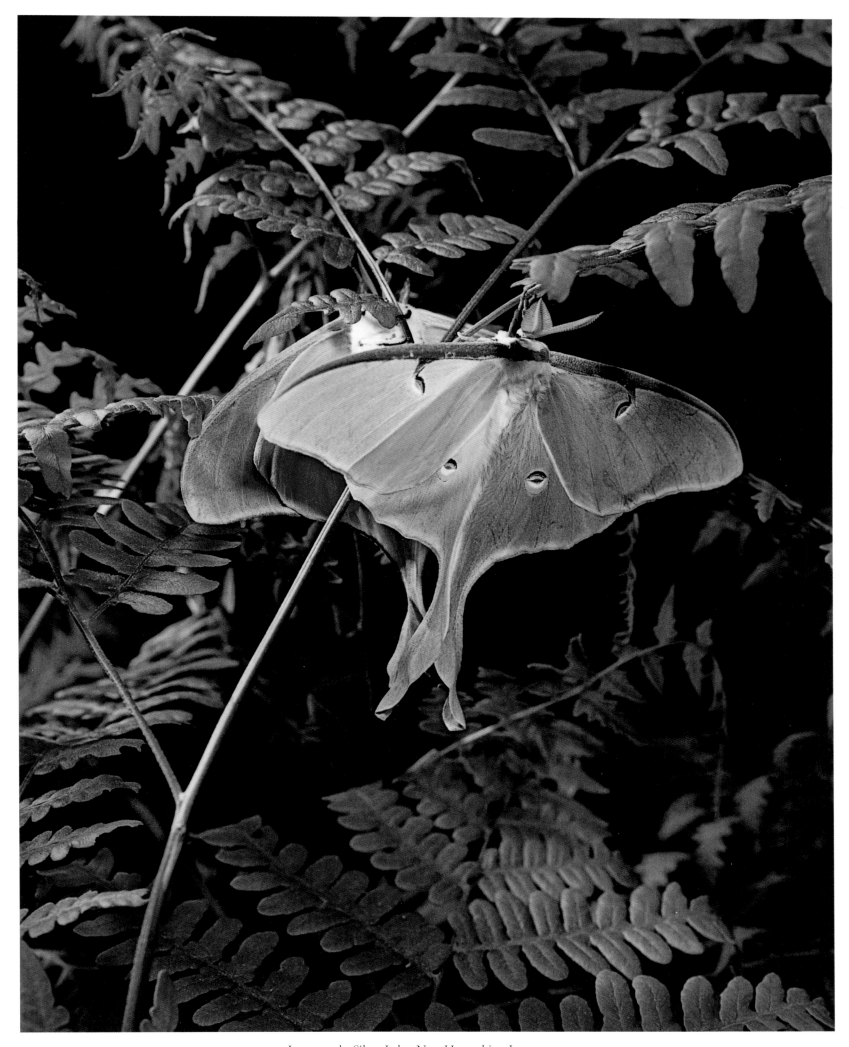

Luna moth, Silver Lake, New Hampshire, June 3, 1953

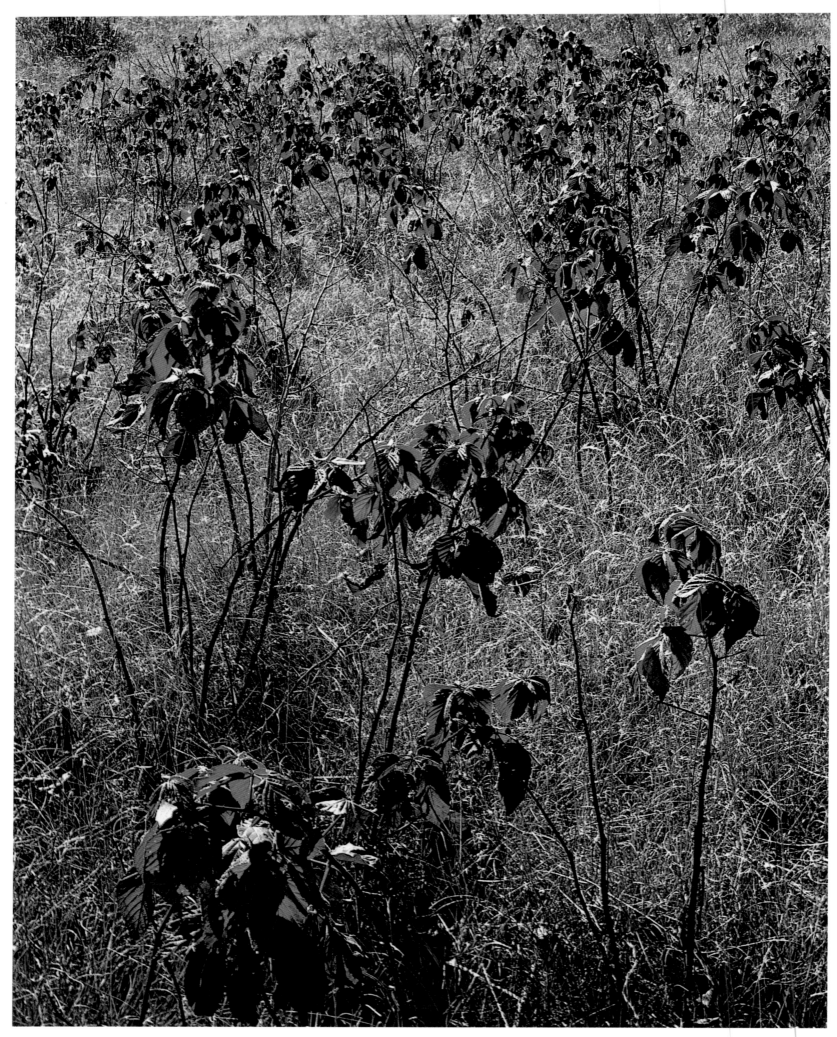

Blackberry bushes in field, Freedom, New Hampshire, October 12, 1956

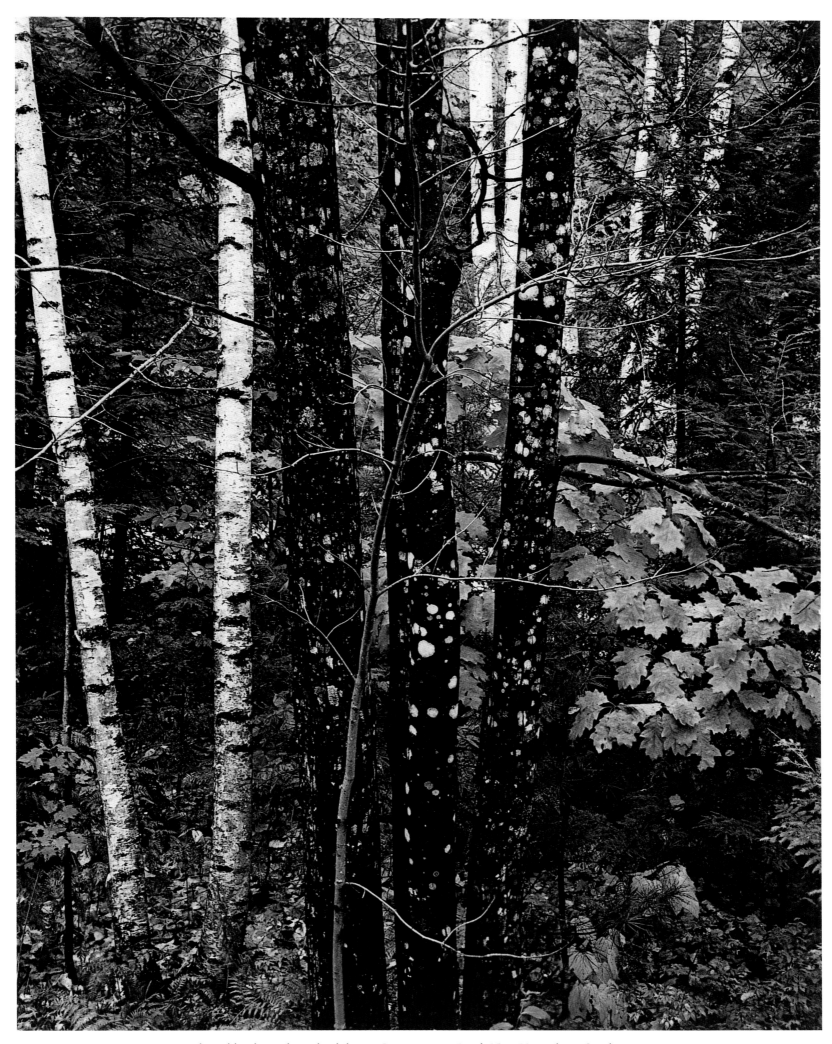

Maple and birch trunks and oak leaves, Passaconaway Road, New Hampshire, October 7, 1956

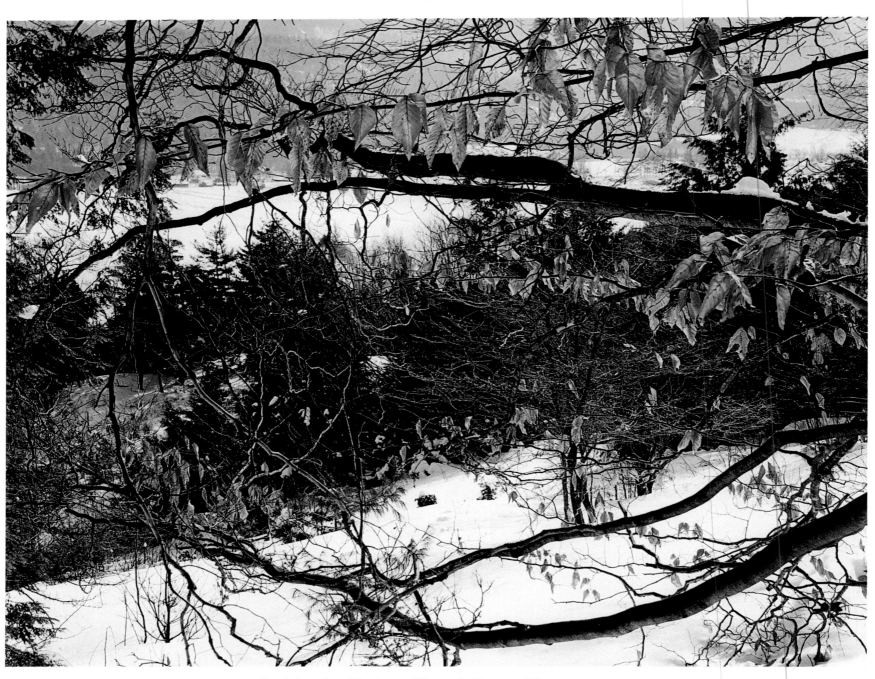

Beech branch and landscape, Tinmouth, Vermont, February 15, 1958

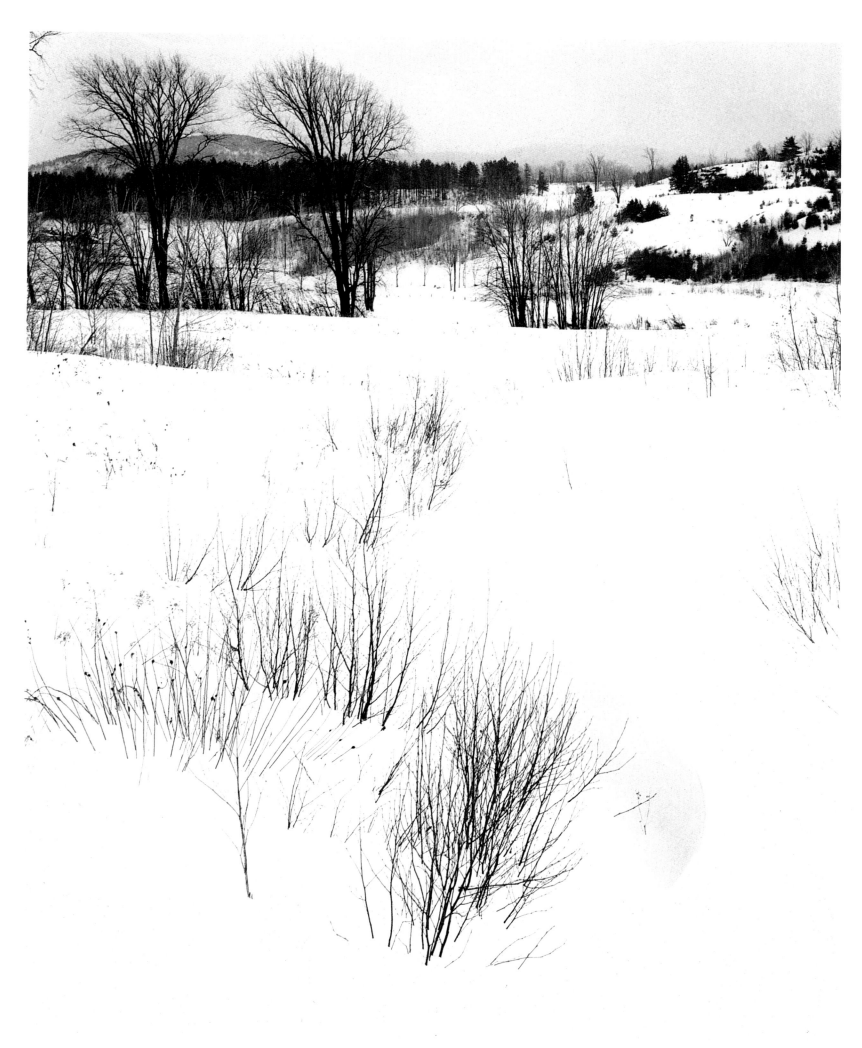

Landscape with elm trees, Au Sable Forks, New York, February 12, 1958

I had heard Glen Canyon described, by those who planned to reserve that part of the river for hydroelectric power development, as an unspectacular, gently flowing stretch of the river unruffled by significant rapids, that in fact the Bureau of Reclamation had begun to dam. . . . From the very first day, I was overwhelmed by the scenery —both in prospect and in description grossly underrated. The monumental structure of the towering walls in variety and color defied comprehension. . . . —E. P.

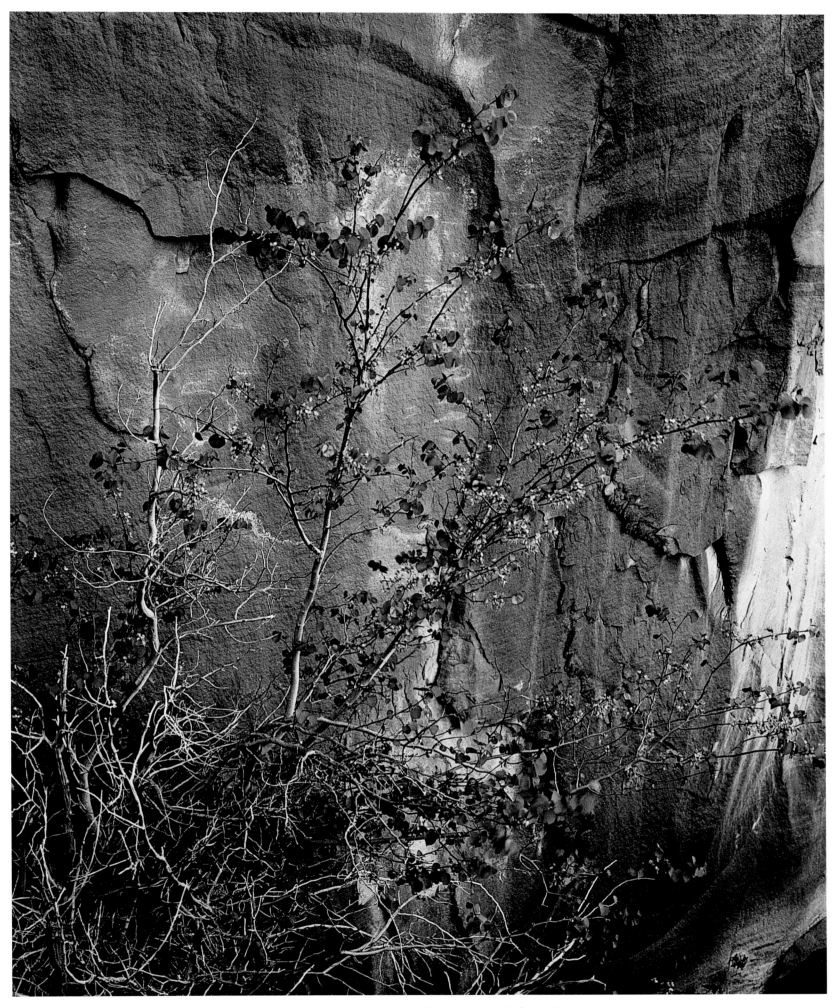

Redbud in bloom, Hidden Passage, Glen Canyon, Utah, April 10, 1963

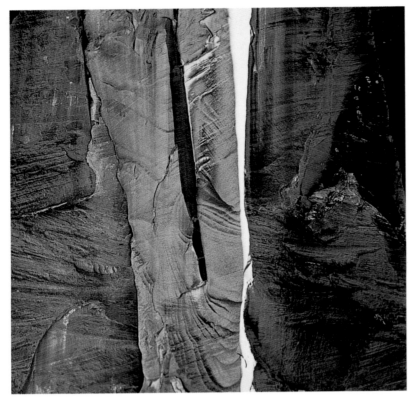

Sheer cliffs, Glen Canyon, Utah, September 1961

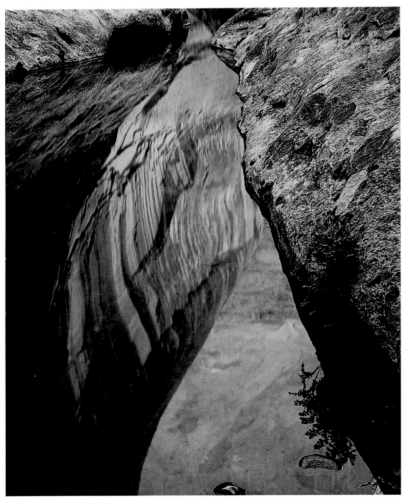

Pool in Hidden Passage, Glen Canyon, Utah, August 27, 1961

We visited Hidden Passage, and Music Temple across the river, made famous by Powell on his celebrated exploration of the Colorado. There were many other hidden passages and even narrower rifts in the sandstone walls that we did not see, did not know existed, that I would on subsequent trips explore: places like Cathedral and Dungeon Canyons. But what I saw and tentatively entered in the short time available on this first visit left me with a feeling of frustration and determination to come back, to explore other mysterious and secret places that I knew were hidden behind the multi-colored sandstone cliffs. I knew that what I had photographed was a superficial record, the slightest vision of this wonderful place. The infinite possibilities required repeated and more leisurely visits than the first, which . . . was the initiation to a wealth of creative opportunities that I could not emotionally ignore.

And so I did come back. —E. P.

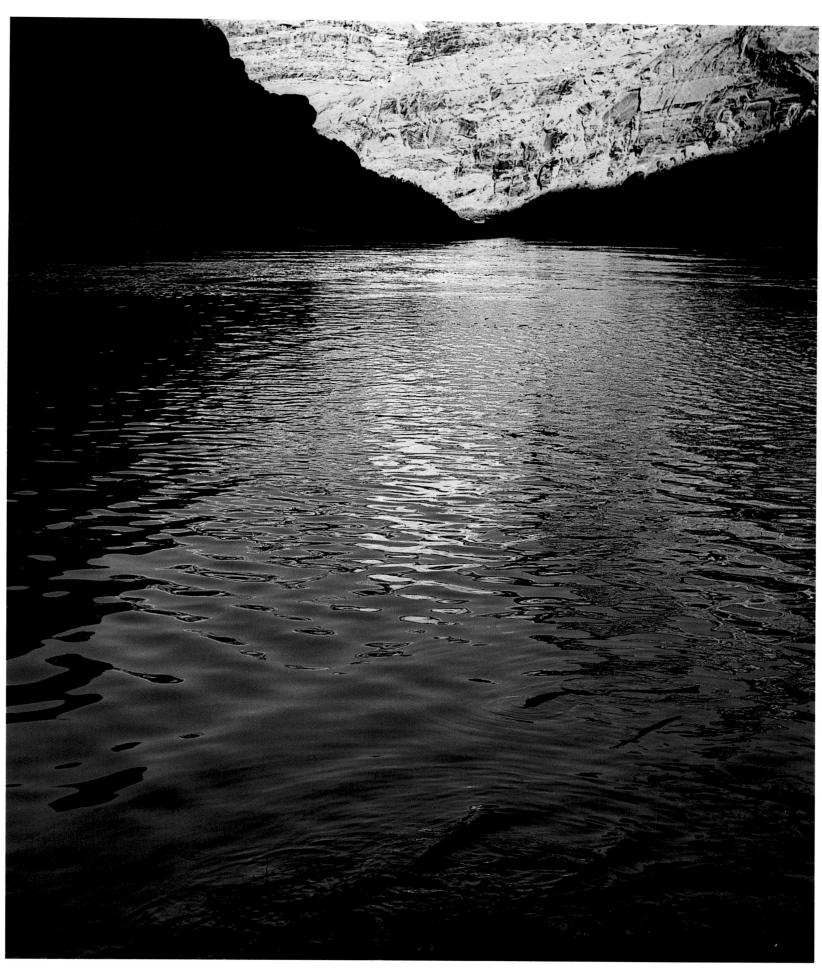

Sunrise on river, Navajo Creek, Glen Canyon, Utah, August 27, 1961

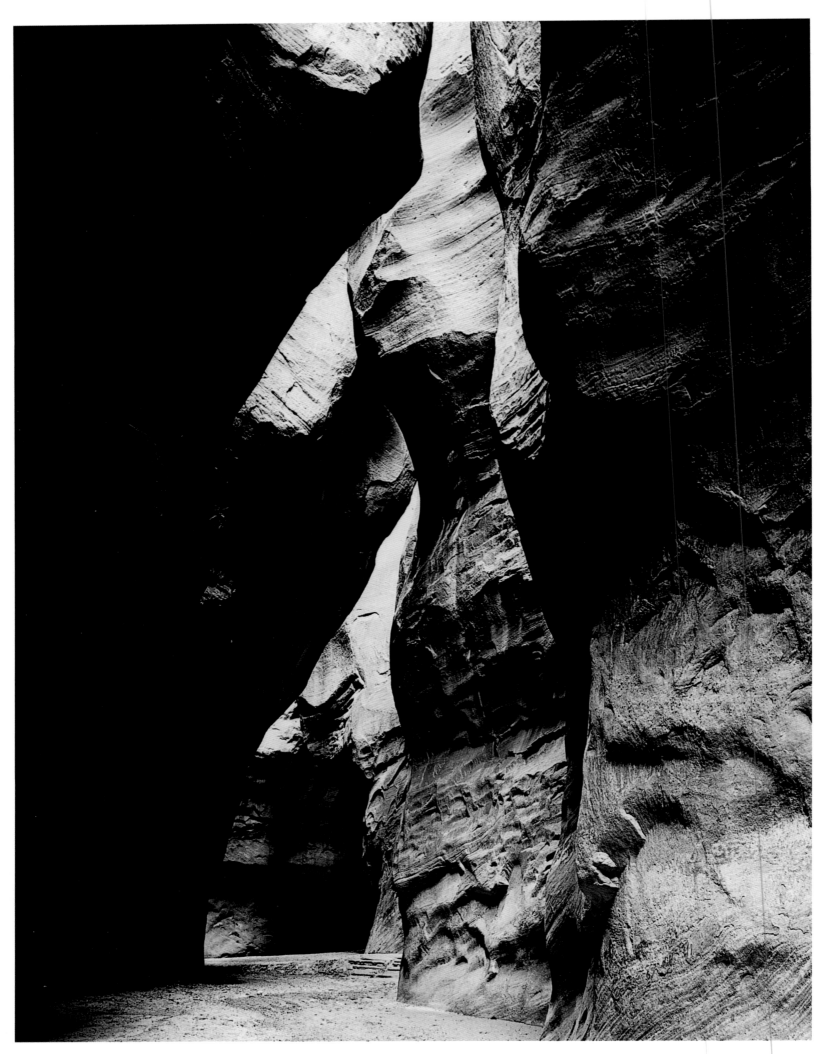

Dungeon Canyon, Glen Canyon, Utah, August 29, 1961

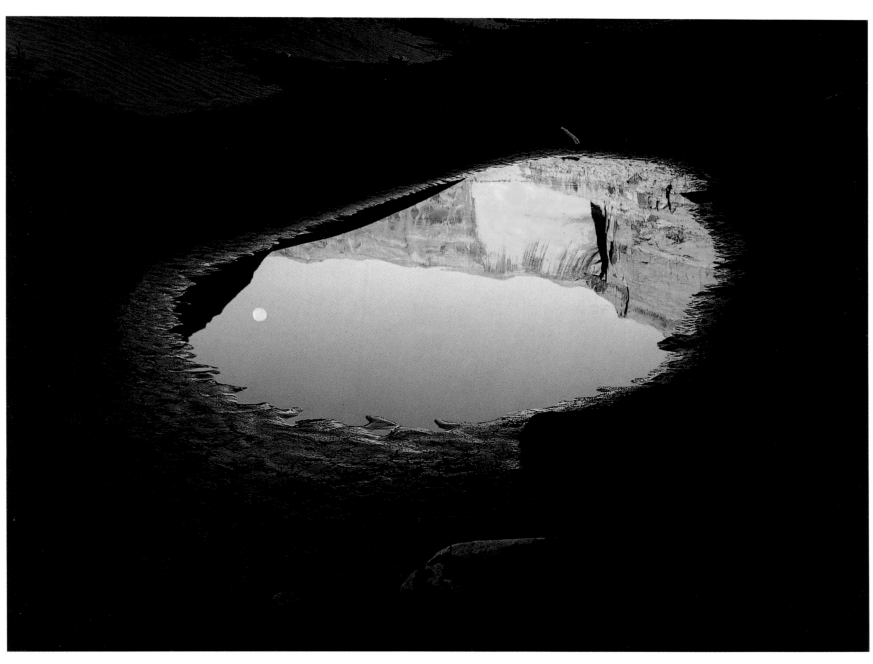

Sunrise, moon reflection in pool, Navajo Creek, Glen Canyon, Utah, August 27, 1961

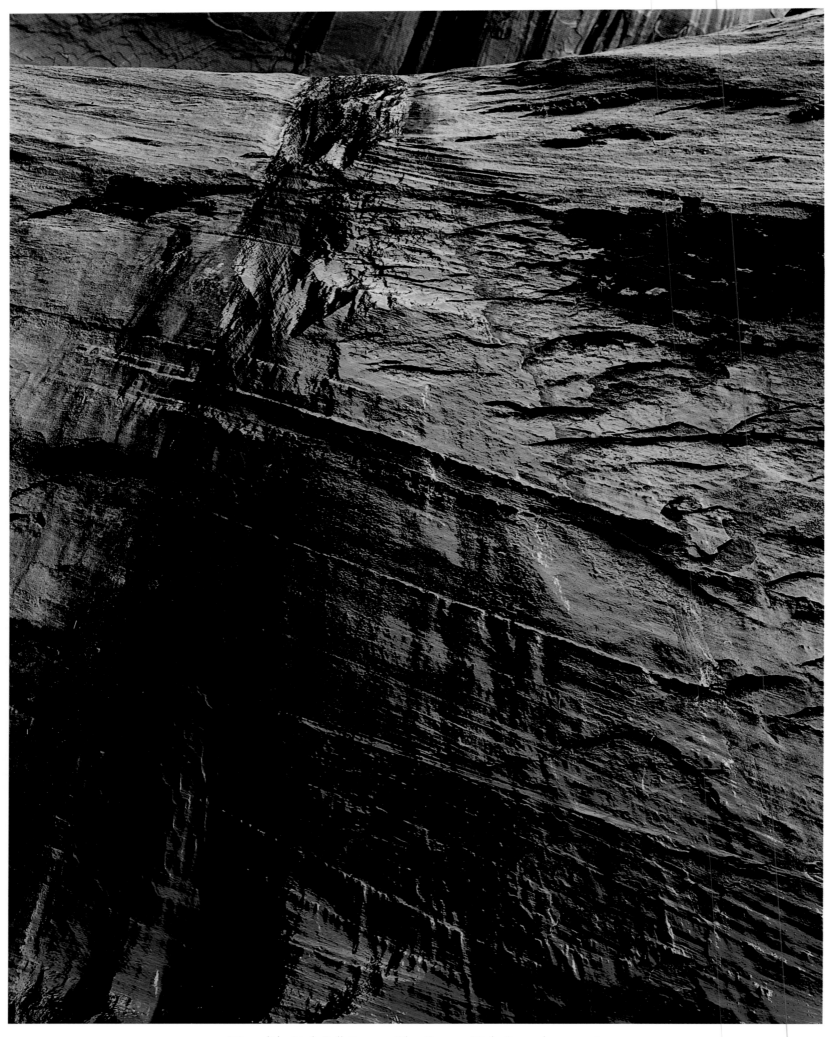

Water slide, Little Ball Canyon, Glen Canyon, Utah, September 23, 1965

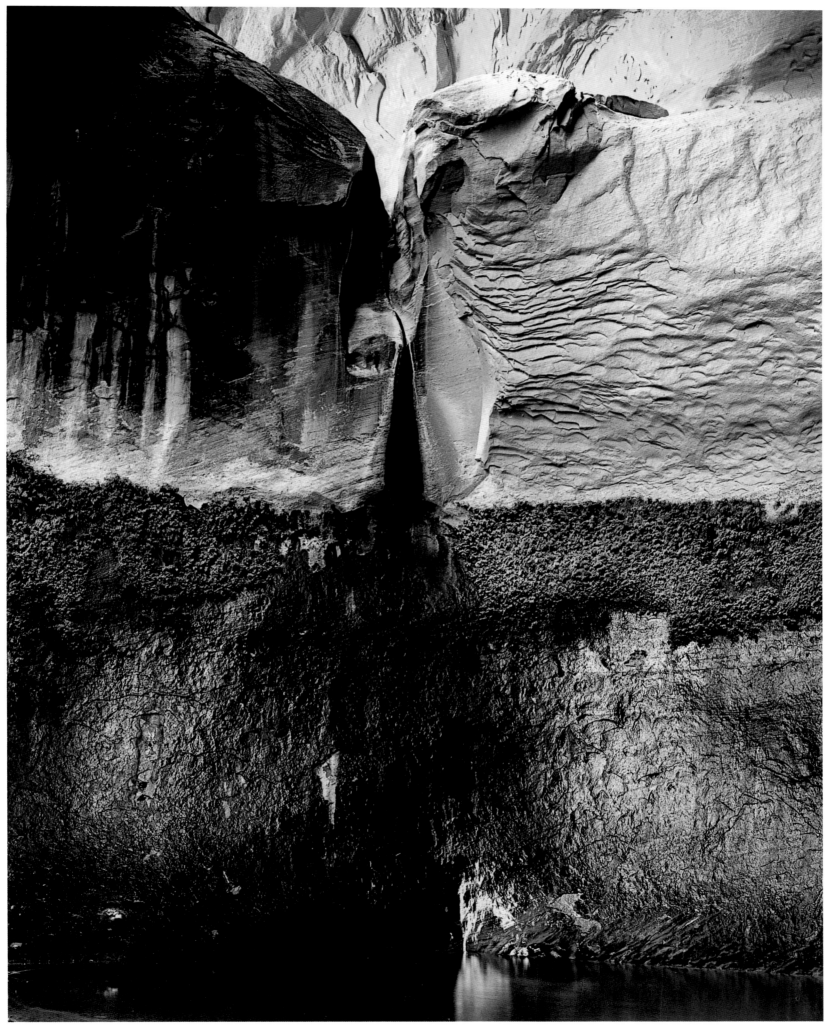

Plunge pool, Cathedral in the Desert, Clear Creek off the Escalante River, Glen Canyon, Utah, August 23, 1964

I wandered through the forests and bogs and alder thickets from dawn to dark, day after day and summer after summer, listening, searching, tense as a taut wire for the slightest vibration and flick of movement. Unaware of time, I moved through the day without plan or design, following the trails and random leads laid out by nature. At sunrise I waded through dew-laden redtop grass that soaked my sneakers and legs and crept through bushy thickets from which drops showered down on my face, neck, and back. Often I was drenched before the warming sun had dried the leaves. I went out in fog and rain all day and returned late in the afternoon, without a dry spot on my body, but neither cold nor uncomfortable. —E. P.

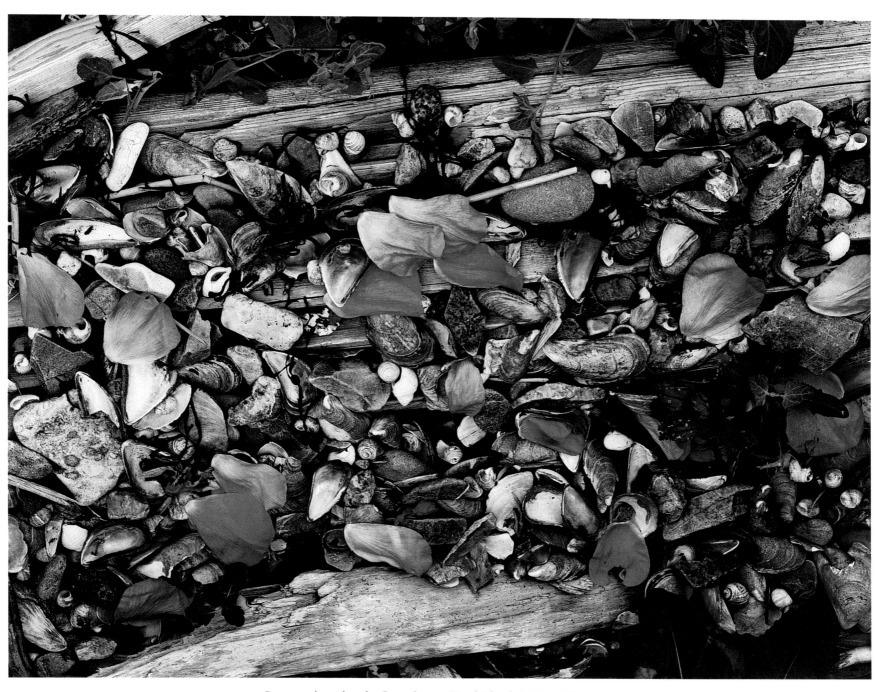

Rose petals on beach, Great Spruce Head Island, Maine, July 1, 1971

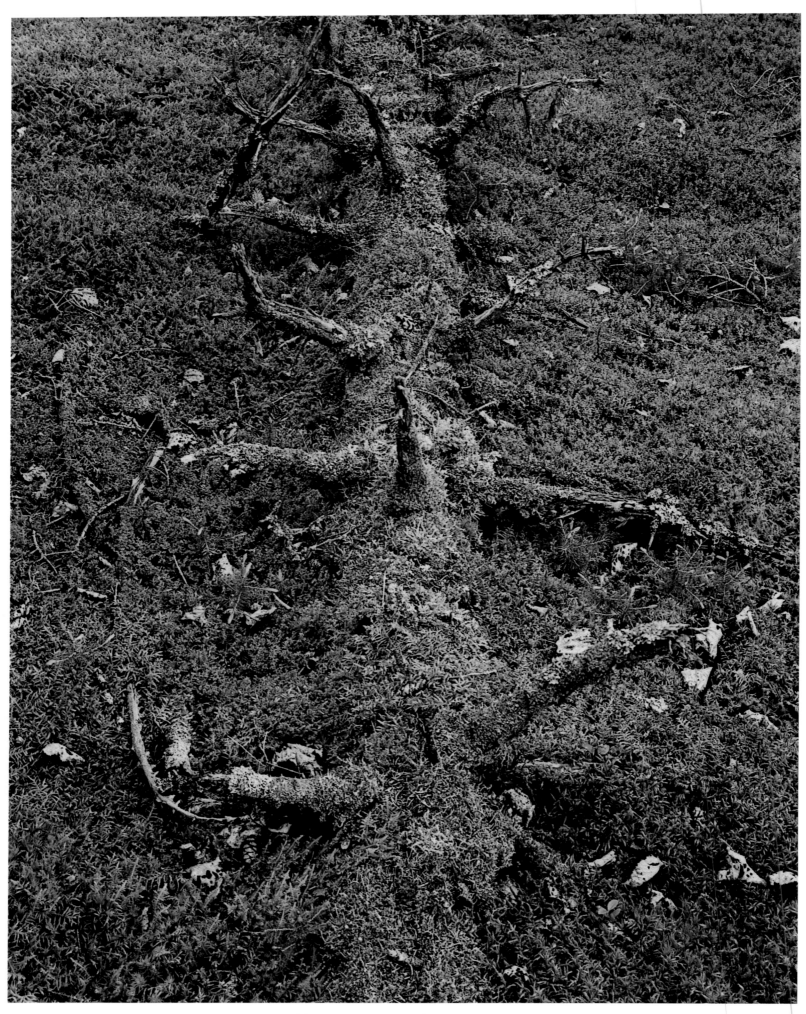

Moss-covered log, Great Spruce Head Island, Maine, June 18, 1968

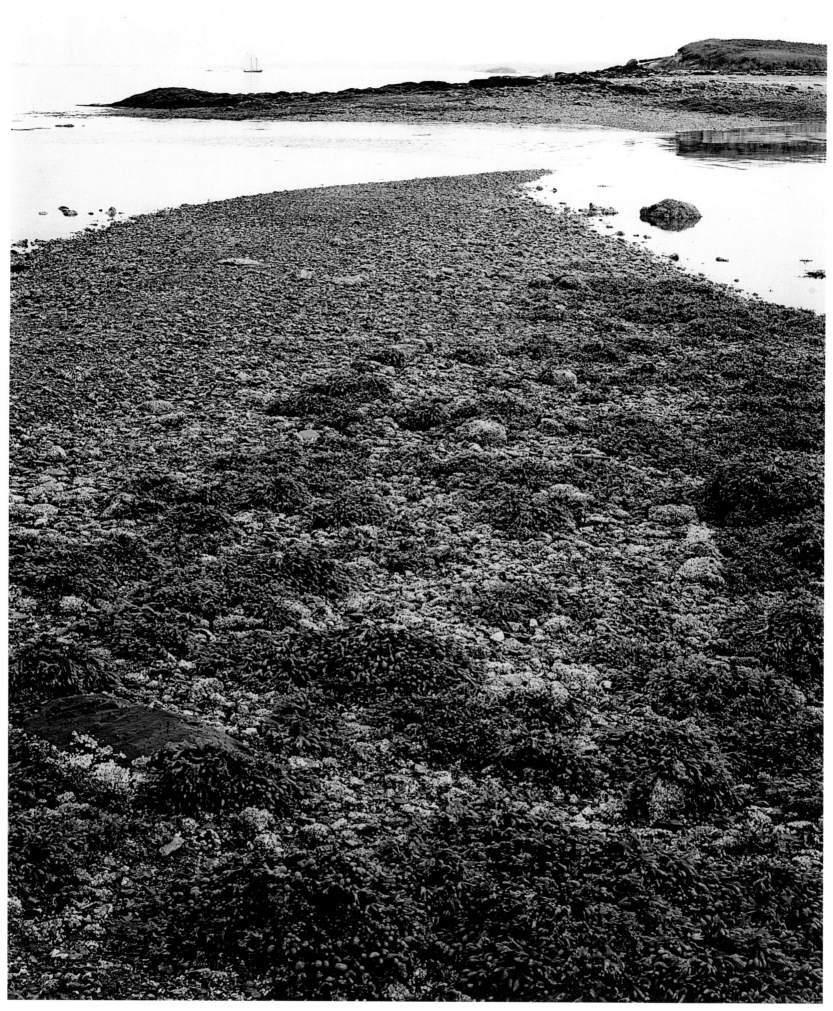

Tidal bar, Barred Islands, Maine, July 21, 1963

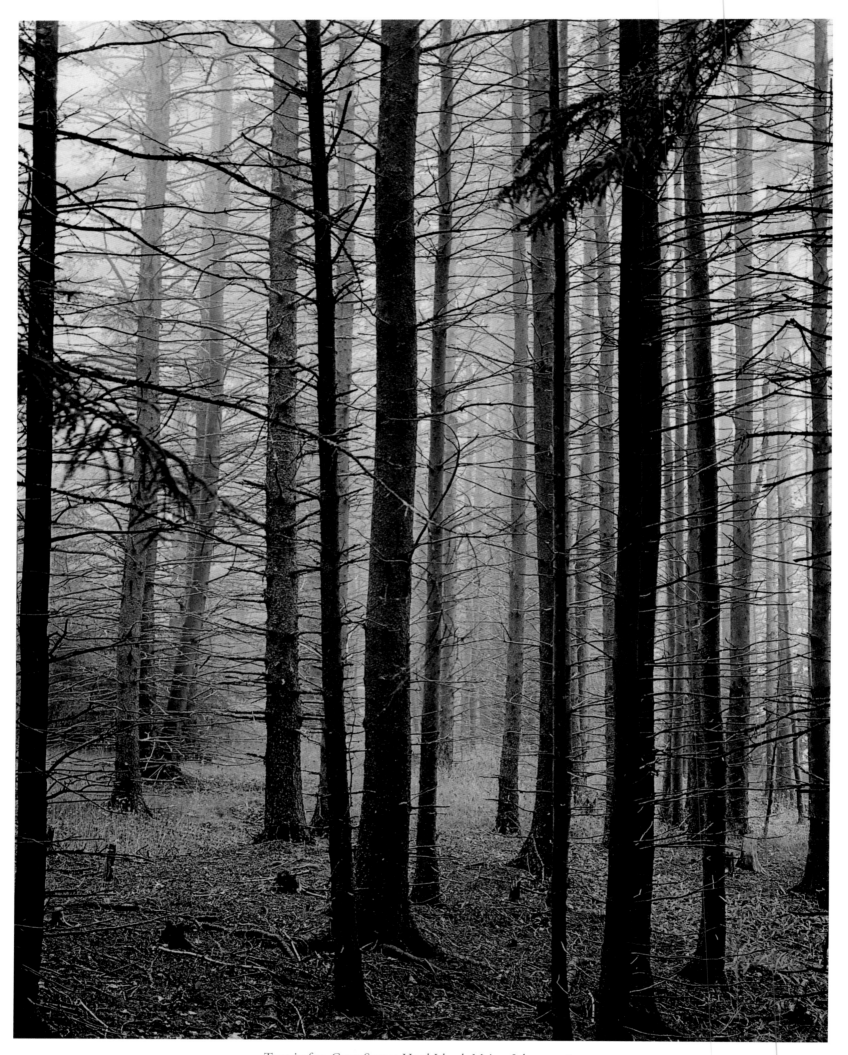

Trees in fog, Great Spruce Head Island, Maine, July 29, 1963

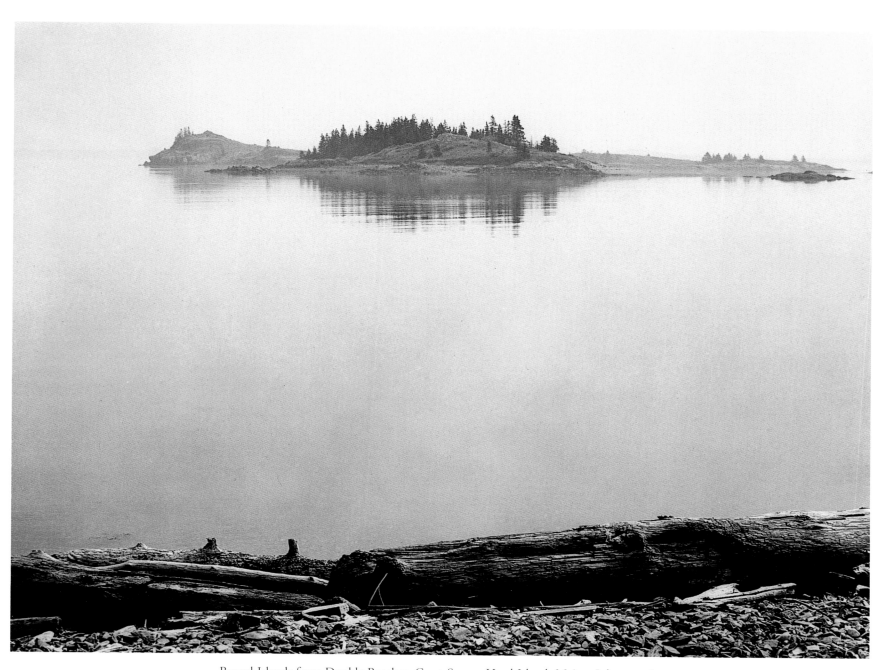

Barred Islands from Double Beaches, Great Spruce Head Island, Maine, July 17, 1964

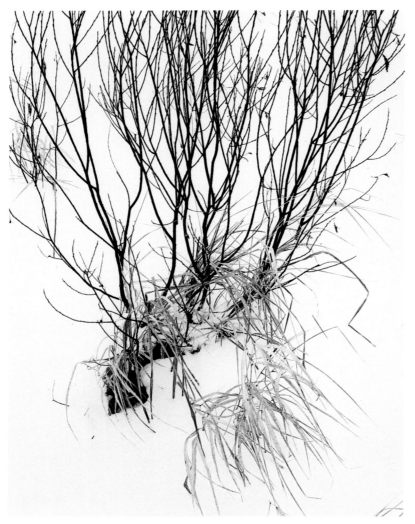

Grass in snow, Route 3, north of Saranac Lake,
Adirondack Mountains, New York, February 5, 1965

Photography for me is a creative art. It is not simply an illustrative or interpretive medium. An artist creates according to his deepest feeling—his emotional inspiration. He cannot invoke these feelings, together with their fulfillment in an objective work, on order. It has to come from within himself… I try, not always with success, to photograph only what stimulates a recognition of beauty, either that which is intrinsic in the objects of nature or is a manifestation of the wonderful relationships of things in the natural world.…

Mrs. Hochschild wanted pictures of old Adirondack farms tucked away in the mountains and views of the high peaks from outlooks. George Marshall wanted pictures of virgin forests, the rocks in relation to the lakes, mountain views, sphagnum bogs, the mountains displaying the various tones of summer green. This is a big order…but it is much more than that: it is a request that I see the Adirondacks through their eyes. An artist's outlook on the world is unique. He, or anyone else for that matter, sees things his way only. —E. P.

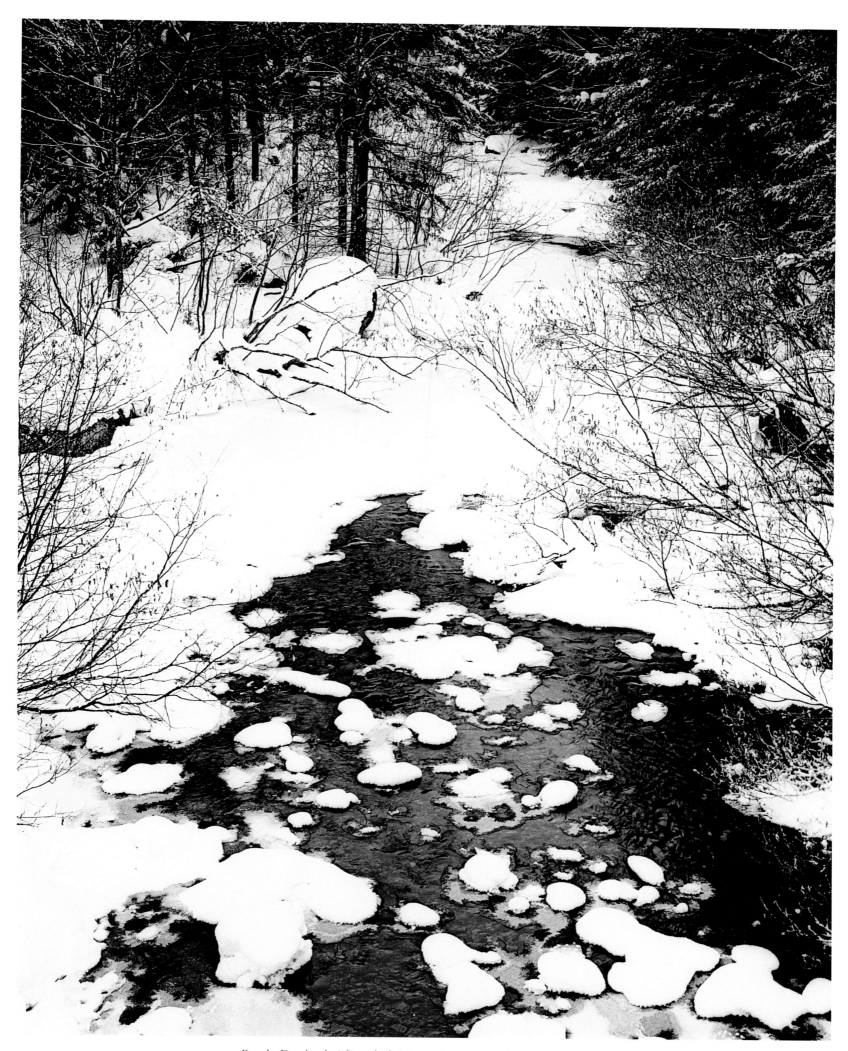

Brook, Deerland, Adirondack Mountains, New York, February 4, 1965

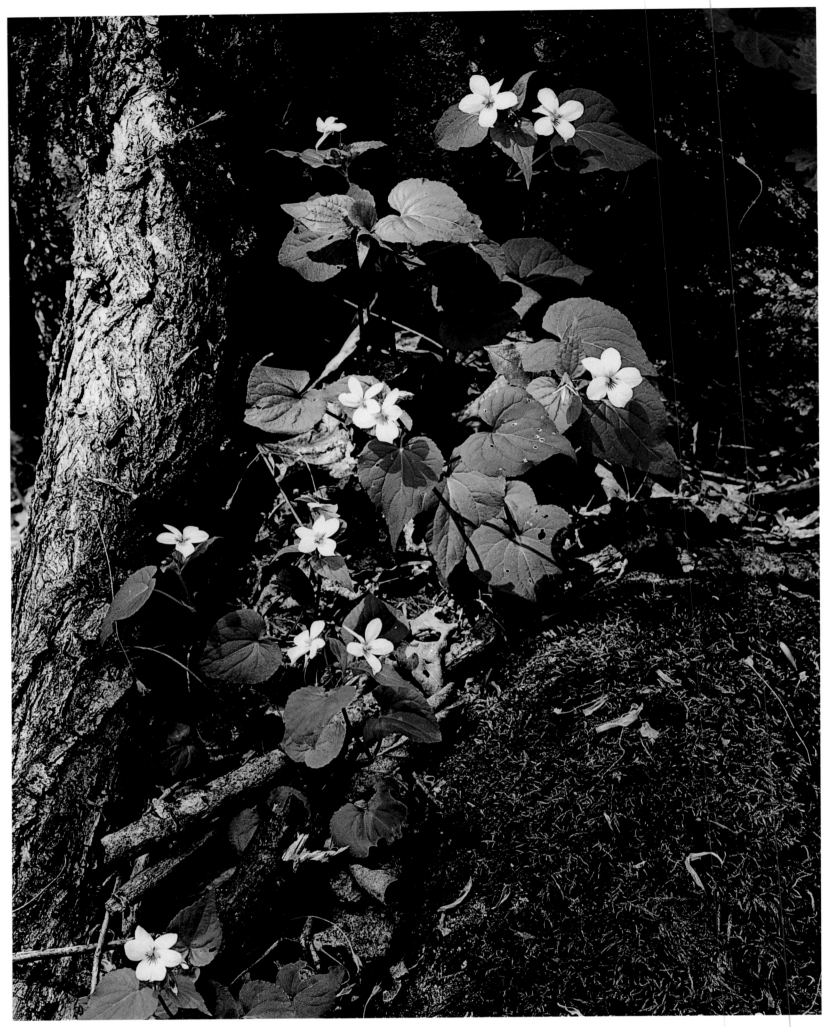

White violets, on Brown Farm, Cedar River Road, Adirondack Mountains, New York, May 16, 1964

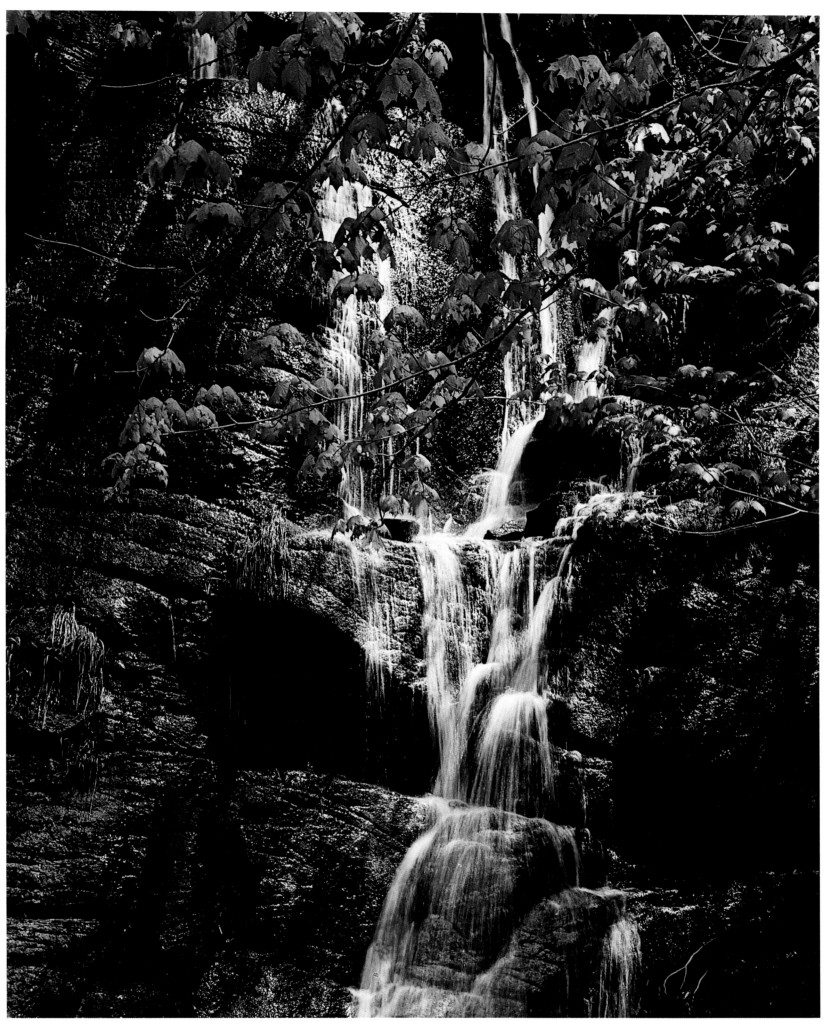

Waterfall and maple leaves, Adirondack Mountains, Keene, New York, May 21, 1964

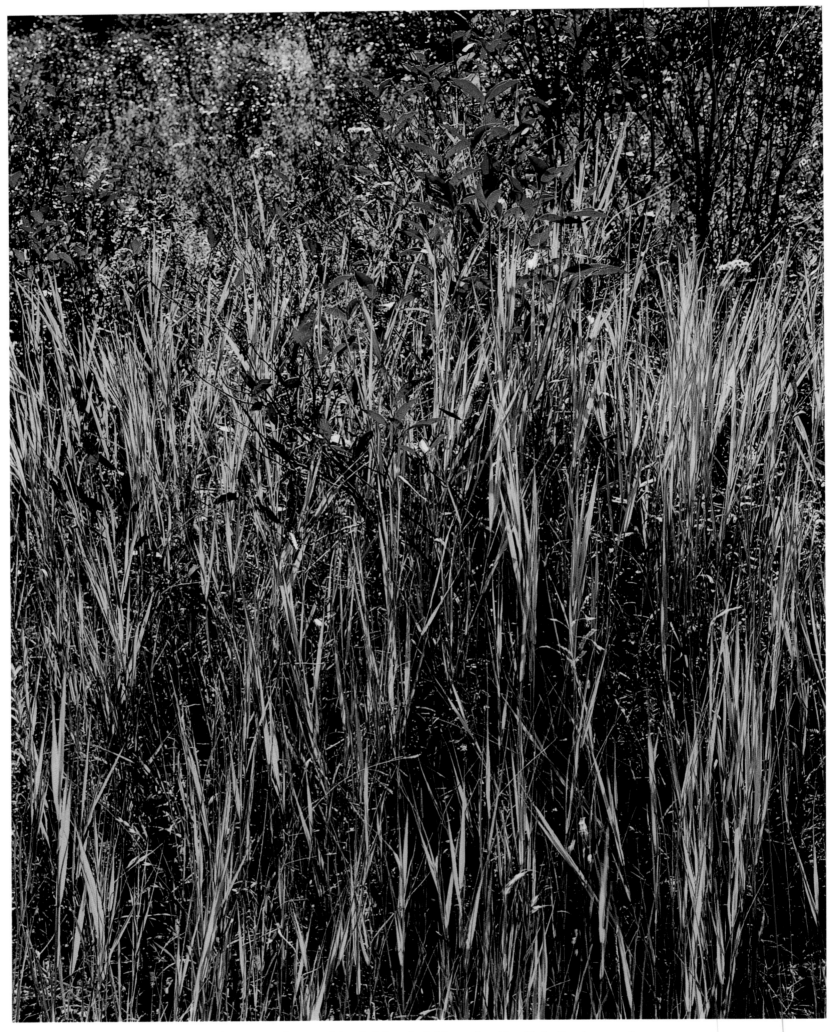

Sunlit grasses, Clear Pond Road, Adirondack Mountains, New York, October 2, 1963

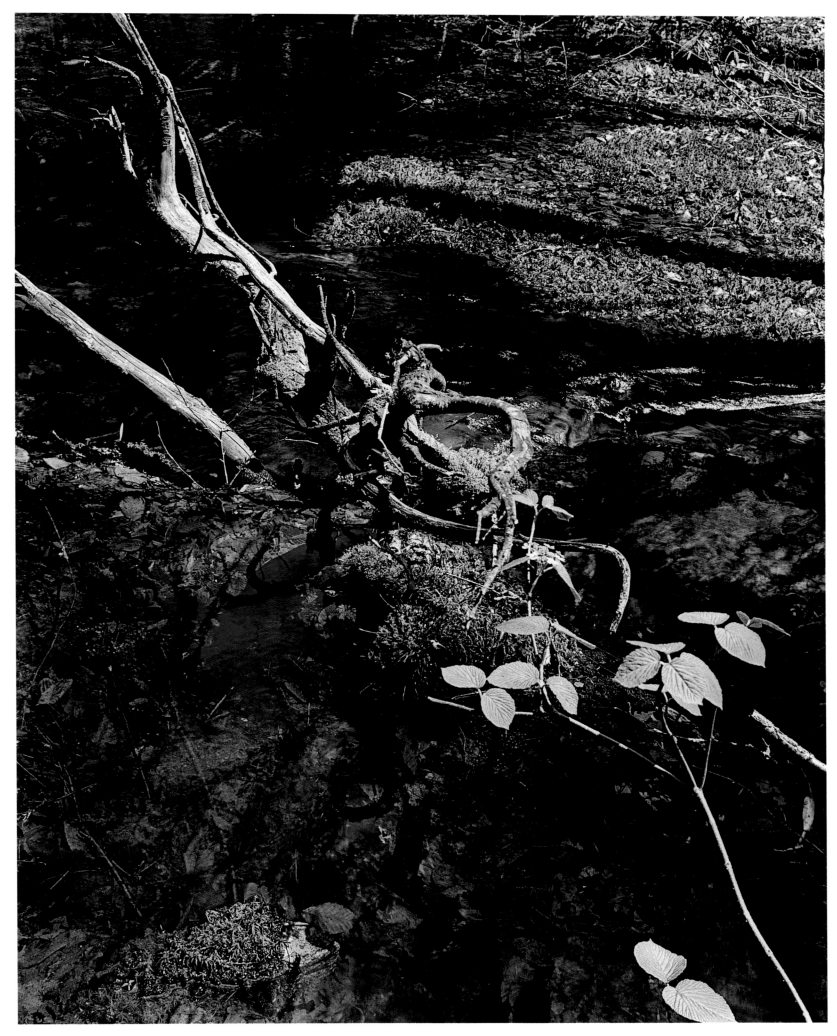

Woodland brook, Sargent's Pond Trail, Blue Mountain Lake, Adirondack Mountains, New York, May 15, 1964

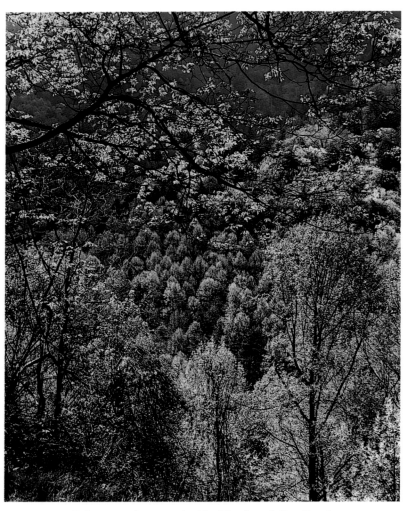

Oak tree and mountainside, Newfound Gap Road,
Great Smoky Mountains National Park, Tennessee, April 23, 1968

As I became interested in photography in the realm of nature, I began to appreciate the complexity of the relationships that drew my attention; and these I saw were more clearly illustrated in color than in tones of gray. The first objects of nature that attracted me, as might be expected, were the most colorful ones. Of the birds they were those with the brightest plumage, while among other subjects they were the flowers, lichens, and autumn leaves. Gradually the more subtle hues began to draw my attention—the colors of earth, of decaying wood, of bark, and then the strange colored reflections one sees when one looks for them. To be aware of these relationships of light and color requires an education of perception, of training oneself to see; not that in my case the process was a purely conscious one, for if it had been the results would have been stiff and contrived, lacking in spontaneity, as in fact they almost always were when I did make a conscious effort. Rather, the things I began to see were the result of continuously observing the fine structure of nature. —E. P.

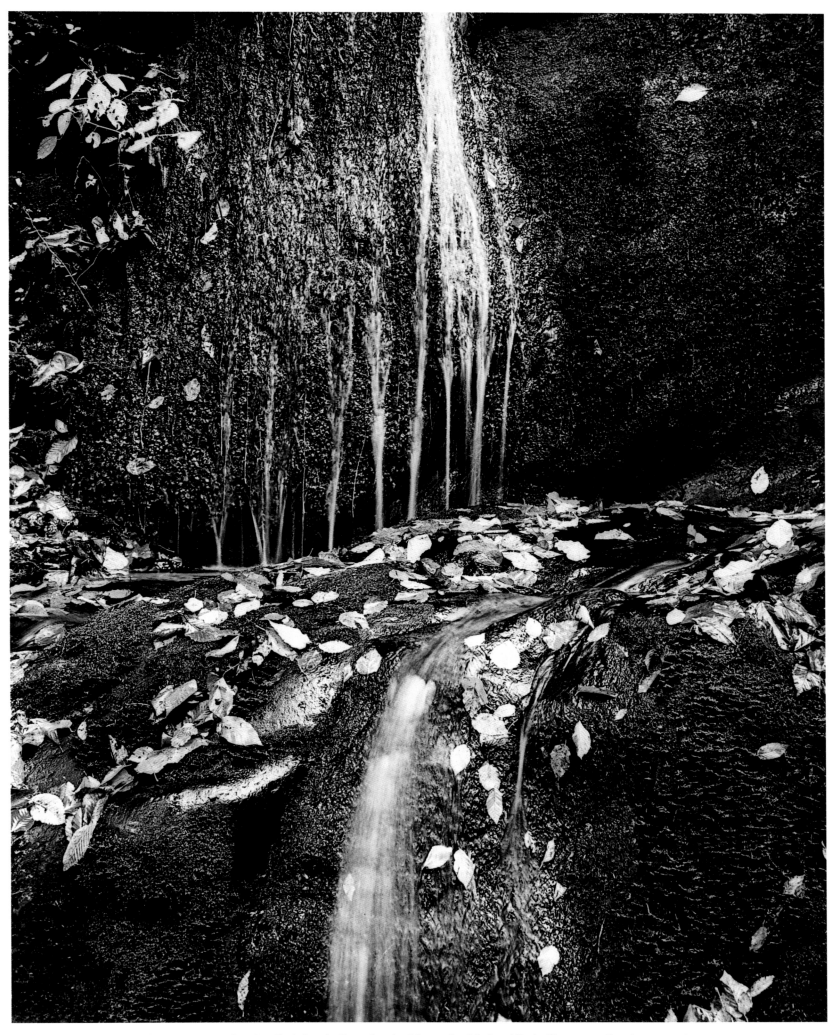

Running water, Roaring Fork Road, Great Smoky Mountains National Park, Tennessee, October 17, 1967

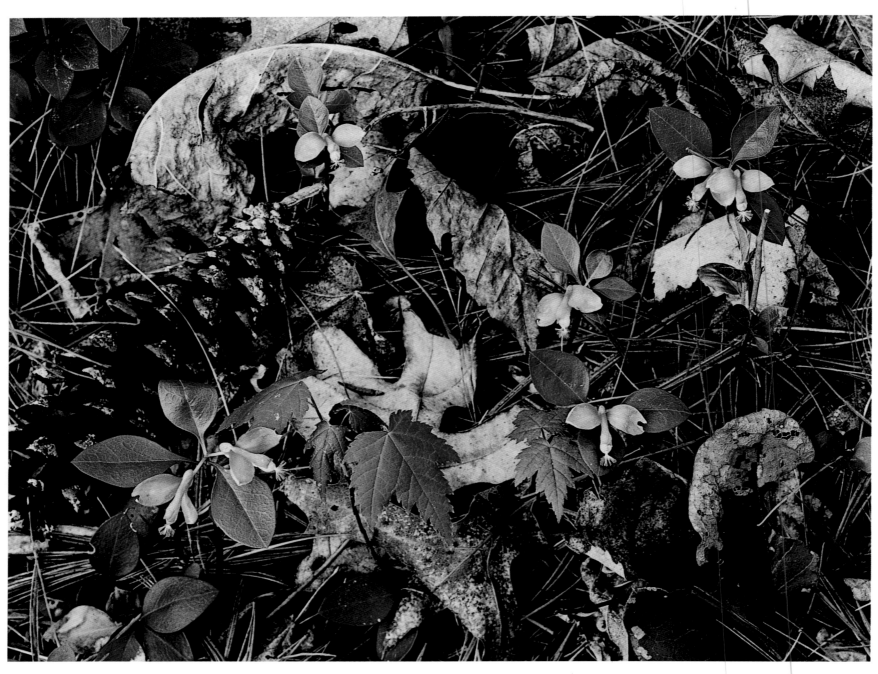

Polygola, Arbutus Ridge on road to Cades Cove, Great Smoky Mountains National Park, Tennessee, April 25, 1968

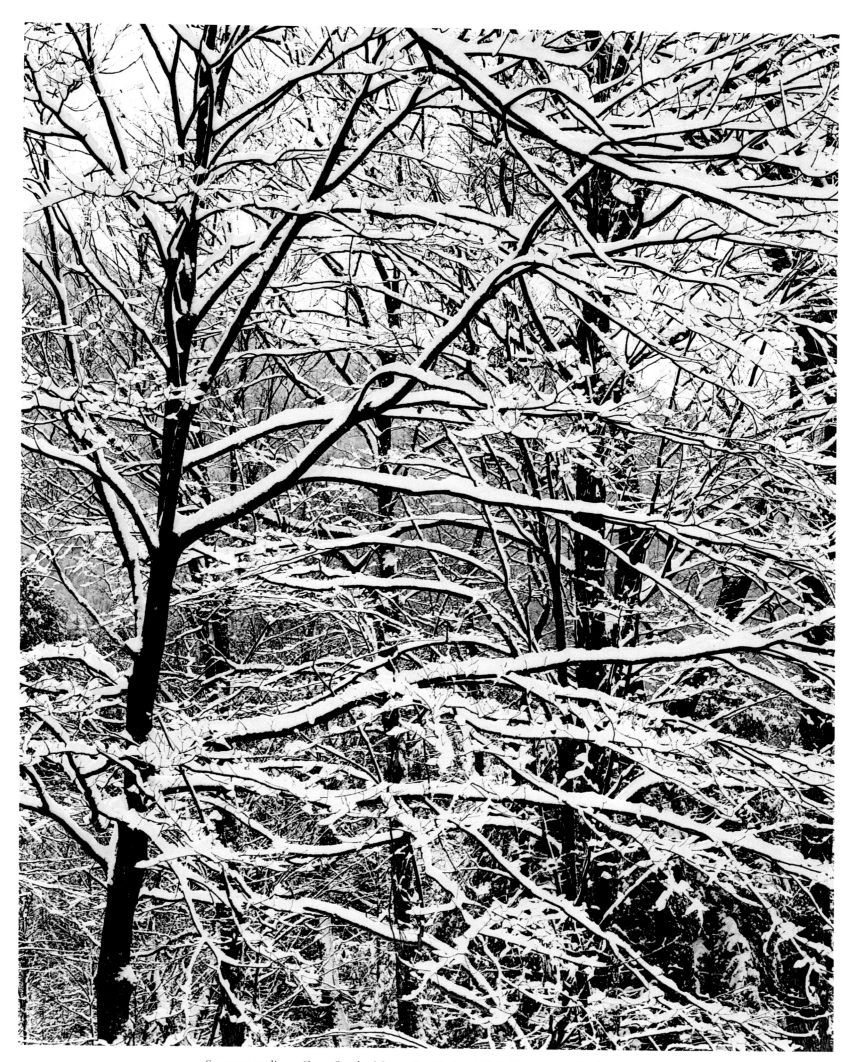

Snow on saplings, Great Smoky Mountains National Park, Tennessee, March 11, 1969

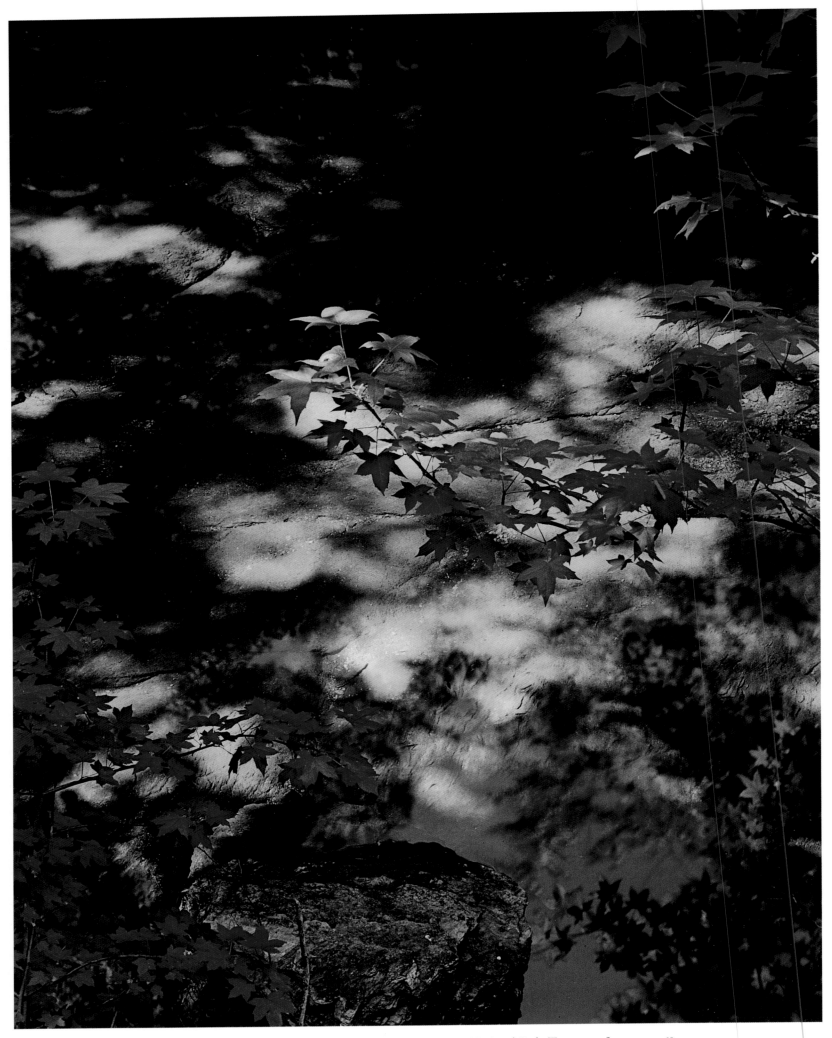

Sun on brook, Cades Cove Road, Great Smoky Mountains National Park, Tennessee, June 30, 1968

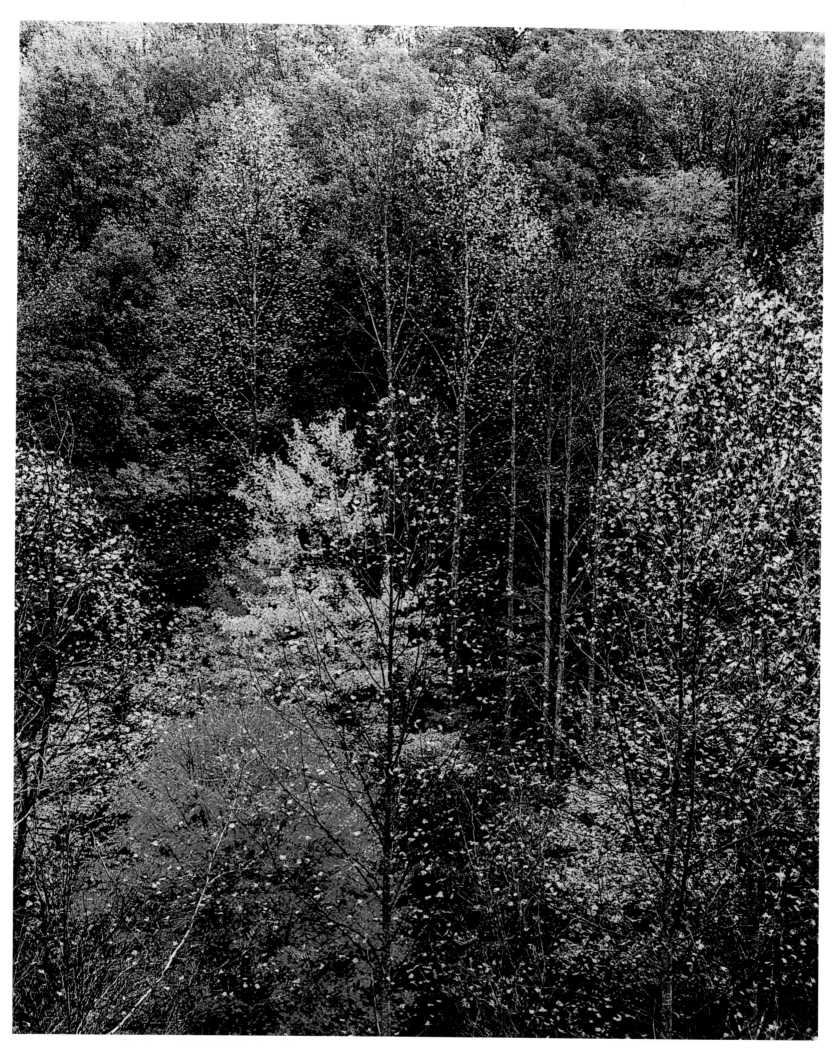

Poplars and hillside, Newfound Gap Road, Great Smoky Mountains National Park, Tennessee, October 17, 1967

As the photographer of the social scene records human emotions and behavior, normal and abnormal, man's relationship to his fellow men and to the environment, and the impact of his activities on his surroundings— how he alters them to his advantage and disadvantage, and how he copes with the situations he creates—so the photographer of the non-human world is concerned with the interrelationships between other living things and between them and the physical environment. The study of these relationships is ecology. Ecology in its broadest sense includes man, too, and in its most comprehensive meaning ecology is the study of life.

Baja California is epitomized by this resplendent bay, where the real and the romantic are juxtaposed, just as other opposites are up and down the lower and wilder California—the chill winds against the oppressive heat; torrents and mud against the dusty desiccation; forested shade against desert waste. The vegetation itself seems to defy the seasons. Leaves are born in winter and blossoms in summer. Fall, the season of ripening, may come in spring; and spring may come if it rains. The bare, leafless bones of the elephant trees stand against the lava chunks and gravel. In the heat of mid-July they bring forth fluffy masses of the most delicate, fragrant flowers. The very geology testifies to agony on a grand scale, when the granite spine and its metamorphic core, upheaved in eons past, was shattered by volcanic thrusts and buried in the ensuing floods of lava. —E. P.

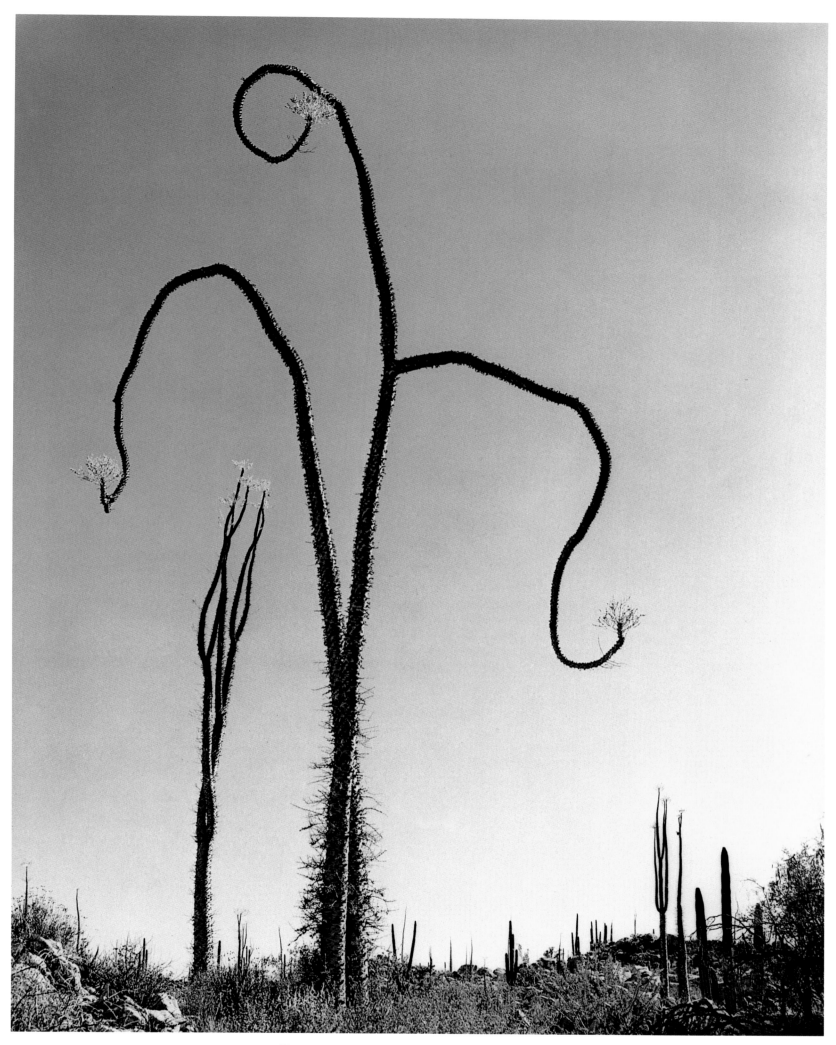

Cirio, near La Virgenes, Baja, California, July 31, 1966

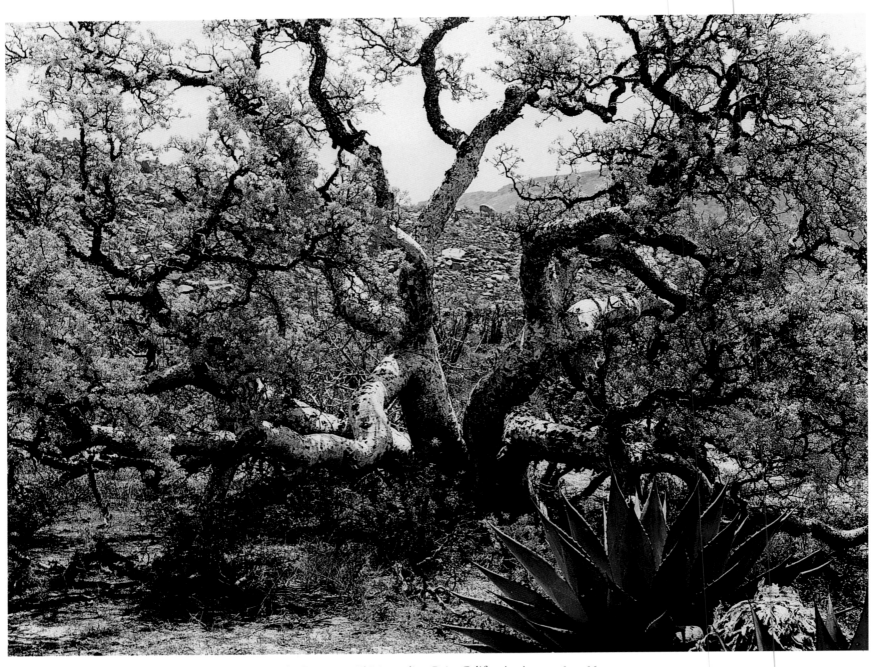

Elephant tree, El Marmolite, Baja, California, August 6, 1966

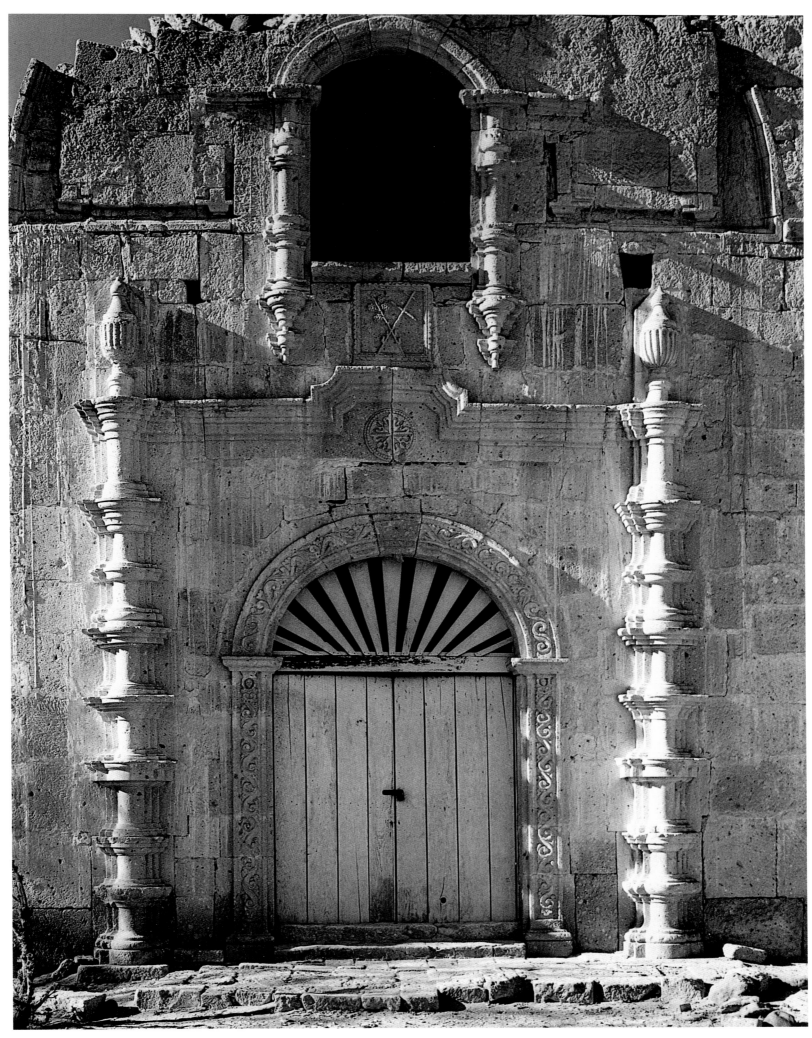

Façade, San Borjas, Baja, California, February 21, 1964

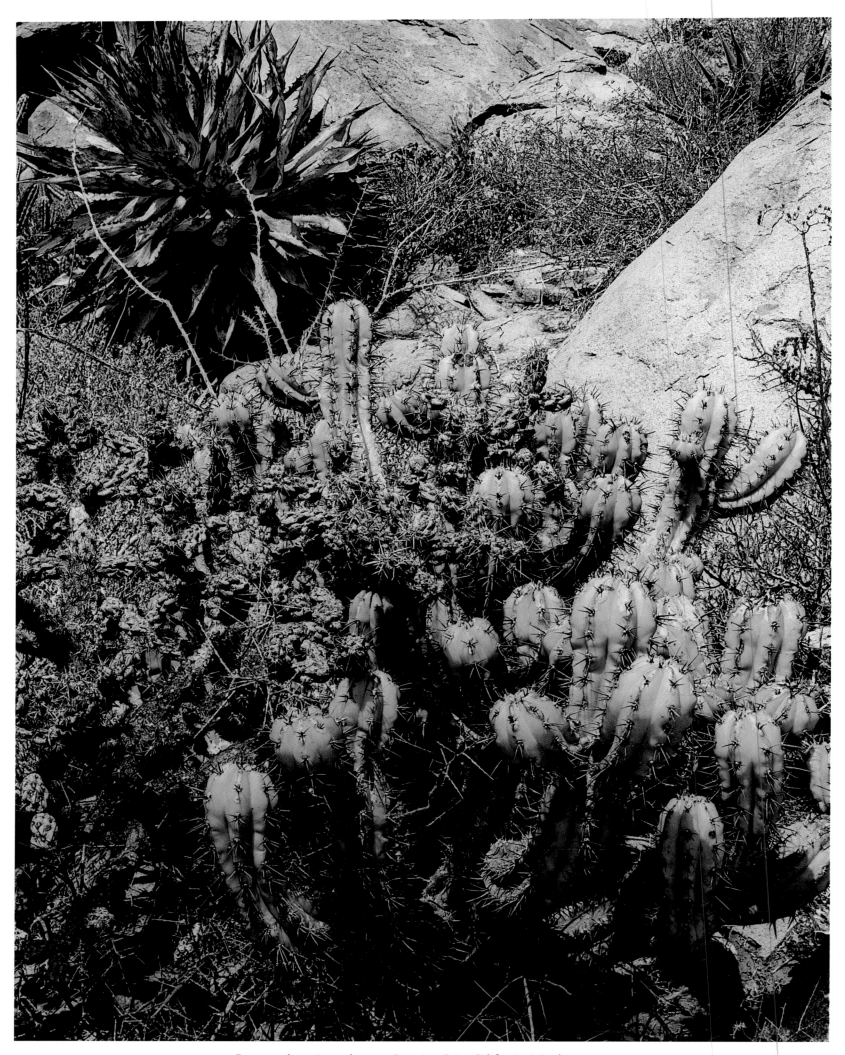

Cactus and granite rocks, near Rosarito, Baja, California, March 29, 1964

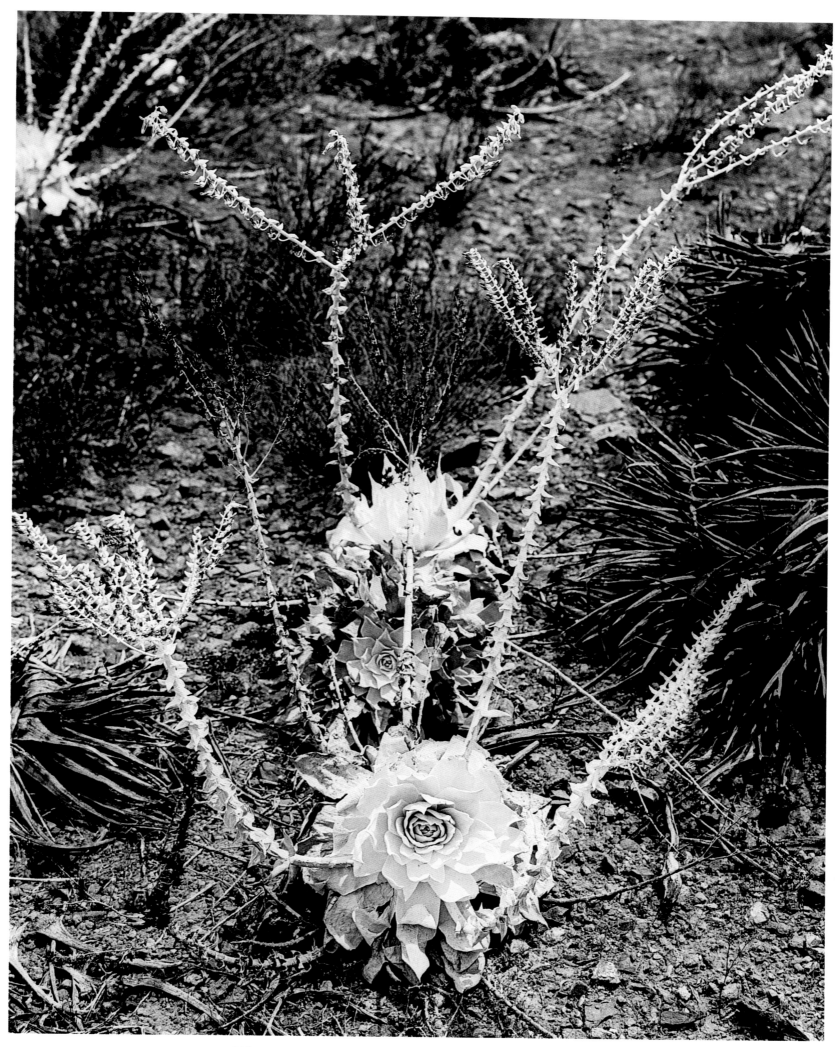

White succulent, near Rancho Arenose, Baja, California, July 27, 1966

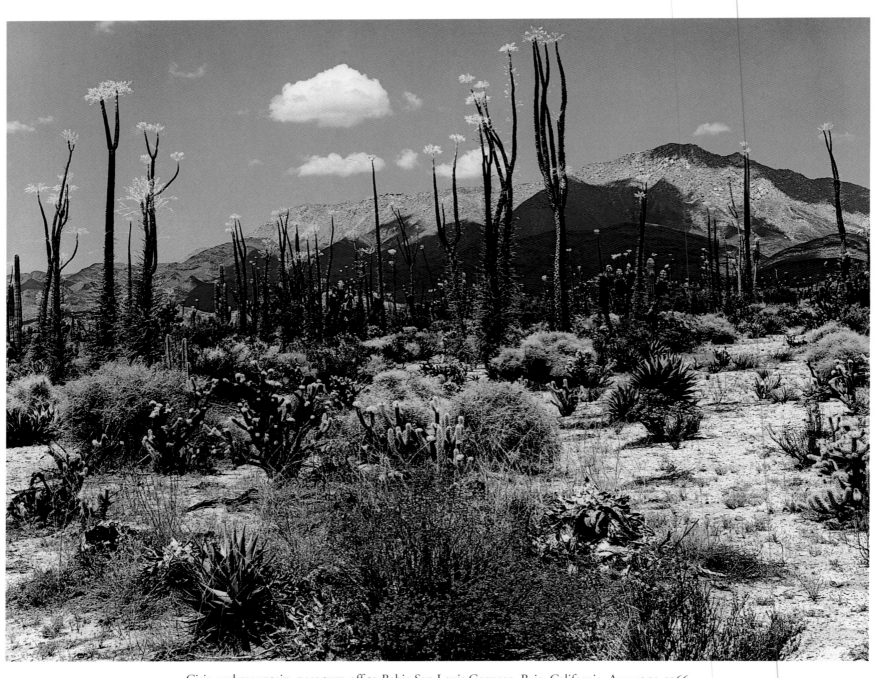

Cirio and mountain, near turn-off to Bahia San Louis Gonzaga, Baja, California, August 15, 1966

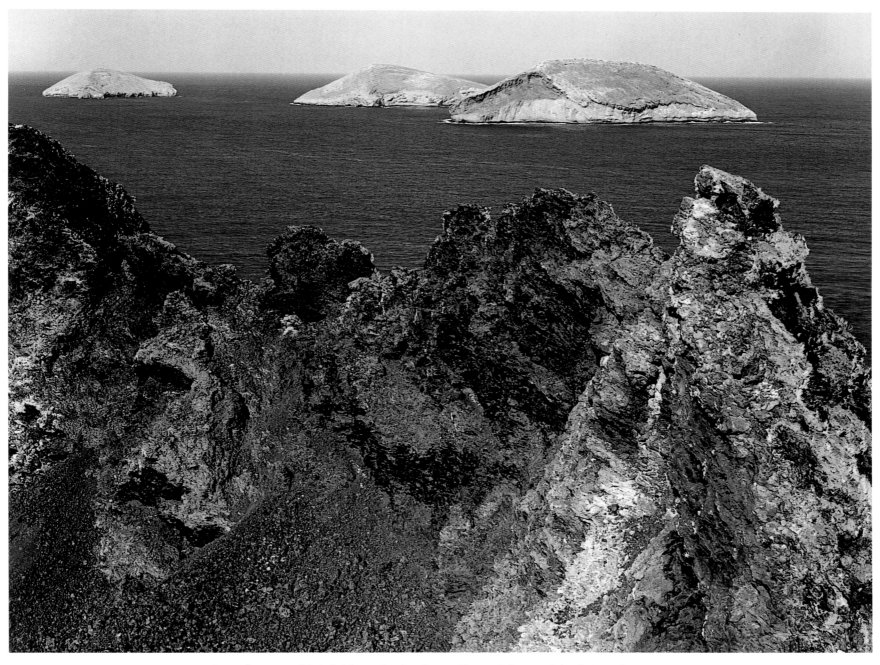
Rim of crater and Bainbridge rocks, Sombrero Chino, Galápagos Islands, March 11, 1966

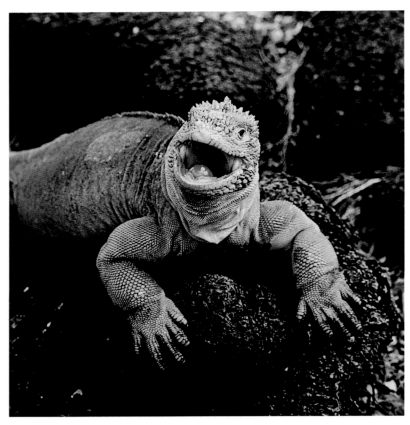

Land iguana, Cartago Bay, Isabella, Galápagos Islands, May 8, 1966

Among the many small [Galápagos] Islands there are a great number on which landing is impossible. They are mere pinnacles of rock, basalt cores, or fragments of eroded craters that drop sheer into the sea. Even if you did succeed in getting ashore probably little would be found to distinguish them from the more accessible small islands. Still you continue to locate them on the charts and view them with longing from the deck of your boat. On land the situation is even more frustrating. Each lava flow invites exploration; the more recent in origin the stronger the urge to cross it. You know it will be rough going, exhausting, and hot, but the strip of green on the far side beckons you; or the island of old rock and trees which splits the flow and is enclosed by it demands your attention. What isolated creatures might be found there, you can only guess. —E. P.

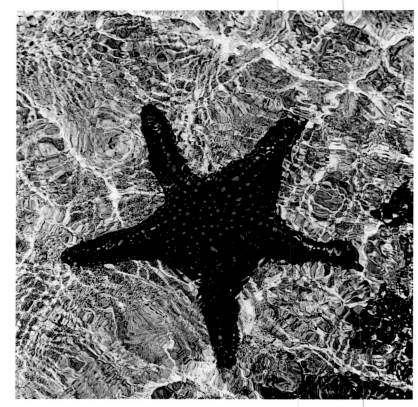

Starfish, San Cristobal, Galápagos Islands, May 23, 1966

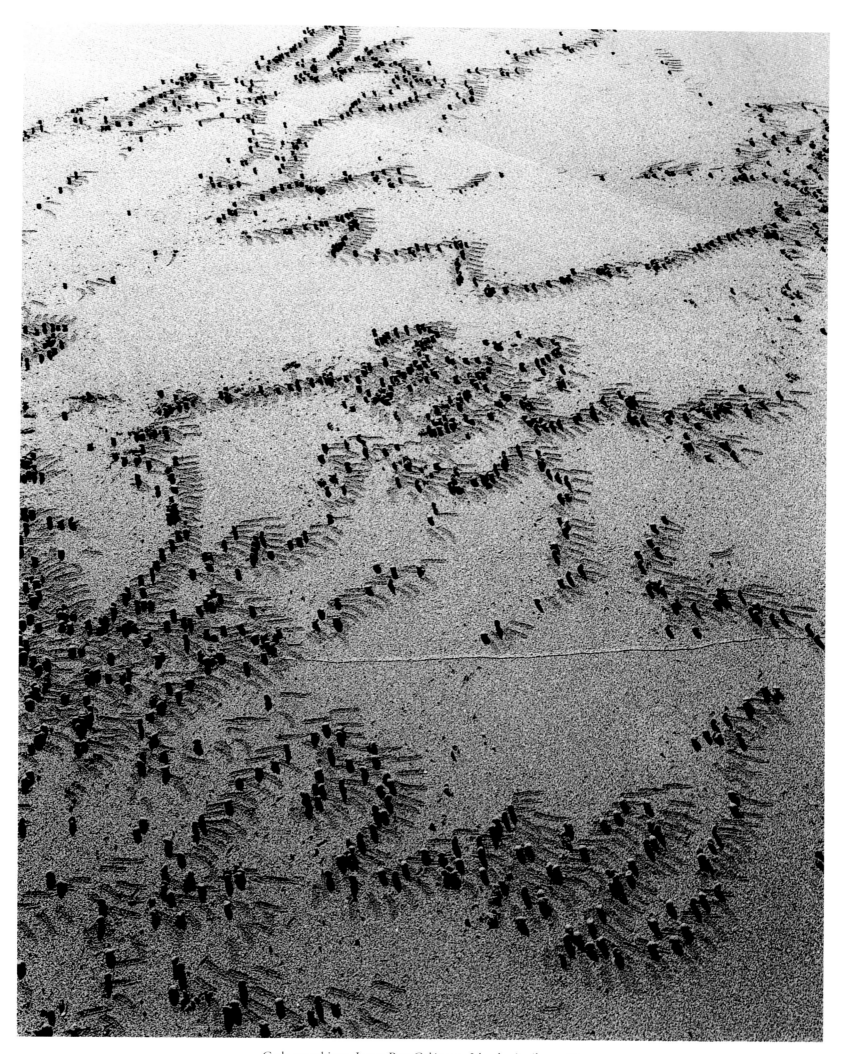

Crab scratchings, James Bay, Galápagos Islands, April 1, 1966

Optuntia trunks, Darwin Station, Santa Cruz Island, Galápagos Islands, April 28, 1966

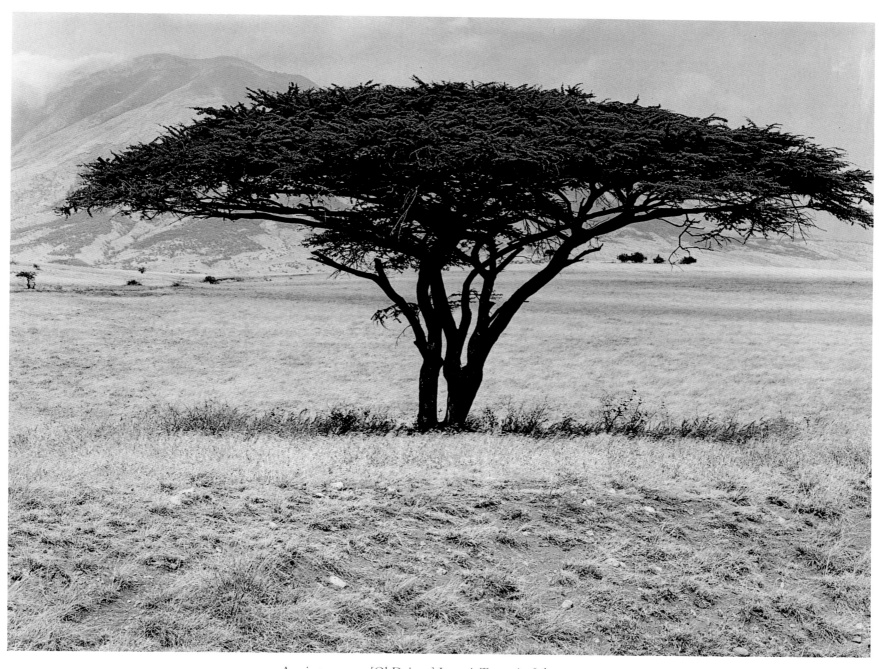

Acacia tree, near [Ol Doinyo] Lengai, Tanzania, July 13, 1970

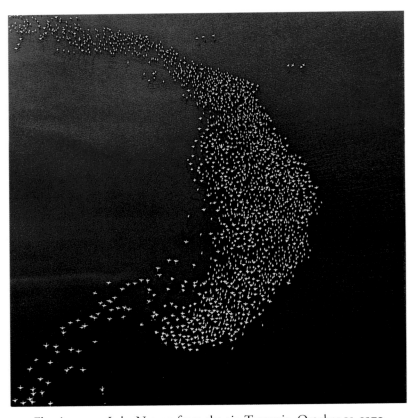

Flamingos on Lake Natron from the air, Tanzania, October 15, 1970

In my life my chosen subject has been nature and my chosen medium color photography. My devotion to the natural world was the inevitable consequence of childhood environment and family influence; my sense of wonder was first aroused by the physical and biological mysteries of science, and when I became interested in photography the subjects that occupied my attention were those primarily connected with the natural scene. At the same time, nature became intimately associated with my perception of beauty. This feeling has persisted throughout my life, although with maturity my appreciation for what is beautiful has vastly expanded. And so the aspects of nature that I perceive as beautiful in the conventional sense as well as in a phenomenal sense are what I attempt to record photographically. —E. P.

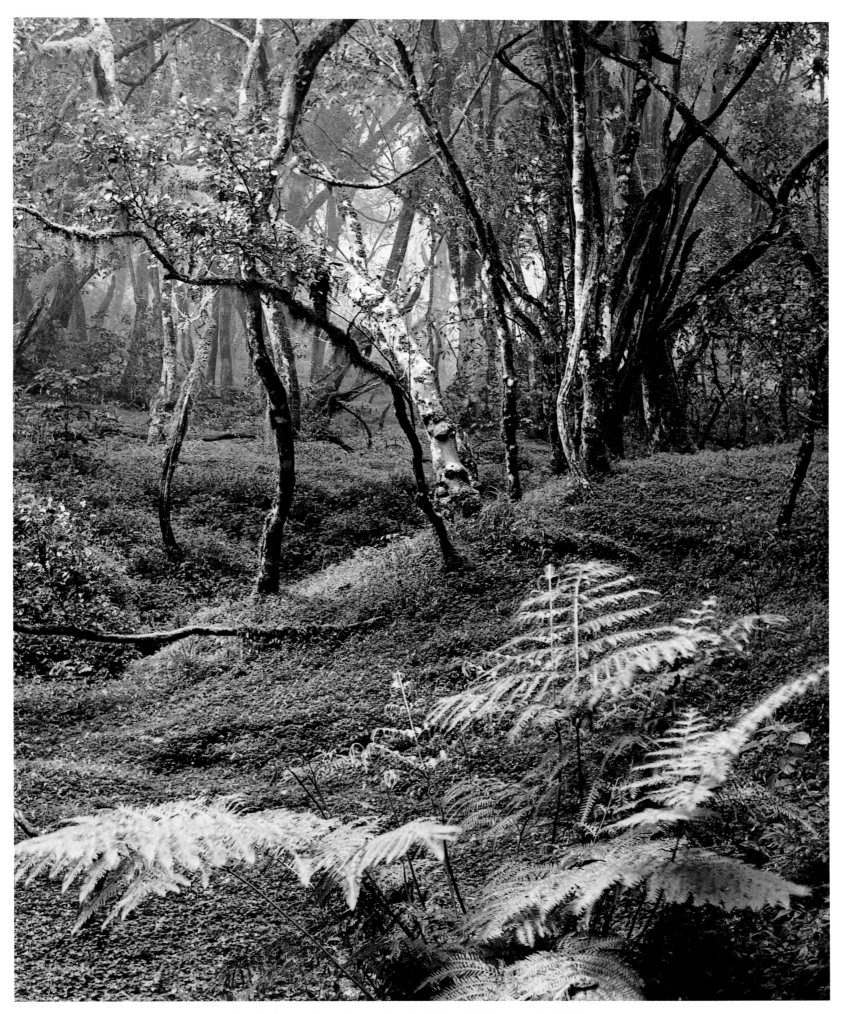

Ferns in forest, Mount Meru, Arusha National Park, Tanzania, July 8, 1970

My primary concern in traveling to unusual places was adventure—the opportunity to see new places, especially places that were dramatic. Though my purpose was not always to take photographs for publication, wherever I went I always took photographs because this was how I expressed the impressions these places made on me. —E. P.

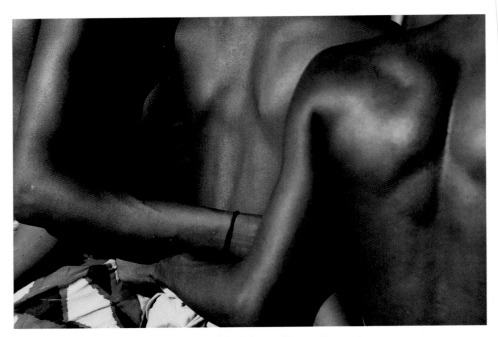

Lo-Molo dancers, Lake Turkana, Kenya, June 26, 1970

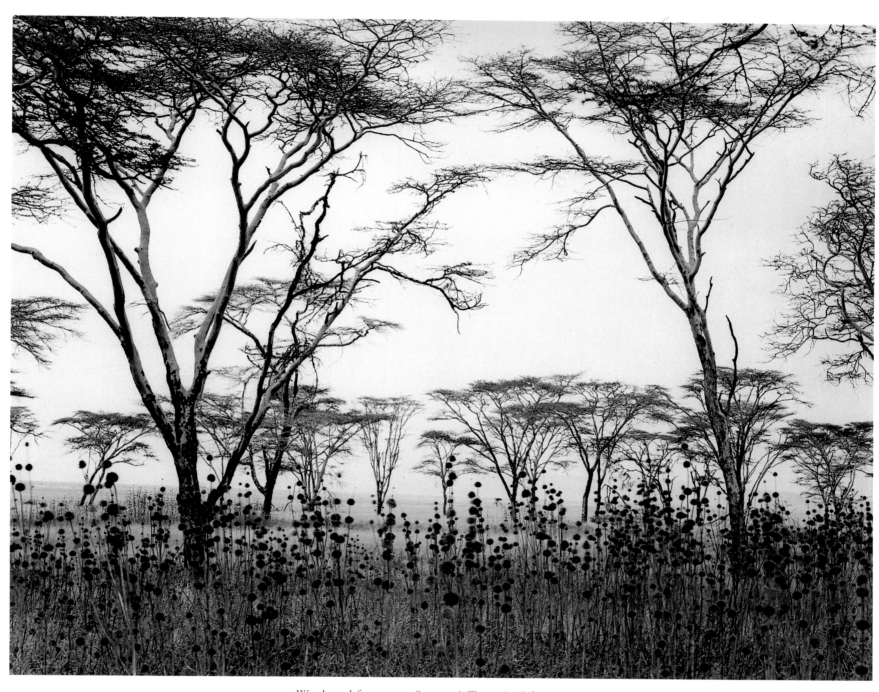

Weeds and fever trees, Serengeti, Tanzania, July 19, 1970

I was intrigued by Iceland in large part because it is entirely volcanic in origin; Iceland is situated on the northern end of the mid-Atlantic ridge, which extends across the island from Mt. Hekla (an active volcano on the south side) in a northeasterly direction to the hot springs area near Mývatn. The beauty of the Icelandic landscape is not limited to volcanic phenomena, the mountains of igneous rock, the torrential rivers and thunderous falls, or the ice-filled glacial lakes; its vegetation is also a major attraction. The trees are dwarfed and stunted. Tundra covers much of the interior; arctic and alpine wild-flowers bloom in seemingly unlimited abundance in summer. But the most striking contributor to Iceland's plant life is its mosses. Old lava flows every-where are encased in pillowy, gray-green, spongy masses. . . . And we found the lichens that had brought us to Iceland in the first place, decorating the older rocks everywhere in bright-colored geometric plaques. —E. P.

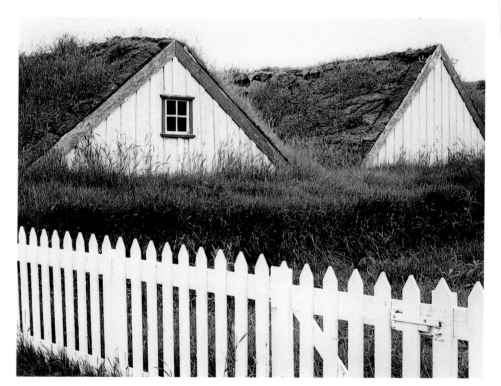

Turf farm near Laufás, Iceland, July 18, 1972

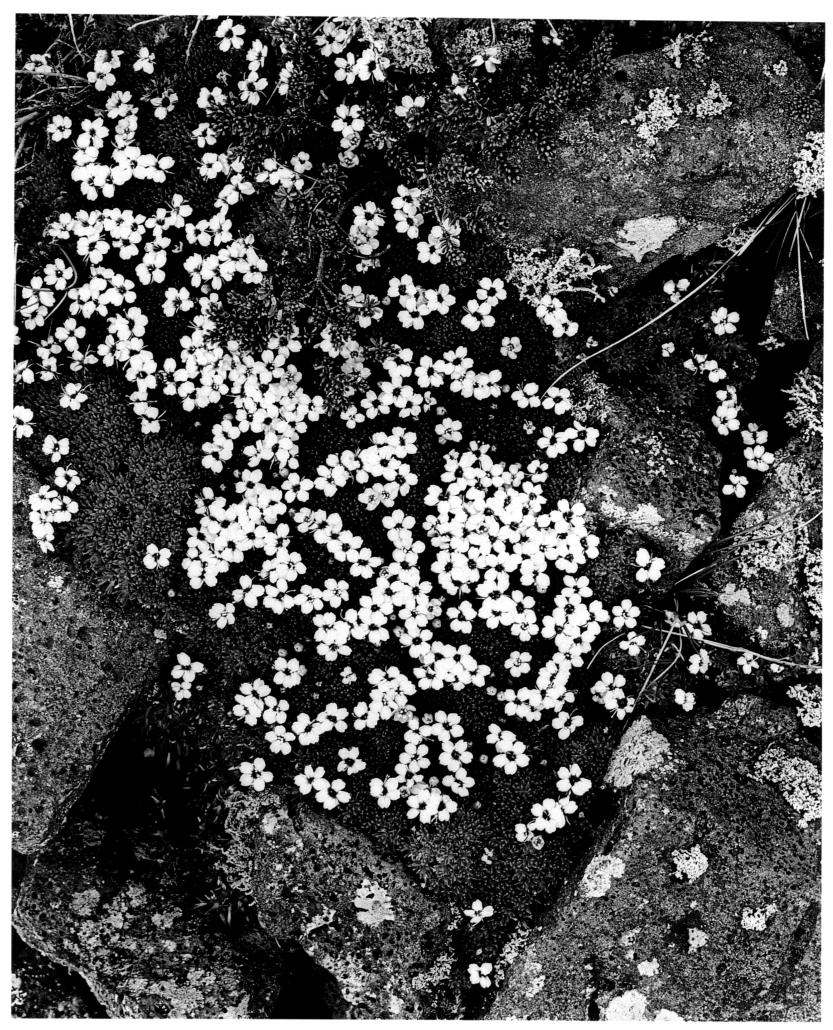

Pinks, road to Krísuvík, Reykjanes, Iceland, June 17, 1972

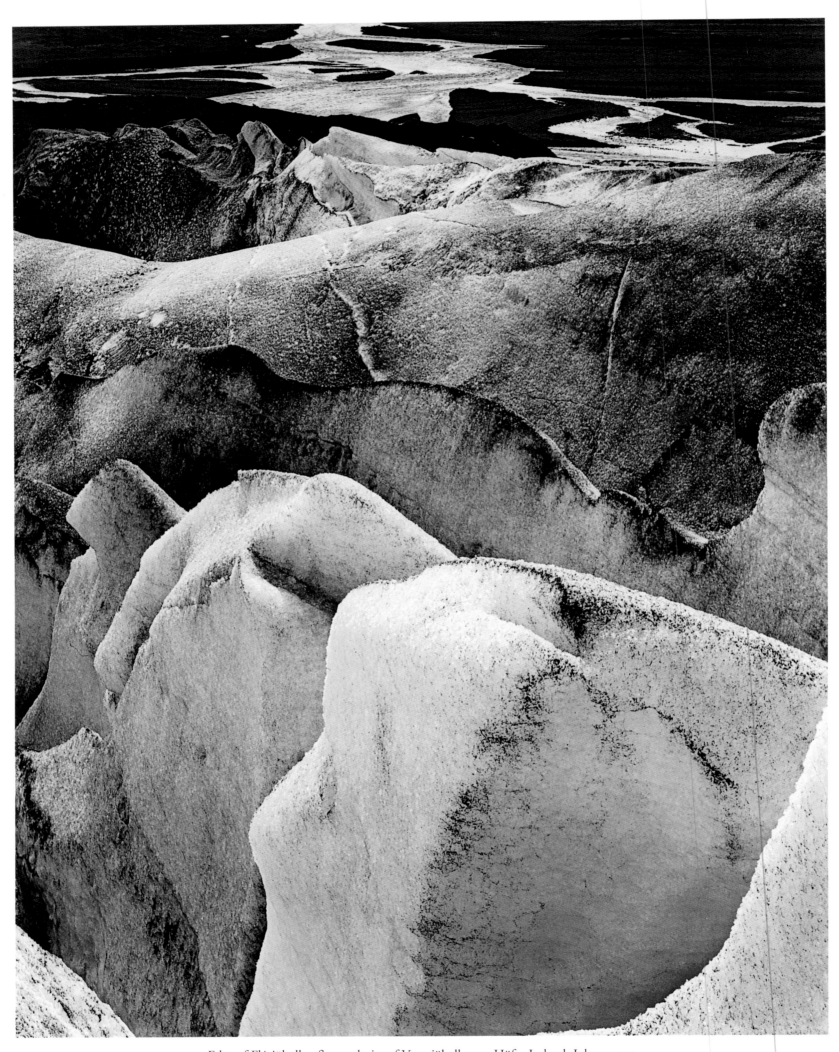

Edge of Fláajökull, a finger glacier of Vatnajökull, near Höfn, Iceland, July 31, 1972

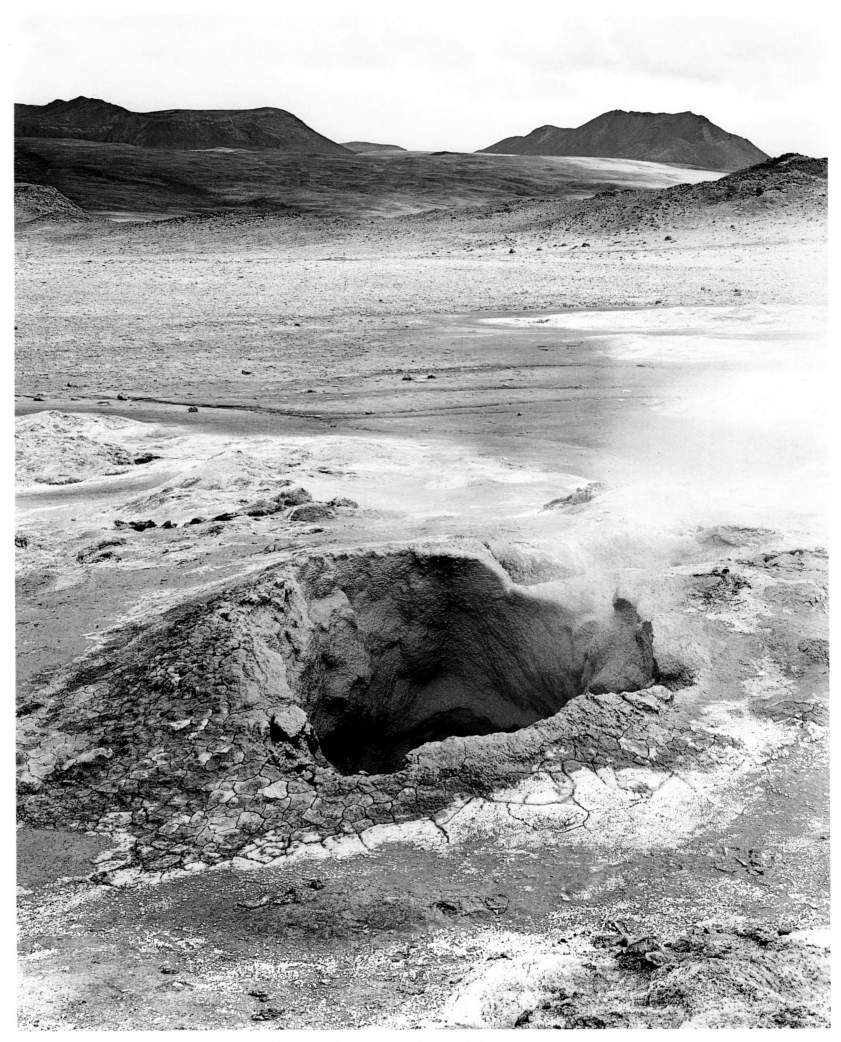

Mud pot in hot spring area, Mývatn, Iceland, July 23, 1972

To most people, I am sure, the beauty of nature means such features as the flowers of spring, autumn foliage, mountain landscapes, and other similar aspects. That they are beautiful is indisputable; yet they are not all that is beautiful about nature. They are the peaks and summits of nature's greatest displays. But underlying and supporting these brilliant displays are slow, quiet processes that pass almost unnoticed from season to season—unnoticed, that is, by those who think that the beauty in nature is all in its gaudy displays. Yet, how much is missed if we have eyes only for the bright colors. —E. P.

Lichens on rock, road to Laki, Iceland, July 3, 1972

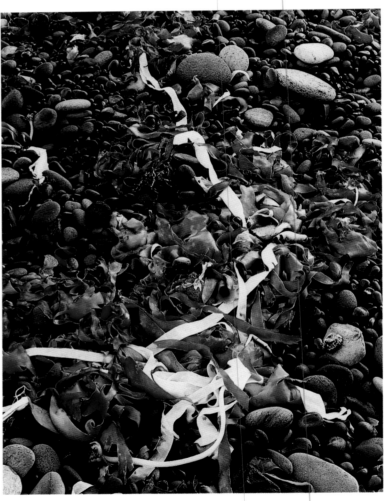

Kelp on black stone beach, Dritvík, Snæfellsnes, Iceland, July 13, 1972

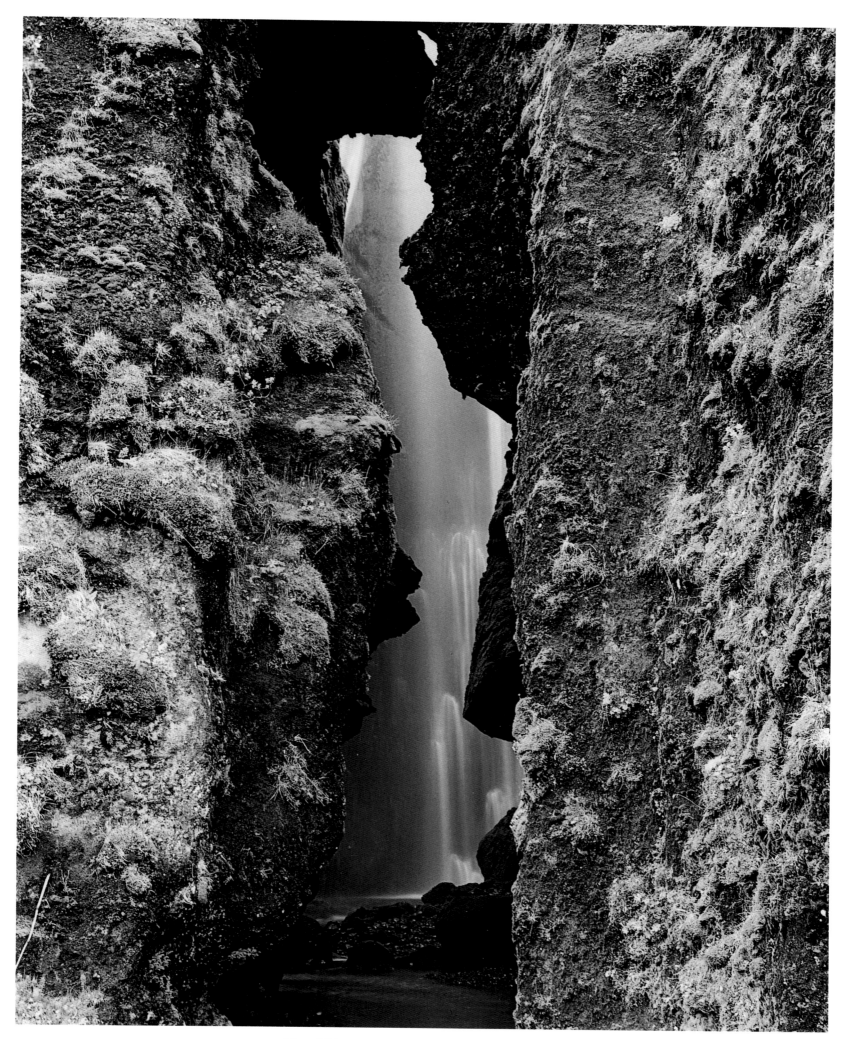

Waterfall in crevice, road to Vik, Iceland, July 1, 1972

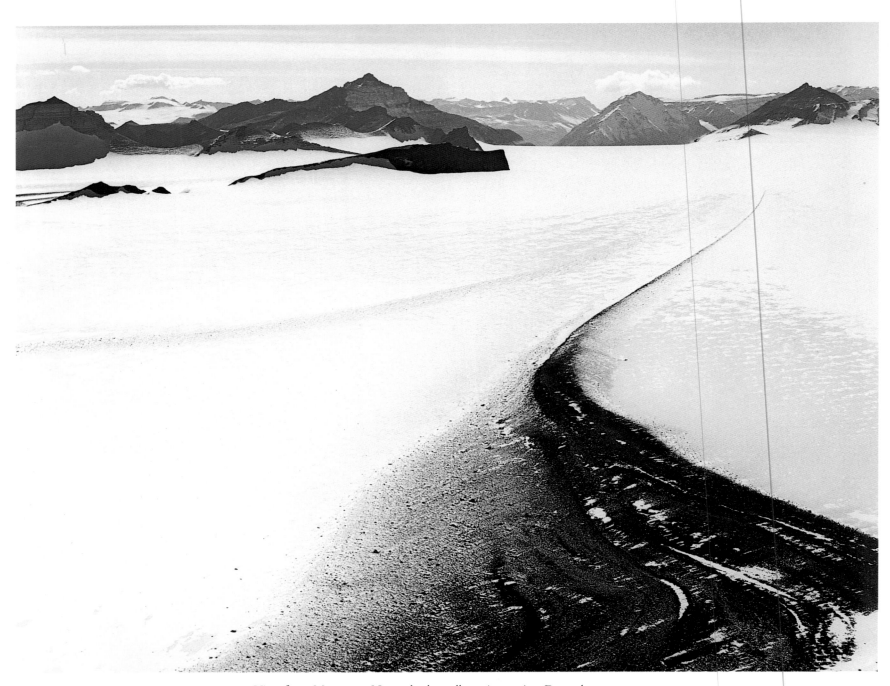

View from Monastery Nunatak, dry valleys, Antarctica, December 31, 1975

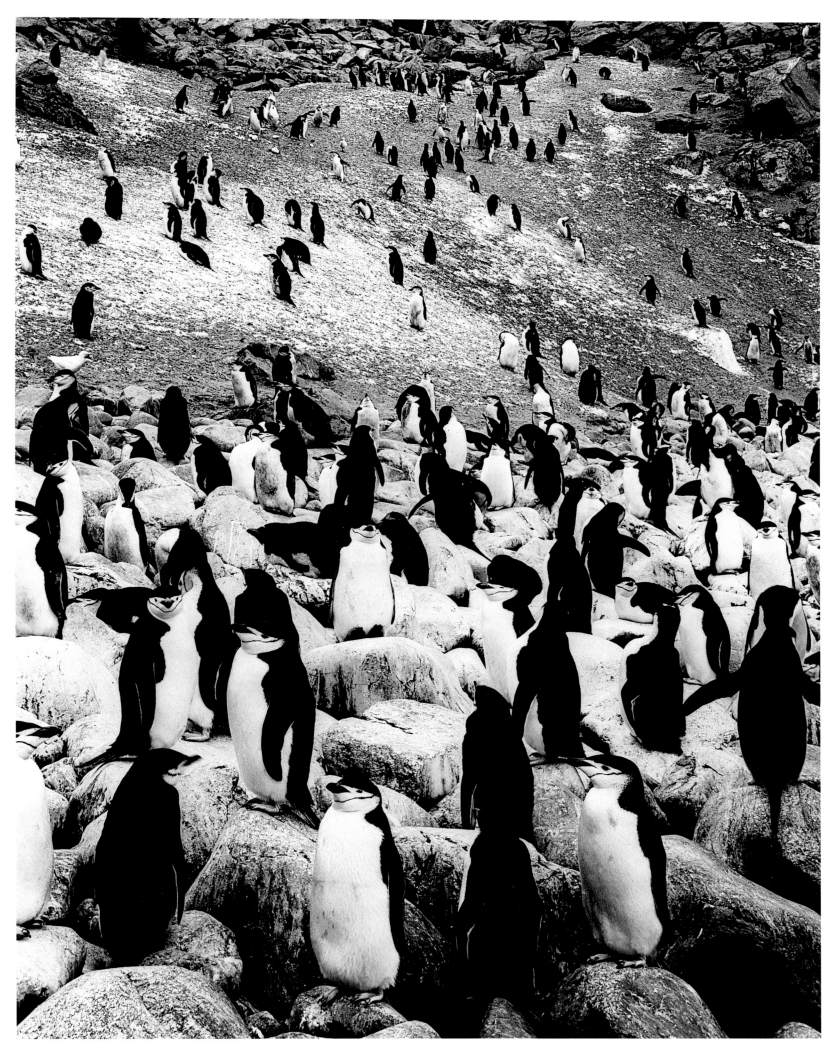

Chinstrap penguins, Stigant Point, King George Island, Antarctic Peninsula, January 11, 1975

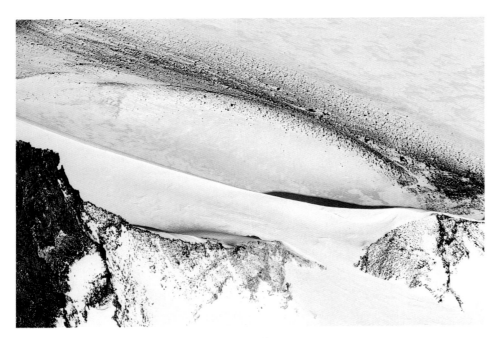

Airdevonsix Icefalls, Wright Upper Valley, Antarctica, winter 1975–1976

The atmosphere is so clear in Antarctica that one is easily deceived by distances; mountains that seem only fifty miles away may be two hundred. And in the absence of haze the colors of distant objects are not like those in other parts of the world.

The large icebergs that we passed close aboard were fantastically shaped by pounding waves and the melting heat of the sun. Below the waterline green grottoes gave glimpses into dim recesses beyond the reach of day, leading down to the icy heart of the iceberg. And above, under the gentler working of wind and sun, the sides were honeycombed, fluted, and sculpted into thin fins and grotesque figures suggesting unimaginable creatures. The whole iceberg was suffused with blue except for highlighted surfaces or surfaces white with a pinkish cast, where snow had lodged; and in all recesses, pockets, and grooves the color intensified to a Della Robbia blue, a condensed distillation of ocean purple. —E. P.

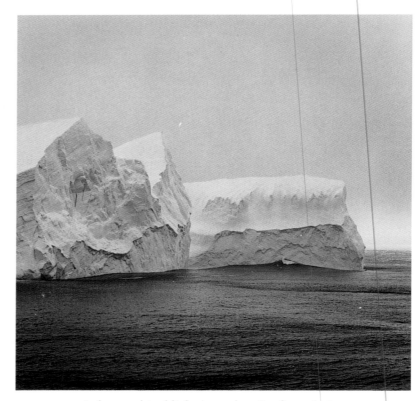

Iceberg and ice blink, Amundsen Sea from glacier,
Antarctica, February 1976

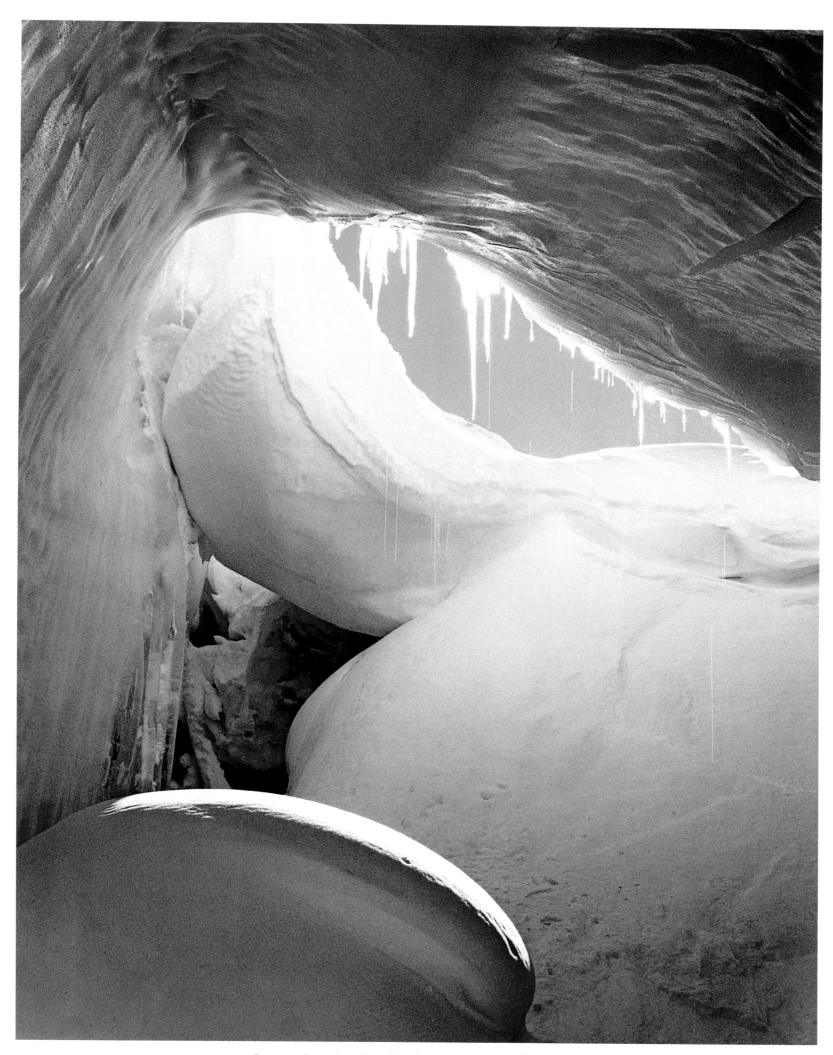

Ice cave, Scott Base, Ross Island, Antarctica, December 7, 1975

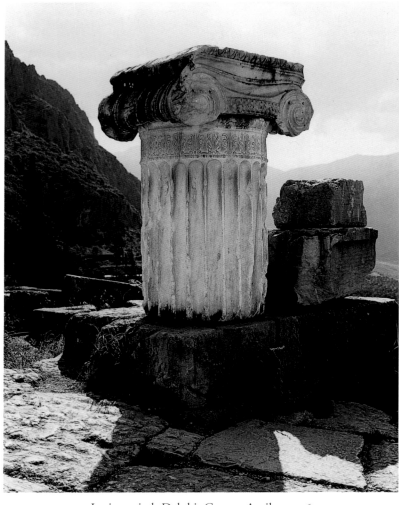

Ionic capital, Delphi, Greece, April 23, 1967

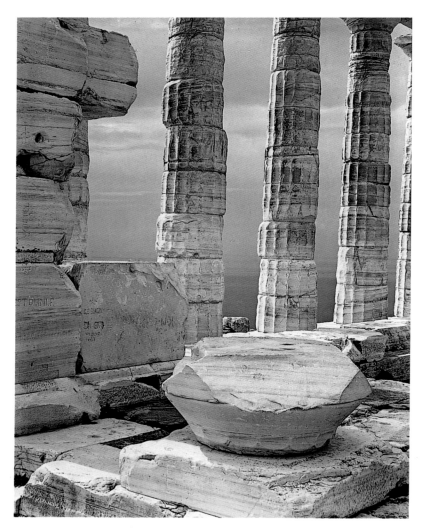

Sounion, Greece, March 7, 1970

In the spring of 1967 Aline and I had gone to Greece, a romantic adventure inspired by Edith Hamilton's book The Greek Way. *We wanted to see the almond trees in bloom and the wildflowers for which Greece is famous, and I had always wanted to see the classical temple architecture that my father had admired so much.... The purpose of the trip was not originally photographic, but I photographed everywhere we went....* —E. P.

Temple of Hadrian, Athens, Greece, April 1970

Theater of Dionysus, Athens, Greece, April 4, 1967

Interior of temple, Bassae, Greece, March 16, 1971

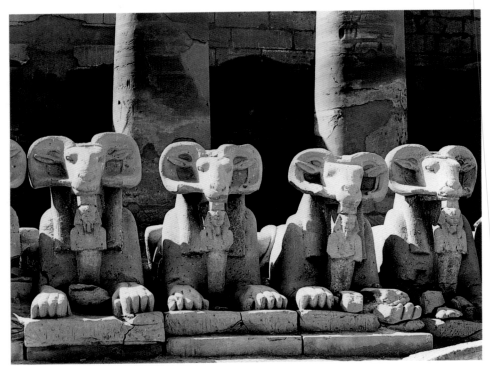

Ram-headed sphinxes, forecourt, Temple of Amun, Karnak, Luxor, Egypt, 1973

It is Porter's great achievement as a photographer that he finds, in each environment he explores, a way to communicate the deeper reality of the place. Yet his method is so subtle that we simultaneously accept each picture as the simple capturing of surface appearance. It is the integration of that surface and the inner reality that he creates with such apparent ease. In the end, we truly know the essence of every place we visit through his art.

—Wilma Stern, Monuments of Egypt

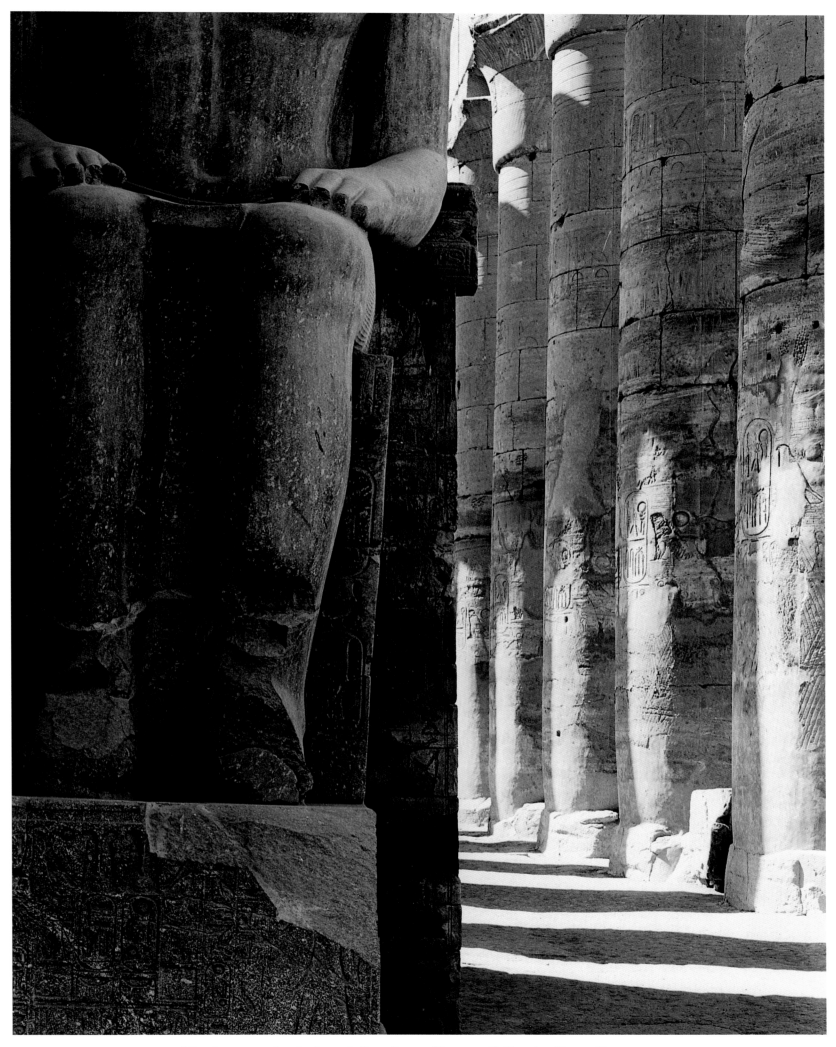

View into processional colonnade from Court of Ramesses II, Temple of Luxor, Egypt, 1973

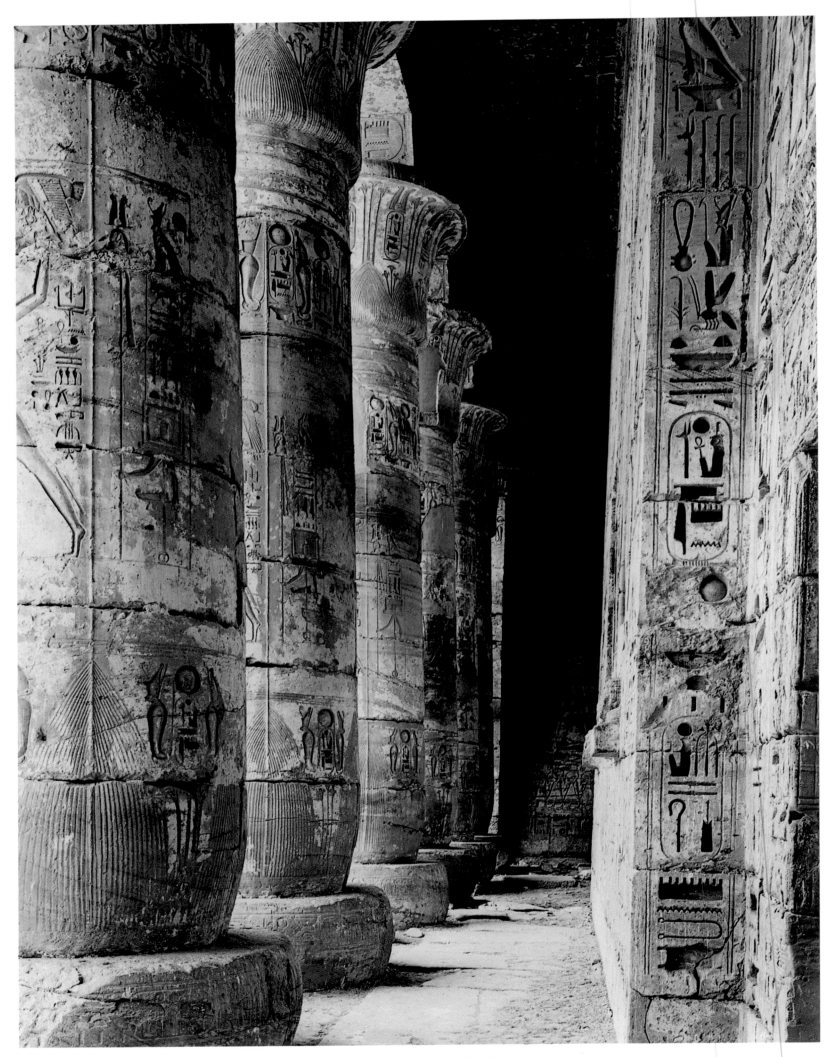

Columns in first court, Medinet Habu, West Thebes, Egypt, 1973

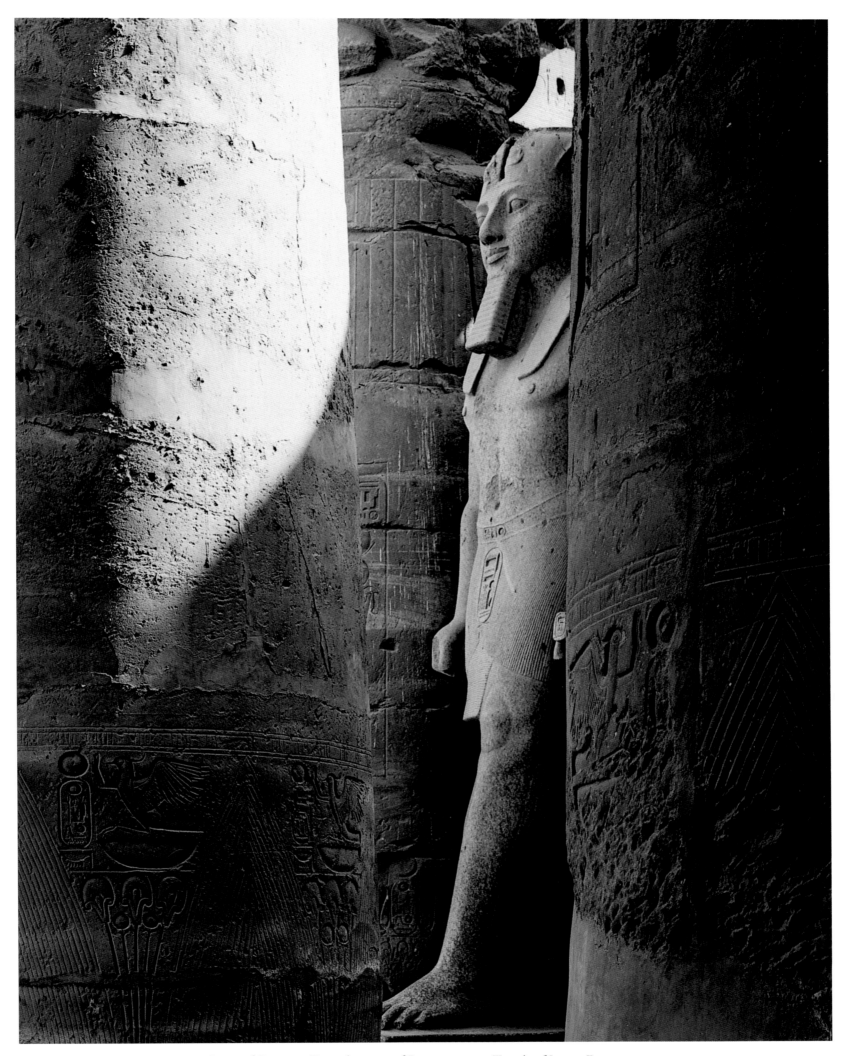

Statue of Ramesses II, south corner of Ramesses court, Temple of Luxor, Egypt, 1973

Near Laixi, eastern Shandong, China, Fall 1981

Our project was to photograph the landscape and historic monuments of China, but we discovered that many of the temples and shrines had been vandalized or destroyed by the Red Guards during the Cultural Revolution. However, we found that the activities of the people in their everyday pursuits were as interesting and captivating as their cultural achievements. Consequently we spent more time than we had originally planned walking about in the cities we visited, photographing street scenes, shops, markets, and people at work. —E. P.

Penglai-Ge Temple, Shandong, China, September 22, 1981

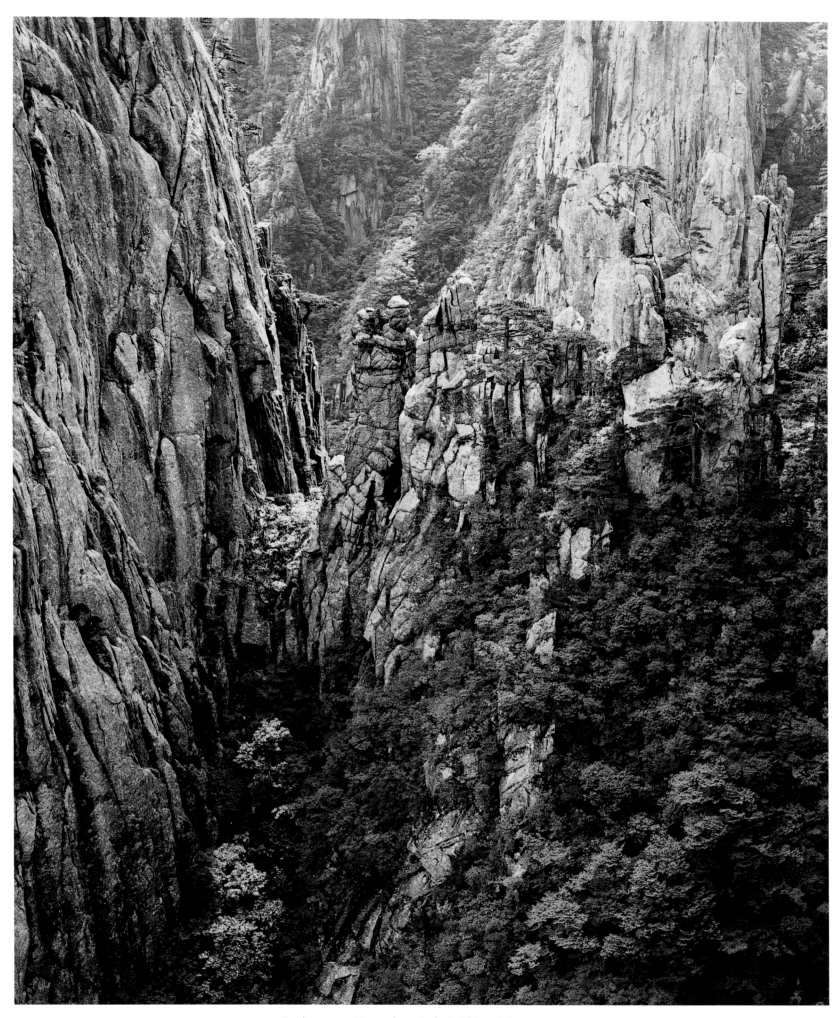

Rocky gorge, Huangshan, Anhui, China, July 19, 1980

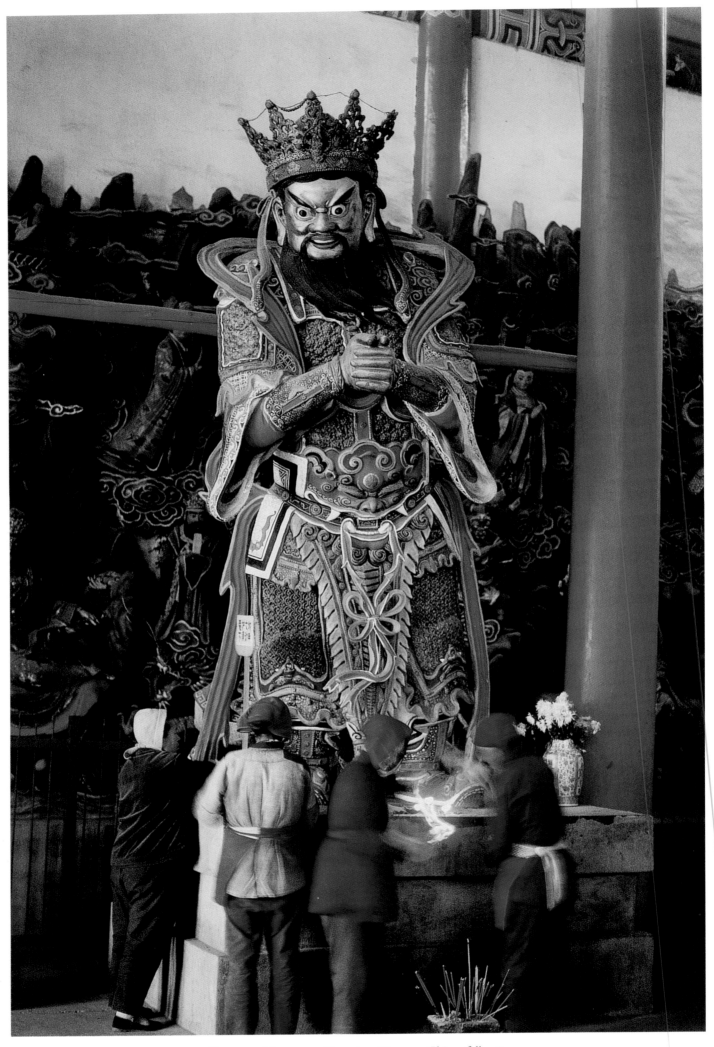

Yuantong Monastery, Kunming, Yunnan, China, fall 1981

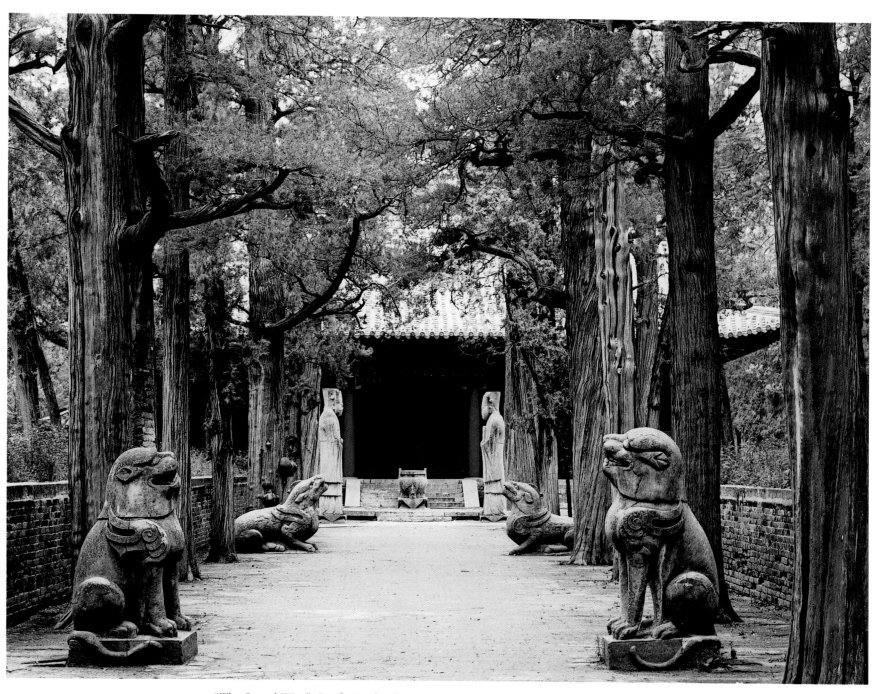

"The Sacred Way," Confucius family cemetery, Qufu, Shandong, China, June 19, 1980

On our travels by car we frequently stopped in villages in which a degree of entrepreneurism was evident in the activities of the villagers. We asked to visit agricultural production communes and factories, an aspect of Chinese life that we had not seen on our first trip and a far cry from our original purpose of photographing the landscape and historic monuments. No objections were raised to this request with the result that we were taken to communes and state farms, textile mills, sugar refineries, heavy-industry factories, and steel mills. . . . Our second trip to China was drawing to a close. The places we had visited and peoples we had seen complemented our experiences of the first trip; yet, even combined, they were scarcely more than a superficial introduction to China. My impressions, however, were of the almost incomprehensible richness of Chinese culture and history, made concrete by the respect and admiration I felt for the Chinese people we had met. —E. P.

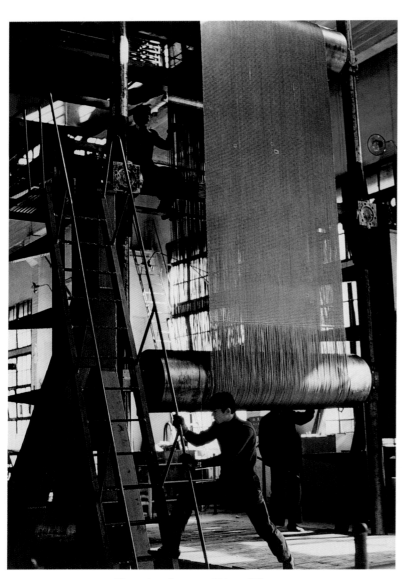

Kunming factory, China, fall 1981

Poster of Zhou Enlai, Mogao Grottoes,
Dunhuang, Gansu, China, summer 1980

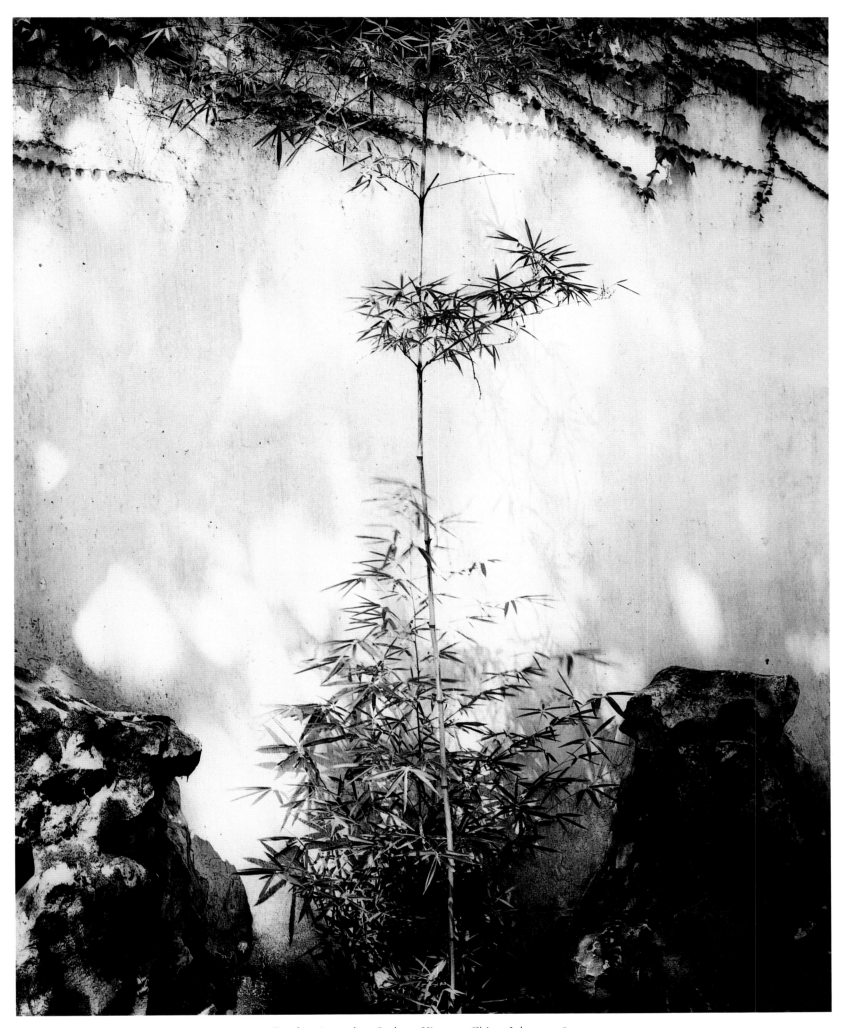

Bamboo in garden, Suzhou, Kiangsu, China, July 22, 1980

I believe that when photographers reject the significance of color, they are denying one of our most precious biological attributes—color vision. . . . —E. P.

ENVISIONING THE WORLD IN COLOR

JOHN ROHRBACH

Eliot Porter gained his most significant artistic acclaim before he had ever thought of making a color photograph. In late 1938 Alfred Stieglitz, the champion of American modernism, presented twenty-nine of Porter's black-and-white photographs in a solo exhibition at his midtown Manhattan exhibition room, An American Place, instantly catapulting Porter into an elite group of the most respected and influential contemporary artists. In more than thirty years of singling out compelling modern art, Stieglitz had offered such one-person exhibitions to only two other photographers, Paul Strand and Ansel Adams.

At the time, Porter was in the early stages of a promising career as a bacteriologist at one of Harvard University's medical research laboratories. Over the few years immediately preceding the exhibition, however, he had become disenchanted with conducting biochemical experiments and had increasingly gone photographing when he normally would have been in the laboratory. Stieglitz's exhibition suddenly and succinctly vindicated these extracurricular efforts. Two days after the show opened, a reviewer in *The New York Sun* declared that Porter "look[ed] upon nature with the appreciative eye of a painter."[1] David McAlpin, cofounder of the photography department at the Museum of Modern Art (MoMA) and a board member of that institution, purchased seven prints from the show. The avant-garde filmmaker Henwar Rodakiewicz bought another print. By late spring of the following year, taking advantage of a small family trust fund, Porter had quit medicine for good, much to the chagrin of his family. Rather than continuing to build a career in an established field, he now felt the confidence to pursue the open path of personal expression.

Porter's passion for photography actually had developed years earlier. In 1912, upon receiving a Brownie camera for his eleventh Christmas, he immediately began making photographs of birds nesting around his family's home in Winnetka, Illinois, and near their summer house on Great Spruce Head Island in Penobscot Bay, Maine.[2] Such attentions derived from a deep love of nature inculcated by his father, who loved to regale his family with detailed descriptions of the natural world during walks through the woods and along the shore. Although Eliot's photographic interests subsided somewhat during high school and college, a fellow doctor in Harvard's bacteriology department reignited them in 1929, when he showed Porter one of Leica's recently invented 35mm cameras. Porter immediately went out and bought one himself. But rather than photographing birds, he focused on architecture and other subjects reflecting the popular "New Vision" style, which sought to explore the world in distinctly photographic ways, such as drawing attention to the beauty of pure form, shooting from unusual angles, and creating photograms or montages.[3]

In 1934, when Porter's brother Fairfield, then a fledgling painter, introduced him to Stieglitz, Eliot proudly showed the master his depictions of splash patterns, close-ups of plants, and details of bridges and buildings around Cambridge. But Stieglitz called the images "woolly," leaving Porter confused. His prints, after all, were sharply focused. Only later, when a friend invited him to dinner with Ansel Adams, did he come to understand what Stieglitz had meant.[4] Porter had never heard of Adams before he arrived for dinner that evening, but he was excited because the two men were scheduled to share their work with the group after the meal. Porter showed his prints first. But when Adams then brought out several of his own new prints, including *Frozen lake with cliffs, Sequoia National Park* (figure 1), Porter was devastated. Here was an attention to expressive mood, visual detail, and print quality that he had never

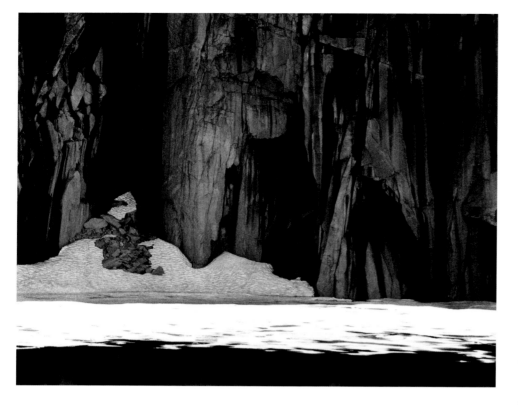

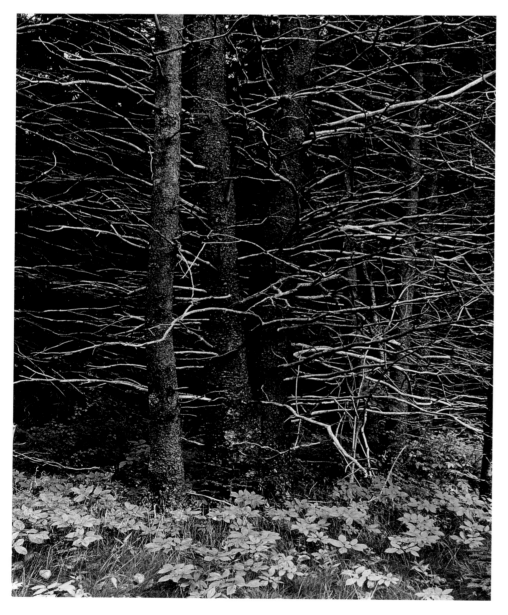

imagined. But the experience also invigorated him. Upon Adams's advice, he bought a 9-by-12-centimeter Linhof view camera and began experimenting with the pristine, crafted naturalism that had so impressed him in Adams's prints.

By the time of his An American Place exhibition, Porter had not only returned to making close-up portraits of birds, he had thoroughly absorbed the visual vocabulary of Adams, Strand, and others of the Stieglitz circle. Although he included a few bird and nest pictures in the show, large-format views of Great Spruce Head Island and close-ups of rocks and plants dominated the presentation (fig. 2). Like Strand's nature portraits of the late 1920s (fig. 3) and many of the carefully composed details that Adams had showed in his own 1936 solo exhibition at An American Place, Porter's photographs were quietly attentive to often overlooked aspects of nature's beauty. But where Strand had reveled in the sculptural elegance of rocks and plants and Adams had constructed poetic visions of light, texture, and form, Porter now distilled the atmosphere of place. It was an approach that held particular resonance for Stieglitz, who had been photographing around his own family's summer retreat in Lake George, New York. At the end of the exhibition, Stieglitz thanked Porter with the remarkable declaration, "Some of your photographs are the first I have ever seen which made me feel: 'There is my own spirit.'" [5]

Yet, rather than bask in Stieglitz's acclaim, Porter almost immediately turned to color. In so doing, he carried American photographic modernism into uncharted territory. Color had been photography's "holy grail" ever since the medium's invention in 1839. But an easy means to produce credible color images had been developed only recently. [6] Kodak's and Agfa's invention of dye coupler films in the mid-1930s had allowed photographers for the first time to produce vividly colored transparencies, slides, and negatives with the same cameras used for black-and-white photography. Not surprisingly, amateurs and many professionals had jumped at the opportunity to take up color. Hoping to open new avenues for publicity, government agencies and corporations had immediately begun passing the film out to their staffs. [7] Attracted to more experimental applications, New Vision photographers like Henry Holmes Smith

and László Moholy-Nagy, the head of Chicago's Bauhaus-inspired Institute of Design, had started exploring abstract patterns of colored light.[8] At the Massachusetts Institute of Technology, scientist Harold Edgerton had started applying the new technology to his photographic strobe experiments. Optimism reigned.

Porter had not planned to work with color after his An American Place exhibition. He actually had taken advantage of his new stature to present a proposal to Paul Brooks, editor-in-chief at Houghton Mifflin, to publish a book of black-and-white bird photographs (fig. 4).[9] Brooks was an apt target because he had overseen the publication of Roger Tory Peterson's commercially successful handbook, *A Field Guide to Birds* (1934). But while Brooks expressed great admiration for Porter's photographs, he declined the project. Porter's images needed to be in color, he explained, to make the birds identifiable and thus attract a commercially viable audience. It was a challenge the artist could not refuse. Throughout the spring of 1940 Porter figured out how to produce sharply focused, compositionally pleasing 4-by-5-inch color transparencies of live birds seen from one to two feet away.[10] He then taught himself how to make his own color prints, using Eastman Kodak's new wash-off relief process. Neither effort was simple. Although photographing in color was now relatively easy, photographing motion was difficult, because the much slower film called

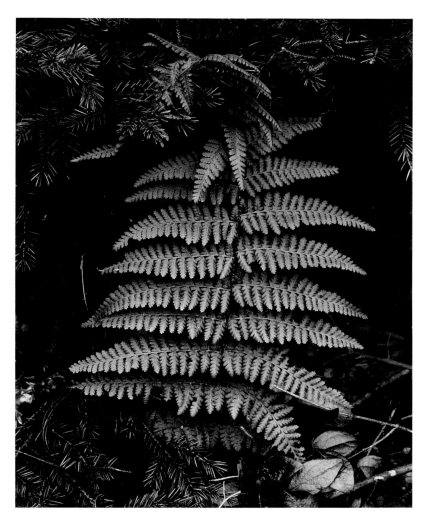

for substantially more light than black-and-white required. To make good prints, one still had to divide the colors of the original negative or transparency into color-separation negatives exposed through red, green, and blue filters, then recombine their complementary hues (cyan, magenta, and yellow) in the final print via three film positives. The work demanded the kind of exacting precision that Porter had learned in his medical studies. It also demanded a lot of money. To gain financial support for his work, Porter assembled what would become a successful fellowship application to the Guggenheim Foundation. His goal, he wrote, was to photograph as many American bird species as possible and thereby raise the aesthetic quality of ornithological photography.[11]

Although Stieglitz by now wanted to assemble another exhibition of Porter's work, color portraits of birds were not what he had in mind. Voicing concern that Porter had not sufficiently extended his artistic vision, Stieglitz put off scheduling the show.[12] McAlpin was more enthusiastic. Just as he had done for Ansel Adams, McAlpin actively used his connections and resources to promote Porter's new work. Not only did he broker sales of Porter's prints to associates such as Dorothy Norman, but he also helped arrange exhibitions of the work, first at the Bronx Zoo, then at MoMA in the spring of 1943.[13]

Other important art world figures also admired Porter's color bird portraits. MoMA director Alfred Barr and the museum's acting Photography Committee chair James Soby both lauded Porter's MoMA show. Georgia O'Keeffe and Walker Evans enthused over the work, and Lincoln Kirstein raved that Porter's bird prints represented the finest color photographs he had ever seen.[14] They had good reason for their judgments. Not only were the prints finely composed close-ups suggestive of the great bird illustrator John James Audubon (1785–1851), they exhibited an unparalleled immediacy and delicacy of hue[15] (fig. 5).

In four short years since quitting medicine, Porter's artistic career had gained solid footing. Even *Life* magazine featured his work.[16] Although World War II cut his Guggenheim work short by halting his ability to travel, Porter returned in 1946 to his bird project with the help of a renewed fellowship. This time he took up Kodak's new dye transfer color printing process. (While faster, this

(*figure 1; opposite, top*)
Ansel Adams,
Frozen lake with cliffs,
Sequoia National Park, 1932

(*fig. 2; opposite, bottom*)
Spruce trees,
Fish Hawk Point,
Great Spruce Head Island,
Maine, July 1934

(*fig. 3; above*) Paul Strand,
Fern, New England, 1928

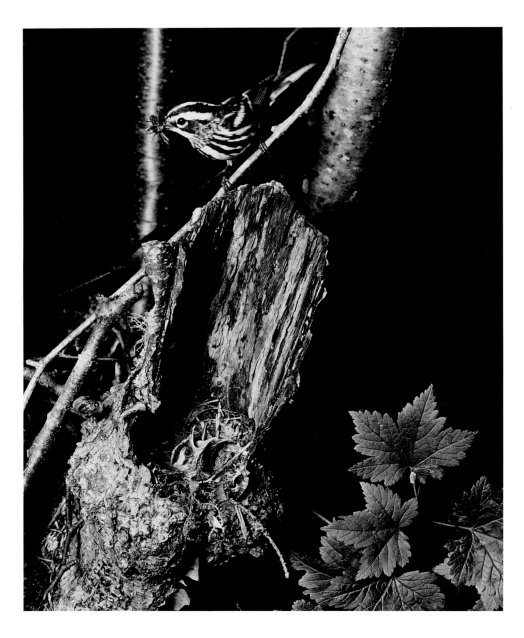

(*fig. 4*) Black and white warbler, Great Spruce Head Island, Maine, July 1, 1939

process still required the separation and recombination of colors to make prints.)[17] He also started broadening his subject matter. While continuing what would become a lifelong pattern of focusing on birds throughout each spring, he began further fulfilling and sharing his love for nature by producing exquisitely rendered, sharply focused color landscapes through the remainder of each year. In so doing he inadvertently entered an extended and at times quite acerbic debate among photographers and critics over color's expressive potential.

The main question dividing Porter's associates was whether color photography's artistic potential lay in describing the world or in exploring the nature of color itself. This debate would play out over decades through personal letters, conferences, and numerous articles in the photographic press. It would affect museum exhibitions, critical discussion, and certainly Porter's career. Complicating the debate was artists' recognition of the growing popularity of color in the amateur and commercial markets, their desire to distinguish their work from mainstream commercial photography and amateur snapshots, and their concerns about technical control of the medium. Unfortunately for Porter, these anxieties would undercut his colleagues' sympathy for naturalistic color and thus for his work.

Moholy-Nagy started the debate over how to understand and use color photography when he hypothesized, as early as 1937, that the medium would give birth to a new kind of abstraction.[18] He explained this idea in more detail in his Bauhaus curriculum, published posthumously a decade later as *vision in motion*. Since color photographs were built by layering three primary colors—red, green, and blue—he argued that the medium could never truly mimic the full range of the world's colors.[19] Nor could it provide the nuance of hue and brightness offered by paint. Yet rather than being deficiencies, he suggested, these characteristics freed the medium from subservience to the strictures of either photographic naturalism or painting. Do not struggle with trying to mirror the naturalistic scene, he admonished. Leave that to snapshooters and commercial photographers. Instead, building on photography's unique ability to capture light, one should explore the physical and psychological effects of colored reflections and shadows. To illustrate his point, Moholy-Nagy included photographs of specially constructed light boxes that filtered, split, and mixed colors, color photograms, and the unusual patterns recorded when either the camera or objects before the camera moved. These plates reflected the investigations being taken up at the Institute of Design by a number of young artist-photographers, including Henry Holmes Smith, Arthur Siegel, Gyorgy Kepes, and Harry Callahan (fig. 6)[20].

But those artists and critics who were more sympathetic to photographic naturalism were not ready to let go. The same year that *vision in motion* was published, photography critic Jacob Deschin asked a group of twenty photographers and critics to define the aesthetic potential of the medium. The participants universally subscribed to the notion that photography's role was to describe the world.

Yet, despite dismissing as trite the standard commercial dictate to organize compositions around one or two bold colors like red or blue, they did not proffer an alternative. Photographer Edward Weston's vague suggestion that the aesthetic potential of color was dependent on the practitioner was typical of the participants' answers.[21] Weston provided an influential voice. He had received two Guggenheim fellowships in the mid-1930s, and MoMA had just presented a retrospective of his black-and-white photographs. He also was one of four leading artist-photographers whom the Eastman Kodak Company had recently engaged to try out their new 8-by-10-inch Kodachrome sheet film.[22]

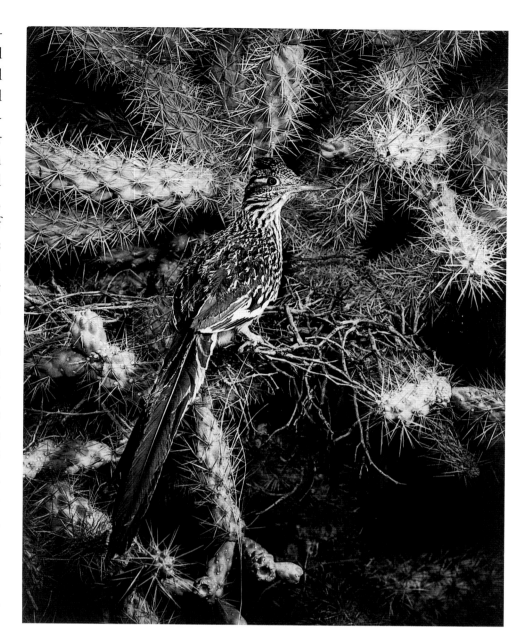

(*fig. 5*) Roadrunner, San Xavier Indian Reservation, Arizona, April 1952

The previous year, to publicize the virtues of color photography, Kodak had contracted with Ansel Adams, Paul Strand, Charles Sheeler, and Edward Weston, providing the photographers with free film and processing, along with the opportunity to photograph whatever they desired.[23] In return, Kodak asked each artist to share with the company any image that they liked. The company also agreed to pay $250 for each image used in advertisements touting the beauty and versatility of the film. The decision was astute. If the company could convince these masters to take up color, other artist-photographers might quickly fall in line, perhaps boosting the whole amateur market.[24]

Weston and Adams spent the most time of the four working with the new film. Weston was so delighted initially that he sent thirteen of his first twenty-five transparencies back to Kodak for the company's ad consideration, telling them "Several equal my best in black-and-white or, at least, seem to in my first enthusiasm."[25] In May 1947, Kodak started placing advertisements with Weston's Kodachromes in a variety of photography magazines, challenging readers with questions like, "If you have been working only in black-and-white, isn't it high time you joined Edward Weston in exploring the boundless possibilities which Kodak color holds?"[26] One ad even quoted Weston's declaration, "I feel color will be part of my future."[27] Unfortunately, Parkinson's disease forced the photographer to give up making new pictures before he had the opportunity to explore the medium in depth.

Adams shot transparency film over the course of a Guggenheim-funded project to photograph America's National Parks and even took on other color commercial work for Kodak, including the production of transparencies for the company's huge new Colorama in Grand Central Station.[28] Yet undercutting his excitement was a disquieting fear that his color photographs were no more interesting than amateur snapshots. Contributing to his consternation was the critical response to his color work in Edward Steichen's 1948 exhibition *In and Out of Focus*.[29] This summary of contemporary trends focused mostly on black-and-white photography, but color provided the show's centerpiece. James Fitzsimmons's abstractions, built on solarization, surface reticulation, and extreme close-up, counterpointed Adams's and Weston's Kodak naturalistic transparencies, which culminated in Kodak's mural-sized transparency of Adams's view of Wyoming's Teton Mountains. Never one to hide his opinions,

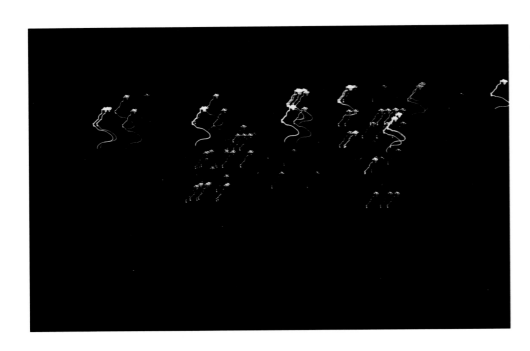

(*fig.6*) Harry Callahan, Camera movement on neon lights at night, Chicago, 1946

Steichen drew special attention to Adams's and Weston's work in both the exhibition press release and central text panel. Calling the transparencies "breathtaking," he suggested that the work represented "possibly the ultimate solution of the term 'holding the mirror up to nature.'"[30] But photography critics remained unimpressed with both schools of color. Deschin dismissed Fitzsimmons's work as more appropriate to painting.[31] And Milton Brown, writing for the photography newsletter *Photo Notes*, labeled Adams's and Weston's transparencies "garish."[32]

By early 1949 Adams himself had begun publicly voicing his concerns about color's expressive capabilities. In a series of articles in *Photo Notes* he called on artists to use muted colors, complaining that the reigning paradigm had become "If you can't make it good, make it red."[33] Ridiculing color film's contrast range as being too narrow to handle the bright skylight and deep shadows so central to his own landscape work, he concluded that "the expressive capabilities of black-and-white vastly exceed those of color photography."[34] Yet he could not quite let go of his attraction to the medium. Recognizing Porter's proficiency with it, Adams asked the artist in December 1949 to consider creating a book entitled *My Camera on Birds* for his ongoing "My Camera" series.[35] He also remained pleased enough with his own National Parks transparencies to approach Paul Brooks in early 1950 with a detailed proposal to assemble a National Parks book that likewise would be chiefly in color.[36]

Color clearly had great appeal. Artist-photographers across the gamut of the medium were trying their hand, or eye, at it.[37] In recognition of this popularity, Beaumont Newhall, who had just become the photography curator at George Eastman House in Rochester, selected one of Weston's color views of the Monterey waterfront to be the frontispiece of his 1949 edition of his important text *The History of Photography from 1839 to the Present Day* (fig. 7).[38] The attention to color peaked in mid-1950 when Steichen presented what he hoped would be the first in a series of major exhibitions assessing the expressive achievements of the medium. *All Color Photography* presented 342 works by more than seventy-five photographers, including Porter, Adams, Callahan, Walker Evans, Weegee, Henri Cartier-Bresson, Todd Webb, Roman Vishniac, Robert Capa, Elliott Erwitt, Arnold Newman, Ralph Steiner, and many others who are far better known today for their black-and-white photography (fig. 8).[39] Unfortunately, the show was diminished by its breadth. Even though Steichen optimistically set fashion and advertising photography aside for upcoming exhibitions, he culled the majority of the exhibition's contents from magazines like *Life* and *Vogue* and advertisements for corporations like Standard Oil and Kodak. The result was a confusing mélange of fine art and commerce. Further problems were created by the uneven quality of the original works. Mixed among strikingly brilliant magazine tear sheets were transparencies that often were small and difficult to see, alongside murky, off-color chromogenic prints. Porter was one of the few participants to present prints offering any subtlety of color. His achievement only emphasized what would continue to be the main barrier to the full acceptance of color by his fellow artists. The dye transfer process, which offered the only viable means for making prints of substantive brightness, color delicacy, and permanence, imposed burdensome barriers of technical complexity and high expense. Even Adams, despite his love for the technical minutia of photography and frustration over the loss of control to labs demanded by color processing, did not have the patience to teach himself dye transfer printing.[40] Remarkably, Steichen retreated even before the show opened. In the exhibition's introductory wall text he admitted that color remained "a riddle" and echoed Adams's declaration that black-and-white photographs still provided the best evidence of photography's artistic capabili-

ties.[41] The press, not surprisingly, agreed.[42] Steichen canceled his planned additional color exhibitions, and while he later periodically presented color work, including a small selection of Porter's new color landscape photographs, he did so with only limited commitment to the medium.[43]

Although Porter remained firmly committed to color, the medium had by the early 1950s become something of an embarrassment to his colleagues. Harry Callahan, for example, chose not to include any of his color work in his spring 1951 retrospective at the Art Institute of Chicago. The following year, Edward Weston likewise chose not to include any color work among the 880 photographs, representing his life's achievement, that he selected for his son Brett to print. In 1954 the Art Institute of Chicago awarded hometown artist Arthur Siegel an exhibition to showcase his color abstractions of Chicago's streets. But the exhibition presented the works more as technical curiosities than as challenging works of art. Compounding that confusion, Siegel felt it necessary to justify the work at the end of the exhibition brochure with the declaration, "I am not a frustrated painter."[44] Although Adams occasionally pined for the opportunity to "do creative color" and even started assembling a color manual for his series of "how to" books. But he remained perfectly happy to be known as a black-and-white photographer.[45]

Despite their consternation over color photography's expressive potential, Porter's colleagues continued to respect him as a great craftsman with a good eye for color and composition.[46] In 1951 he was one of thirteen leaders of photography invited to contribute to an Aspen Institute conference that led to the establishment of *Aperture* magazine.[47] Yet many of his compatriots had come to regard him as someone more attuned to natural history than to fine art. That designation held some truth. Although Paul Brooks had by now suggested that high printing costs prohibited a publication of his color bird photographs, Porter's main focus each spring remained steadfastly on birds.[48] It did not help his standing in the art world that Porter consistently shied away from discussing his artistic intentions. While he was occasionally given small shows at major art museums, he also maintained a long-standing practice of contributing prints to natural history exhibitions and providing images for nature books.[49]

Porter was not alone in braving the art world's hostility to color nature studies. In 1954, Jeannette Klute, director of Kodak's Visual Research Laboratory, published *Woodland Portraits*, a compendium of her finely printed dye transfer close-ups of woods plants and flowers (fig. 9).[50] While Klute's photographs were much like Porter's work, she took a more pictorial approach, employing a shallow depth-of-field to isolate her plants against softly focused, light-struck backgrounds. But while

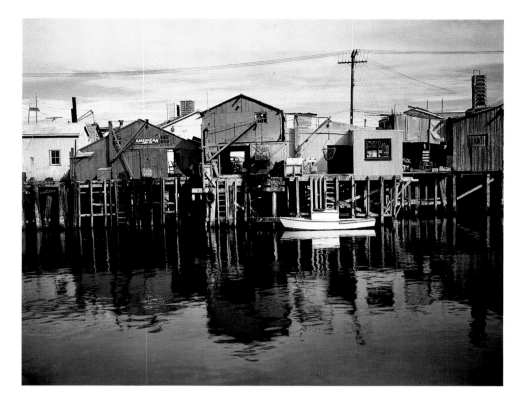

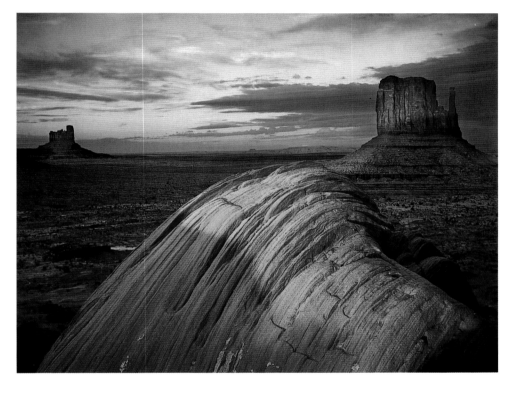

(*fig. 7*) Edward Weston, Waterfront, Monterey, 1946

(*fig. 8*) Ansel Adams, Late evening, Monument Valley, Utah, 1945

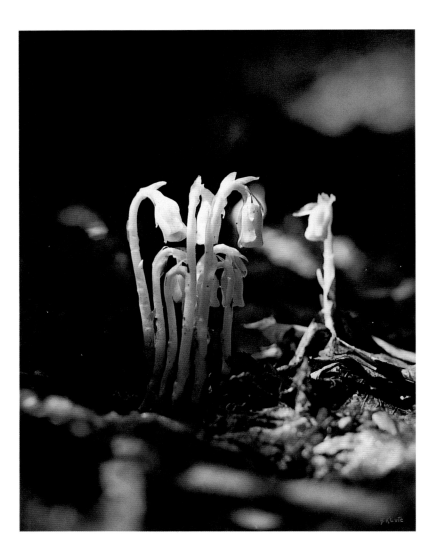

(*fig. 9*) Jeannette Klute,
Indian pipe, ca. 1952–1954

Adams and Steichen each praised the book privately, and George Eastman House exhibited her prints along with her subsequent color tidal-pool studies, the broader art community ignored her work.

Despite Porter's and Klute's achievements through the mid-1950s, *Popular Photography* and *U. S. Camera* each assembled panels of photographers and critics to discuss the medium's drawbacks.[51] These "experts" agreed that the color fidelity of films was still not reliable and that most color films still fell short of rendering true greens.[52] They also worried that Eastman Kodak's recently introduced Ektacolor paper did not simplify printing enough. However, the panelists split over whether to blame the technical limitations of the process or the imagination of photographers for the dearth of engaging color photography. Generally, those panel members working in the commercial and amateur arenas, such as Eliot Elisofon, placed the blame on photographers, suggesting that they were not being creative. Those who practiced photography as a fine art, such as Paul Strand, Arnold Newman, and Bill Brandt, claimed that the technical limitations remained too severe. Interestingly, color accuracy was not the issue. In contrast to Porter, almost all of the panelists concluded that strict verisimilitude was the domain of amateurs. Strand even went so far as to call the exact rendering of the world "corny."[53] Roman Vishniac, who worked mainly in scientific and commercial circles, agreed: "The simple copying of colors can never stimulate the vibrations of life."[54]

Underlying this debate, of course, was the universal recognition of color's triumph in the commercial world. As early as 1951, in his book *The Art and Technique of Color Photography*, Condé Nast art director Alexander Liberman had proclaimed the preeminence of magazines in developing and showcasing exciting color photographs.[55] By the mid-1950s, color had become de rigueur for younger fashion and commercial photographers from Richard Avedon to Garry Winogrand. In explicit recognition of that fact, when showcasing the expressive highlights of contemporary color in his 1958 book, *The Picture History of Photography from the Earliest Beginnings to the Present Day*, Art Institute of Chicago curator Peter Pollack filled most of his thirty-one pages of color plates with works from either *Life* or Condé Nast magazines.[56]

What Porter's colleagues refused to see was the nuance that Porter was achieving with the dye transfer process. When Arnold Newman and Paul Strand complained in *Popular Photography*'s *Color Annual* for 1957 about not being able to control specific hues, they clearly did not understand, as Porter did, that dye transfer printing provided exactly that control. When Ansel Adams rejected color landscape work as incompatible to the higher contrast and limited range of the film, he ignored the dye transfer's ability to overcome those limitations through film masking. Porter was one of the few artists who made his own color prints, and virtually the only one who had mastered the craft of dye transfer printing and applied it to landscape.

One of the few people within the fine art photographic community to publicly support Porter was Helen Gee, owner of the New York City coffeehouse and gallery, Limelight. In March 1955, she countered Edward Steichen's immensely popular and almost wholly black-and-white *The Family of Man* exhibition at MoMA with an exhibition of sixty of Porter's color nature studies.[57] Two years later, she presented eighty prints from one of Porter's unusual side projects: a record that he and photographer Ellen Auerbach had assembled of the churches, religious celebrations, and market scenes of Mexico (fig. 10).[58]

Porter ignored much of the debate swirling about him, confident in his vision and financially free to pursue it. But he found Ansel Adams's increasingly vociferous rejection of naturalistic color difficult to accept. Despite Adams's initial support, in November 1957 he, too, publicly asserted that: "as photography approaches the simulation of reality it withdraws from the esthetic experience of reality."[59] Adams also suggested, despite being well aware of Porter's work, that he had not yet seen any color photographs that fulfilled his concept of true art. Finally, despite continuing with his own occasional efforts at naturalistic color photography, and quite likely influenced by a new momentum toward photographic abstraction, he heralded Ernst Haas's color work as most closely approximating his expressive ideal.

Adams and Porter remained friends. Yet Porter found it difficult to hide his frustrations. Describing to his son Jonathan a visit from Adams in late 1958, Porter complained, "He is such a dynamic person and such an egoist that I could hardly get him to look at my pictures and when he did, in a great hurry, it was with his mind on his own technique…I have felt for a long time that he doesn't like color photography because he doesn't do it very well, that is, very imaginatively."[60] Porter also concluded that Adams never quite understood how to see in color. Recompense came at least in the response of another visitor who stopped by that same month:

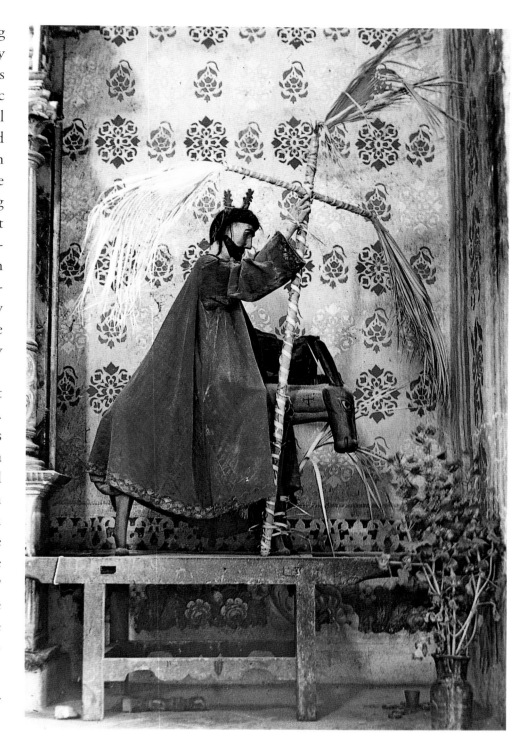

(*fig. 10*) Christ entering Jerusalem on a donkey with palm leaf cross, Church of Matatlán, Oaxaca, Mexico, March 1956

> *It is a curious phenomenon that photographers on the whole do not like to look at color prints, whereas painters are usually very much interested. This is born out by the reaction of Elaine de Kooning who has spent the week-end with us, and who said, when I first met her, that she was not interested in photography but then spent several hours looking at my pictures without being asked to and finally simply took possession of several Mexican prints from my show and several other pictures from the pile of discard prints on my table.*[61]

De Kooning may well have been more receptive to Porter's work because as a painter she stood outside the debates over photography's naturalism and the medium's relationship to the other arts.

Adams was not the only art-world figure to celebrate Haas's work. In 1957, *Popular Photography* editor Bruce Downes had called the photographer's color explorations "the answer to the conundrum of expressive color."[62] Steichen hesitated, initially assigning Haas to the overflowing category of photographers who he said were merely mimicking painters. But in his fall 1957 exhibition, *Seventy Photographers Look at New York City*, he too had presented Haas's work as his ideal in color photography (fig. 11).[63] What apparently drew Steichen's revised opinion was Haas's new series of motion studies of sports events. Steichen probably realized that in both these works and Haas's better-known urban light studies, the

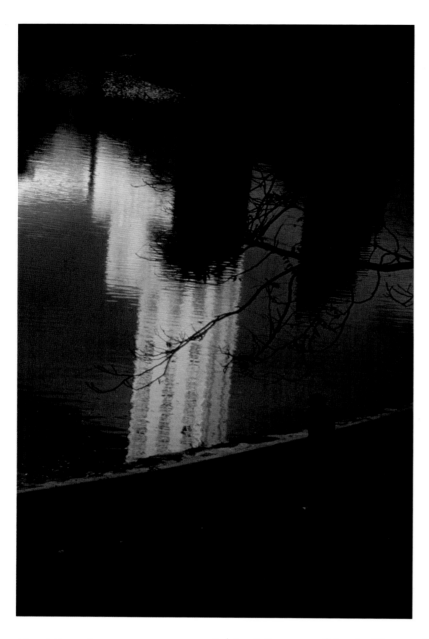

(*fig. 11*) Ernst Haas, Central Park reflection, New York, 1952

artist was exploring the vernacular of color itself.[64] Up in Rochester, George Eastman House curator Walter Chappell would soon single out the young artist Syl Labrot's color photographs for similar reasons. In a 1960 exhibition and book, *Under the Sun*, Chappell endorsed Labrot's own definition of his colorful abstractions of mundane objects as presenting a "different" reality located at the crossroads of painting and "normal" photography. Labrot and Chappell both liked the way one read depth into Labrot's images intellectually, but still felt their flatness.[65]

Through the late 1950s, a range of artists, including such established photographers as Helen Levitt, William Garnett, Wynn Bullock, and Minor White, were experimenting with color. In most instances, though, these photographers limited themselves to making transparencies. Generally they focused on the expressive rather than the descriptive qualities of color.[66] In keeping with Ansel Adams's sense that color-film dyes were better-suited to the more acidic hues found in the built world, many of these photographers also focused on urban or industrial subjects.

In 1959, amidst this critical acclaim for expressionistic color, Porter started circulating a project that marked the foundation of photographic realism in color. That project, which he had been working on quietly for almost ten years, interspersed his carefully crafted photographs, mostly of the New England woodlands, with quotations he had selected from the writings of Henry David Thoreau. Echoing the approach taken by naturalists Aldo Leopold and Joseph Wood Krutch, he called his project *The Seasons*. After showing the exhibition in Santa Fe, he found venues at the Baltimore Museum of Art and the Nelson-Atkins Museum of Art in Kansas City.[67] He then sent the prints to MoMA in an unsuccessful effort to get Steichen to look at them.[68]

Counter-balancing Steichen's rejection was Fairfield Porter's strong endorsement in *The Nation* of his brother's work. Fairfield by this date had become a well-regarded painter, critic, and close friend of a number of other influential artists, including Willem de Kooning, Alex Katz, and Larry Rivers. Eliot Porter valued his brother's judgment highly. Of his brother's *Seasons* project, Fairfield observed: "There are no eccentric angles familiar to the movies, snapshots or advertising. . . ." Whereas color usually looks added to such photographs, he explained, in Eliot's prints color was fully integrated with its subject, offering a revelatory range of hue. Extolling Eliot's ability to reflect "the immediacy of experience," Fairfield asked rhetorically, "Can we as adults be sure that we see more deeply, through art, than the photographer who pretends to do nothing but pay the closest possible attention to everything?"[69]

Beaumont Newhall was sympathetic as well. He not only presented *The Seasons* at George Eastman House, but facilitated the show's subsequent travel under the auspices of the Smithsonian Institution Traveling Exhibition Service (SITES).[70] In focusing on the beauty of the natural landscape, and by organizing his presentation on a scaffold of seasonal change, Porter made his presentation accessible. The Thoreau quotations added a poetic pathway into the images. Yet, rather than presenting the kind of saccharine, postcard-like landscape images found in standard commercial work, he offered images whose tapestry-like density of detail filled the surface with bundles of tightly composed energy (fig. 12).

In counterpoint to Adams's dramatic western panoramas, he placed the viewer squarely within the thicket of New England's overgrown fields and second-growth woods. Rarely does sky appear, and almost never is there a clear path through the photographs. The images compel the viewer to notice the small, overlooked details of nature. Porter's delicate use of color also set his photographs apart. The dye transfer process had allowed him, as his brother astutely observed, to present an unparalleled variety of hues. His water was not just blue, but included green, gray, yellow, orange, and black. Fall leaves were not just yellow or orange, but cool red and a variety of browns, grays, and even purples. Winter snow extended from clear white to an array of shadow-laden blues. Porter had even finessed one of color film's main difficulties, portraying a realistic green, by fixing on a slightly bluish palette suggestive of cool, moist weather.[71] Meeting Newhall's long-standing definition of the finest artistic photography, the works project an immediacy of a specific time and place impossible to attain through other media.[72] *The Seasons* constituted a resounding riposte to those who thought that naturalistic color lacked expressive capability.

But the Eastman House exhibition, even with its SITES addendum, did not transform the artist's career as dramatically as did Nancy Newhall's phone call to Sierra Club Executive Director David Brower on the opening night of the exhibition. Fresh from completing her club publication with Ansel Adams, *This Is the American Earth*, Newhall advised that the club now take on Porter's *Seasons* project.[73] Even with the Thoreau connection, other publishers had fretted over whether Porter's book was too esoteric and expensive to print. Out of respect for Newhall, Brower agreed to take a look at the images.[74] Upon receipt of the project, he immediately became captivated. He later described the symphonic artistry of Porter's photographs: "None but a very literal person would fail to see that color is his music, that there is melody line, counterpoint, harmony, dynamics, voicing, and phrasing, all there for those who will listen."[75] Instantly he realized that he had to publish the book even if it meant "tak[ing] up a life of crime to get the funds for it."[76] Eventually, with the help of a significant grant and accompanying loan, Brower convinced a hesitant Sierra Club board to let him move ahead. After consulting with five American printers and four more in Europe, he challenged New York pressman Hugh Barnes to test the true capability of his company's machinery.[77]

In 1961, Ansel Adams graciously hosted a party at his house to celebrate the Sierra Club's plans to publish Porter's book, which had by now taken on the unusually long title, *"In Wildness Is the Preservation of the World," Selections & Photographs by Eliot Porter*. Yet when Porter shared his prints with those attending, Adams left the room without looking at them.[78] Although he privately congratulated Porter on the book shortly before its publication, and even called Porter's new photographs of Glen Canyon "magnificent," he was being either diplomatic or baldly two-faced. A month later, when John Irwin at *Artforum* asked Adams to review *In Wildness*, Adams refused outright, declaring that he simply did not

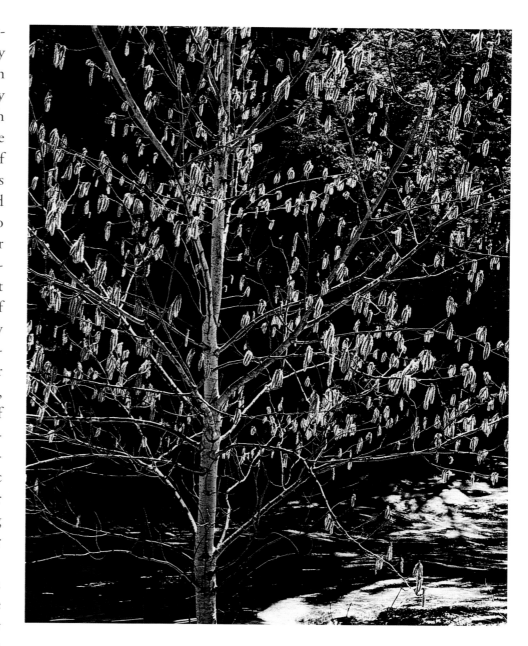

(*fig. 12*) Poplar tree in bloom, near Keene, New York, April 22, 1957

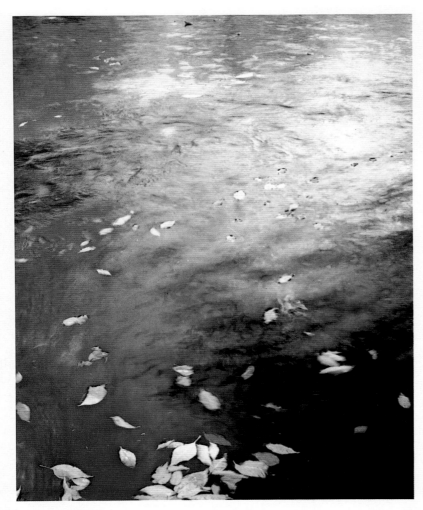

"In Wildness Is the Preservation of the World"

SELECTIONS & PHOTOGRAPHS BY ELIOT PORTER

(*fig. 13*) Book cover, *"In Wildness Is the Preservation of the World,"* Selections & Photographs by Eliot Porter, 1962

like color photography.[79] He surely realized that Porter's color photographs were eliciting an enthusiasm that he was used to seeing applied almost exclusively to his own work.

"In Wildness Is the Preservation of the World" was published in November 1962 (fig. 13). Brower's only changes to Porter's original mock-up were to make a quiet portrait of an old growth spruce forest the last image and to borrow the Wilderness Society's motto for the book's title. Joseph Wood Krutch, the distinguished critic and nature writer who had published a biography of Thoreau, provided the introduction. Although it was the fourth in the Sierra Club's growing series of 10-by-13-inch "Exhibit Format" books, it was the Club's first full-color book and its first runaway success.[80] Despite its supposedly esoteric subject, and what in 1962 was an unusually high retail price of $25, the first printing had sold out before the book even came off press. Within two years the Club would sell more than twenty thousand copies, and stories would be circulating about college students going out of their way to save up enough to afford the book. Published during the centennial of Thoreau's death and the same year as Rachel Carson's *Silent Spring*, Porter's book coincided with a blossoming of environmental interest and concern. But that alone did not account for its surprising, instant success. *This Is the American Earth*, one of the Sierra Club's previous Exhibit Format books, had addressed such environmental concerns more overtly. Neither was the book's color foundation the reason for its popularity; over the previous few years, color photographs had become common features in trade books about nature and the American land. Rather, it was the intensity of Porter's vision, the clarity of *In Wildness*'s design, and the unprecedented quality of the printing.[81] Each plate was printed individually on specially coated Kromecoat paper and then lacquered to deliver remarkable saturation and delicacy of hue. Introduced by a cover photograph of a bright, color-field-like vision of a flowing stream, the book was simply beautiful to see.

Brower meanwhile had already approached Porter with another book proposal. Upon hearing that the artist had started photographing along the Colorado River as it passed through Glen Canyon, he had realized that Porter's photographs would eloquently help the Sierra Club's campaign to block the construction of more dams further downstream.[82] Already sympathetic to Brower's position, Porter jumped at the opportunity. The success of *In Wildness* had helped him realize that "the camera could be a powerful instrument for persuasion for other than exclusively aesthetic and creative purposes, without diminishing in the slightest degree the artistic integrity of photography."[83]

On his first float through Glen Canyon in September 1960, Porter had felt dizzy with confusion. There was so much new to photograph that each time he had raised his camera to shoot the sheer rock walls, the composition passed him by before he could snap the shutter. But his color acuity soon gave him his bearings. He marveled at the canyon's red sandstone walls and the orange-pink glow of the side canyons, writing to his sons, "the smaller unnamed tributaries, reflecting the blue sky, the

green willows and the red rocks acquire all the colors of the spectrum which together with the flowers blooming along their courses adds to the unbelievable beauty of these places."[84] By his second trip the following summer, he had begun to use color much more directly for expressive effect. Up until then, he had generally striven to reproduce nature's colors as naturalistically as possible. Such veracity was essential to his bird portraits, which were directed to ornithologists as much as to audiences of fine art. In assembling the images for what would become *In Wildness*, he had maintained that same approach. But in Glen Canyon he decided to let the colors go as they might, rather than seek exact replication. He also moved more assertively to blend abstraction with reality. Rather than create long, sweeping views of the river anchored by the canyon's rim, Porter focused repeatedly on reflections and close-ups of the side walls (fig. 14).[85] Over what would become a dozen or more trips through the canyon, both before and after the completion of the Glen Canyon Dam, he created a portrait filled with an almost unbelievable array of color. Often he required the viewer to look down to see what was up. The rippled surface of water became one of his favorite subjects. By reflecting light in so many directions, it projected a multitude of unexpected colors. In *Sunrise on river, Navajo Creek*, these hues are so saturated as to become surrealistic

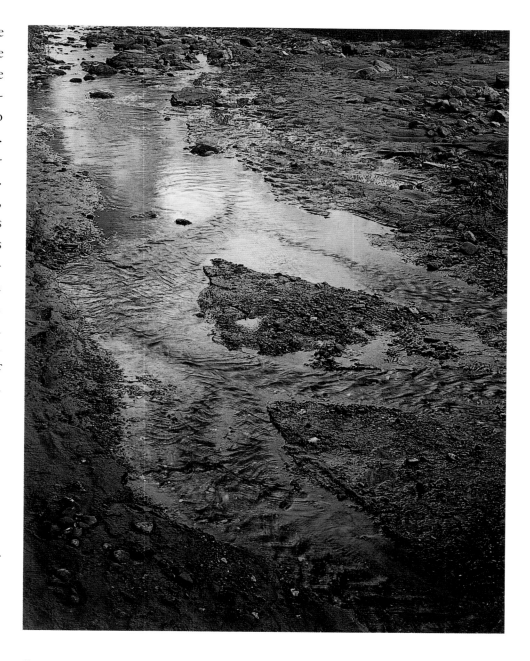

(*fig. 14*) Green reflections in stream, Moki Canyon Creek, Glen Canyon, Utah, September 2, 1962

(page 27). He also took advantage of the inherent flattening of photographs in his close-ups of the sandstone walls. While these images draw attention to the forces that created and still play out in the canyon, optical illusion reigns. Yet even at his most abstract, as in *Sheer cliffs, Glen Canyon*, Porter never loses site of the specificity of the place (page 26, top). When friends complained to him that he was producing prints of false color, he retorted that although he may have taken the liberty of emphasizing or reducing specific colors in making his prints, he took pride in presenting only colors found in the scene.[86]

Central to this new play with color was his employment of Jorge Fick as his private printer. Fick was a painter who had been trained at Black Mountain College and further developed his color sense through work with the distinguished designer Alexander Girard. Porter had initially hired him to print a portfolio to accompany *In Wildness*. But when the Glen Canyon project came up, he kept Fick on.[87] Fick would end up creating most of Porter's dye transfer prints until fall 1968. While he always worked under Porter's close supervision, with the photographer approving each print, he brought an intuitive touch to making the prints and gave them an unparalleled nuance, teasing myriad subtle and rich hues out of the dye transfer's mix of magenta, cyan, and yellow.

In his excitement over Porter's Glen Canyon photographs, Brower initially pushed to create a book that measured an incredible 12-by-17-inches. He planned to call it the Sierra Club's "Gallery Format."[88] But the increased size proved prohibitively expensive. Still, in printing the Glen Canyon book, the Barnes's pressmen had to throw out the first ninety thousand sheets because of the difficulty of cap-

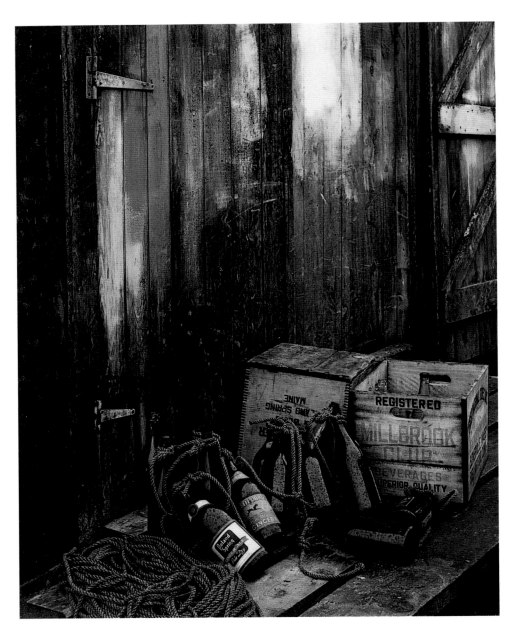

(*fig. 15*) Green bottles, Matinicus Island, Maine, August 24, 1954

turing just the right quality of light and color in offset reproduction. In 1963, a year after releasing *In Wildness*, the Sierra Club published *The Place No One Knew: Glen Canyon on the Colorado*. The book represented the distance the Club had come, marking a huge aesthetic leap over *This Is Dinosaur*, which the Club had published in 1955 in an effort to stop dam construction further upstream.[89] As with *In Wildness*, in *The Place No One Knew* each of Porter's images was paired with a text, in this case with vivid passages about the Colorado River, the West, and nature culled by Porter and others from a variety of historical and contemporary sources. Once again Porter approved the singly printed Kromecoat sheets as they came off press, and the book was side-stitched into what had become the Sierra Club's standard oversize Exhibit Format presentation. As soon as he received the bound copies, Brower sent them to President Kennedy, Secretary of the Interior Stewart Udall, and every member of Congress. The book made a strong impression. Not only did the federal policy of damming western rivers come under immediate review, but it helped renew efforts to pass the long languishing Wilderness Act.[90]

In June 1963, after completing his production of imagery for the Glen Canyon book and stopping in Ohio for a couple of weeks to photograph thrushes and warblers, Porter made his first visit in eight years to Great Spruce Head Island. His burgeoning relationship with Brower had given him hope that he might successfully resurrect his long-held goal of publishing an autobiographical portrait of the island.[91] Now he was returning to add more color photographs to decades of mainly black-and-white work he had made there. Brower's visit to the island the following summer closed the deal. In 1966 the Sierra Club would publish *Summer Island: Penobscot Country*, using the now-familiar Exhibit Format design.[92] Although the first half of the book is illustrated with Porter's early black-and-white photographs, the book as a whole is imbued with a close attention to color. Even as he lists his first memories of the island, Porter is thinking in color: "a sweep of white beach, a dark mass of forest behind it, and in front of it, holding the beach to its arc, a lobe of pure translucent blue."[93] Speaking of his childhood, he remarks:

> We gathered shells along the high-tide wrack: powder blue and purple mussels in all sizes that nested together in compact families; pale green sea urchins washed clean of their spines; and the perfectly preserved, brilliant orange carapaces shed by the small, brown-green crabs that lived in the rock weed of the littoral zone.[94]

The book is about living in close harmony with nature. But it also draws attention to the built environment (fig. 15). A central feature of the book is Porter's recognition of the ways in which human beings have changed the region's landscape over time. It is very much a lived-in place. Reflecting his ecological sensitivities, he presents photographs of buildings, wharves, and lobster buoys as often as trees, grasses, or the shoreline. Mixed among cool blues, greens, and browns of nature the viewer

finds flashes of human-made white, yellow, red, and orange.

New projects were coming on quickly. Upon Porter's return from Maine, shortly after the release of *The Place No One Knew*, Harold Hochschild, the founder of the Adirondack Museum, asked him to photograph the 5,700,000-acre Adirondack State Park in northeastern New York. Hochschild's goal was to create a book designed to counter a lobbying campaign being run by private interests who wanted to open up the park to commercial development. The museum's initial plans were to assemble the work of a number of photographers. But Hochschild and his wife were so pleased with Porter's initial group of fall-season transparencies that they turned the photography entirely over to Porter. The resulting book, *Forever Wild: the Adirondacks* (1966), would match the artist's color-filled photographs with passages by the nature writer William Chapman White.[95]

As with *In Wildness*, Porter assembled his Adirondacks portrait on a structure of seasonal change. But building on what he had learned in Glen Canyon, he repeatedly photographed scenes infused with shimmering light or subjects exhibiting strong contrasts of brilliant sunlight and deep shadow, as in *Waterfall and maple leaves* (page 41), seeking to convey ever more viscerally a sensation of being enveloped by woods. He also ignored the high peaks, making broad scenic views only when that stance jeopardized the publication.[96] To him the park's beauty was best summarized not through panoramas, but by its thick forest details.

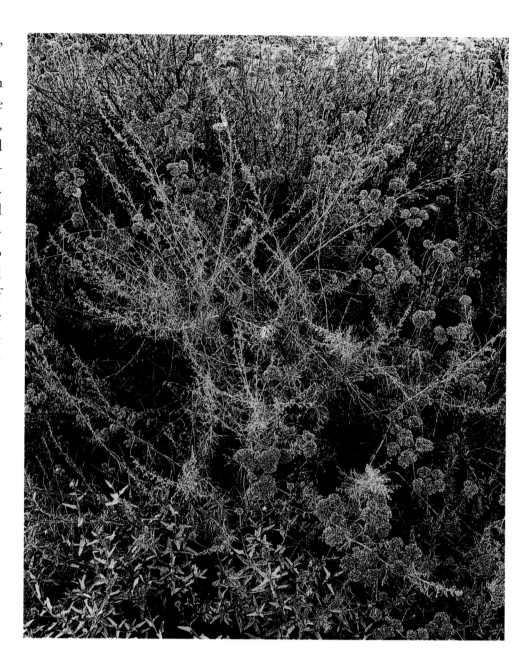

(*fig. 16*) Vegetation detail, on road above La Calentura, Baja, California, July 25, 1966

Although major museums were still unsympathetic to color photography, Porter had found his calling in creating books that presented his photographic portraits of distinctive places in conjunction with evocative textual descriptions of those spots. In the midst of his work for the Adirondack Museum, inspired by Krutch's recent text, *The Forgotten Peninsula*, in the spring of 1964 he made the first of two trips to build a photographic portait of Mexico's Baja Peninsula.[97] (The second trip would come in midsummer 1966.) Following his friend Krutch's lead, he focused on the peninsula's ecologically vulnerable, mountainous spine. He arrived expecting to see bright colors of the spring bloom. Instead, Baja's predominantly overcast skies and subtle desert hues presented provocative, if disgruntling, challenges.[98] Where the artist previously had relied on rich reddish-browns and cool cyan greens, here he had to learn how to work with pale tans and acid yellow-greens (fig. 16). Instead of the cool light of the north, he had to deal with the bright, hot light of the desert. Rather than dwell within the room-like closeness of New England's woods or Glen Canyon's narrow passageways, he had to teach himself how to summarize a wide open desert terrain. Previously Porter had always felt strongly that blue sky and broad vistas were better suited to black-and-white. But Baja's broader spaces and huge flowering cirio cacti now induced him to tilt his camera up and flirt with producing scenes filled with sky.[99] Baja presented just as great a challenge to Fick. Instead of the usual saturated color, Porter's transparencies, such as *Elephant tree, El Marmolite*, were filled with light pastel hues whose delicacy needed to be teased out (page 52).

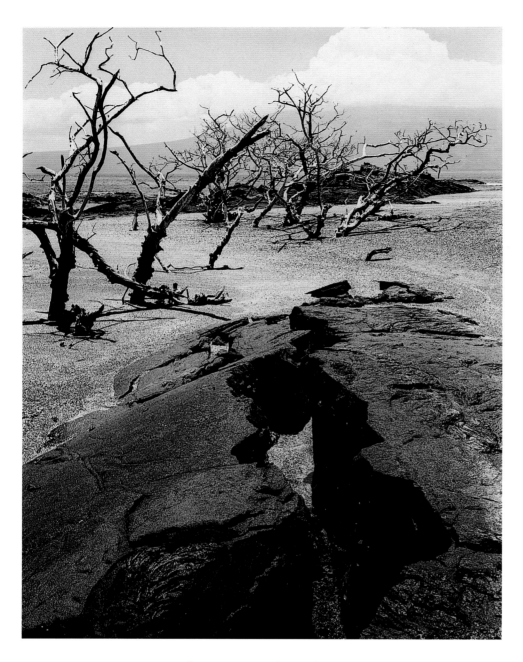

(*fig. 17*) Dead mangrove and lava, Espinosa Point, Fernandina Island, Galápagos Islands, April 7, 1966

By 1965 Porter was lobbying the Sierra Club to sponsor even more books of his photographs. Besides texts on Great Spruce Head Island and the Baja Peninsula, he wanted to create portraits of a broad array of places, including the Galápagos Islands, Alaska's Brooks Range, the desert Southwest, and the Nebraska Badlands.[100] But Porter's publishing success was only making Adams more jealous and more adamantly opposed to color. Recognizing that Porter had replaced him as Brower's favorite photographer, Adams, in a letter to Sierra Club president William Siri, praised his own recently published paean to poet Robinson Jeffers as the Club's "most moving, logical, and beautiful book . . . done to date!"[101] In a rather unsubtle dig at Porter, he argued: "With color plates, you are moved into another world of perception— a literal and harsh world and not in key with the splendors of Jeffers [sic] verse or of many of the black-and-white photographs. But if it is necessary for the success of the book in the 'marts of trade' to have color plates I suppose we must bow to that fact. Personally, I doubt it!"[102]

Even before finishing *The Place No One Knew*, Porter had started seeking the means to photograph on the Galápagos Islands. His father's strong subscription to Darwinian evolutionary theory had passed on to him, and he wanted to see and share this remarkable habitat. Although initially lukewarm to the idea, Brower eventually began to see the Galápagos as a key to his evolving "Earth National Park" environmentalist agenda.[103] Eventually, Porter's photographs and travelogue text created the foundation for the Sierra Club's most ambitious publication yet, the two-volume Exhibit Format book, *Galápagos: The Flow of Wildness* (1968).[104] In contrast to his Baja work, the photographer's Galápagos portrait, as shown in *Rim of crater and Bainbridge rocks, Sombrero Chino*, is enveloped in a brilliant, clear light, delivering at times an almost unnatural saturated color (page 57). Drawn to the islands less by their landscape than by their significance to the study of evolution, Porter spent much of his time making broad shots of the island terrain and photographing the island animals (page 58). The latter he approached much as he did his bird subjects. The composition, quality of light, and array of color were important. But none of these criteria outweighed that of making a clear record of the animal itself. The results are mixed. On first voicing interest in creating a photographic study of the Galápagos, Porter had asserted that he would need eight months to complete the work properly.[105] The three months that he was able to spend photographing on the islands clearly were not enough to capture their visual poetry, much less to fill two volumes.

By the mid-1960s Porter had gotten into such a routine of moving from one book project to another that he was no longer giving each project his full attention. To make matters worse, at the same time that Brower was praising him to the Sierra Club board as the Club's "most valuable property," he was increasingly limiting Porter's role in the production of his own books.[106] The Baja book lacked the sub-

tlety of printing found in Porter's first two books. The two-volume Galápagos book was worse. Not only did its plates show little regard for the nuance of Porter's photographs, but the artist's name was not even on the cover.[107] When Porter saw the book he was furious about the omission. But he accepted the printing for what it was, only because to him the magic lay in photographing and making dye transfer prints. Books were what allowed him to accomplish those activities. When Fick saw the Galápagos book, he cried. Here was a full year of printing "wasted." He soon decided that it was time to return full time to his own work.

In 1967, even before the completion of the Baja and Galápagos books, Porter was on the move again. After taking a spring vacation trip to Greece and Turkey, he floated twice down the Colorado River through the Grand Canyon to collect images for a centennial celebration of John Wesley Powell's first trip through that canyon.[108] And that fall he started assembling a photographic portrait of Great Smoky Mountain National Park for what would become E. P. Dutton's *Appalachian Wilderness: The Great Smoky Mountains* (1970).[109] In this last project the artist returned once more to his artistic roots: building a portrait of seasonal change. But reflecting his intervening experiences, he now created some of his most complex compositions to date. The Appalachian imagery thrives on texture and unexpected delineations of space. In some photographs, such as *Poplars and hillside, Newfound Gap Road*, leaves seem to float on different planes than the rest of the picture (page 49). In *Sun on brook, Cades Cove Road*, a mix of unexpected color and reflection blends into a complex and delicately balanced mosaic (page 48). Even straightforward visions of woodland flowers like Polygola take on a slightly surreal character (page 46).

By the late 1960s, Porter's book successes had opened the door to a regular stream of exhibitions, generally at small museums and university galleries, and even a number of honorary awards. But to his great frustration, he still had to justify his commitment to color to his artist-associates. He was incredulous that photographers of established reputation like Adams and now Walker Evans still refused to see that the medium could have any expressive potential.[110] Their rejection, he decided, was no different from the narrow-mindedness of those in the late nineteenth century who rejected the idea that photography could be art:

> To say that because a photograph is in color it is less creative than one in black and white is to manifest a poverty of perception no less egregious than to condemn photography as a whole because it is the product of an optical instrument. I suspect that if color photography had been invented before black and white, the situation would be reversed."[111]

Repeatedly, in both public lectures and short essays, he defiantly proclaimed the expressive capability of color photography. Adams's continuing suggestions that color photography was too garish and uncontrollable stemmed, Porter decided, from the photographer's refusal to understand two elementary points: first, that photography, whether color or black-and-white, is inherently a translation; and second, that dye transfer printing offered tremendous freedom to control contrast, hue, and saturation.[112] Color actually "broadens the choice within a photographer's working field," he declared.[113] Objects never have a single, unvarying color: "True color is what you thought you saw and therefore what you intend others to see. . . ."[114] Evans's late-1960s declaration that color photography "is vulgar" was just as demeaning. Porter called the statement "reckless," explaining that Evans's parallel assertion, that nature photography was trivial, contradicted the extensive influence of nature on art throughout history.[115] Many subjects, he argued, from sunsets to the reflected colors filling the side canyons of the Colorado River, are impossible to capture in black-and-white. Nature's details, a subject dear to his heart, often required color-differentiation to be seen clearly, or to be seen at all.

Porter always viewed his transparencies as just the starting point. He was more than willing to reinterpret his own prints to build a specific emotional impact. In some cases, as in his 1968 image, *Redbud trees in bottom land, Red River Gorge, Kentucky*, he created diverse finished prints from the

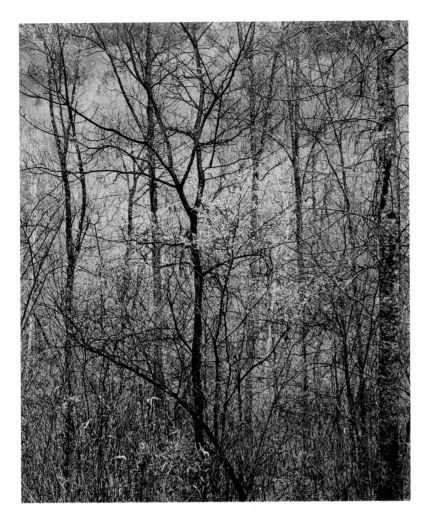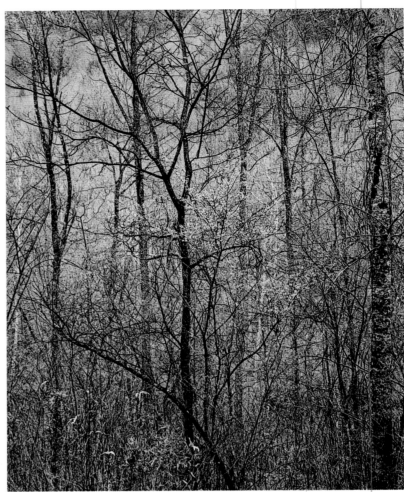

(fig. 18 and 19)
Redbud trees in bottom land,
Red River Gorge, Kentucky,
April 17, 1968

same original transparency that ranged from a cool purple-blue light to a warm, lime-green atmosphere, as if the sun had just come out (figs. 18 and 19). Although the interpretations are very different, both images are believable.

In 1970 Porter's love of travel pulled him to East Africa. He had long been interested in visiting that region, feeling that other photographers had been preoccupied with the large animals to the detriment of the broader landscape and culture.[116] Just as influential was his new interest, piqued by Loren Eiseley's book, *The Immense Journey* (1967), in seeing and depicting the birthplace of humanity. Whereas in the Galápagos he had found a landscape imbued with oranges, lime greens, blues, and volcanic grays, here he faced richer greens and a myriad of browns (fig. 20). But, as in the Galápagos, he never truly engaged with his subject. Too many of his images verge on formulaic reconstruction of *National Geographic*'s safari pictorialism. The resulting book, a co-publication with the writer Peter Matthiessen, was problematic.[117] Porter wanted Matthiessen to build a text around his photographs. Matthiessen considered Porter's photographs mere illustration. Dutton solved the problem by publishing two distinct books under one cover.

In January 1971, the artist hired the printer David Rathbun from the New York City lab that developed his color transparencies. Despite his extensive facility with a camera and in the darkroom, Rathbun, like Fick before him, arrived never having made a dye transfer print. But he quickly became delighted by the process's broad allowance for color control and for making prints in open light. Porter's remarkable facility with the process, on the other hand, induced an entirely different feeling. The printer recently recalled, "I showed Eliot my first print, proud as a peacock; he replied, 'Try it again with these changes,' dictating the recipe. The difference between the two was like night and day. My print was approximate; Eliot's was right on. The elation I felt twenty minutes earlier was replaced by absolute despair."[118] It took a year of constant printing before Rathbun developed an eye for dye transfer that could approximate Porter's. As with Fick, Porter reviewed every print that Rathbun made, making con-

stant suggestions about how to handle the dyes and deciding which prints were good enough to mount. But Porter experienced a very different hand. Where Fick had brought the intuition of a painter to the dye transfer process, Rathbun delivered technical precision. While Fick's prints reveal subtle shifts of color, Rathbun's boast unparalleled clarity of hue.

During Rathbun's tenure, Porter took up two of his strongest late career projects. Where he had been drawn to Baja, the Galápagos, and east Africa out of intellectual curiosity, he traveled to Iceland and Antarctica in the early and mid-1970s enticed by their expressive challenge. In photographing these two places, he revisited his penchant for abstraction and his commitment to exploring unexpected boundaries of color. Luring him to Iceland were the island's extensive patches of lichen. A nexus of biological simplicity and colorful variety, this plant had long been one of his favorite subjects.[119] Close-ups like *Lichens on rock, road to Laki* once again became Porter's key means of describing the land (page 70, left), but now those close-ups were interspersed with the long sweeps of terrain, such as *Mud pot in hot spring area, Mývatn* (page 69). Taking advantage of the island's clear, clean light, other images, like *Waterfall in crevice, road to Vik*, offer strikingly saturated color reminiscent of Glen Canyon (page 71). The effect is powerfully graphic.[120]

In 1974 the National Science Foundation selected Porter to be the first photographer to shoot on and around Antarctica as part of a new cultural program to highlight its interests there. The artist was delighted; not only would the trip indulge his love of adventurous travel, it also would present the twin challenges of remarkably cold conditions and great expanses of white.[121] As in Iceland, Porter defined Antarctica through a combination of sweeping views, as in *View from Monastery Nunatak, dry valleys*, and striking abstractions, as in *Airdevonsix Icefalls, Wright Upper Valley* (pages 72 and 74, top). But while he had initially been drawn to the southern continent by the anticipated challenge of photographing the region's white landscape in color, he had found himself captivated by the changing, often unexpected blues of the sea, ice, and mountains.[122] As he traveled south, he found that the sea turned from cerulean to a purple-blue reminiscent, he later wrote, of the classical Greeks' "wine-dark" Aegean. Soon it underwent another transformation:

I noticed that the water was darker, more ultramarine, and that it seemed to be tinged with red…giving the sky a greenish cast. Even as the sky darkened toward the zenith, it retained the less purple blue of normal skylight. With a gentle wind, I could study the more reflective planes on the upswept inside of small waves, and I saw that they were in fact violet, a color which, when added to the darker blue of the other areas, gave the water a reddish cast.[123]

He studied icebergs with the same attention, describing one as: "suffused with blue except for highlighted surfaces or surfaces white with a pinkish cast, where snow had lodged; and in all recesses, pockets, and grooves the color intensified to a Della Robbia blue, a condensed distillation of ocean purple."[124] In the midst of this excitement Porter once again lost his printer. Rathbun quit to take up Arthur Siegel's challenge to reinvigorate the color photography program at Chicago's Institute of Design. Within two weeks, at Rathbun's recommendation, Porter hired Jim Bones, a color photographer who had been striving for years to mirror Porter's style in his own work. Bones had first encountered Porter's photography in the mid-1960s, when Russell Lee, who was his teacher at the University of Texas, ran into the classroom with *The Place No One Knew*, exclaiming: "I have never seen color like this."[125] Bones's immediate response was to take up color photography. When Porter called to offer a job, he had just published a book of his own Porter-influenced color landscape photographs, *Texas Heartland: A Hill Country Year* (1975). The arrangement, unfortunately, did not work out as well as either man had hoped. Bones found the master in the midst of his Antarctica-induced "blue phase," something for which he had little sympathy. Every time Bones thought that he had made a fine dye transfer print, Porter called for more blue. Although Bones stayed for almost three years, the experience was frustrating for both men. When Bones left, Porter went for ten years without a printer, hiring Bob Widdicombe only when amyotrophic lateral sclerosis, or "Lou Gehrig's disease," began greatly restricting his ability to work.

Still there would be one more major turn in Porter's art. Even as he was turning his sights on Iceland and Antarctica, he embarked on an entirely new visual pathway that would bring him to document three of the world's great cultures. On his 1967 vacation in Greece, he had become captivated by the ruins of classical temples and theaters. Over the course of that visit and two subsequent ones in the early 1970s, he built an architectural portrait of those ruins out of the pastel blues and grays as found in *Sounion, Greece* (page 76, bottom). Then in 1973 he traveled to Egypt, ostensibly to provide illustrations for a monograph on the land's ancient tombs and monuments being written by the distinguished Egyptologist Charles Eaton Kitchener.[126] But where he translated Greece's ancient architecture into an array of blues, he envisioned Egypt as a symphony of yellows and browns, as seen in *Statue of Ramesses II, south corner of Ramesses court, Temple of Luxor* (page 83); where he let Greece bask in light, his Egyptian views arise out of deep shadow. In each project, color defined place.[127]

Porter was seventy-eight years old in 1979, when the United States normalized relations with the People's Republic of China. But he was far from finished photographing. He had long dreamed of retracing the steps of Marco Polo with his son Jonathan, a scholar of Chinese history at the University of New Mexico. Nixon's trip to China in 1972 had given him hope. The formal Sino-American rapprochement now opened that opportunity. Although the Chinese government did not allow the two men to set their own itinerary or photograph wherever they liked, its guides took them through diverse sections of the country. Through Jonathan Porter's text and his father's photographs, they created an ecologically conscious historical portrait of a culture bound in a long-standing relationship with the land.[128] Deferring to his age in relying largely on a 35mm camera, Porter now took up an overtly documentary approach that he had not used since his earliest years. He photographed architectural details, street scenes, and people as much as the open landscape. Blues, browns, and grays predominate in the resulting prints, often accented by gold and red. Color is subsumed by subject. But every once in a while, the artist's long-standing fascination with the emotional qualities of color comes through, as in his portrait of a group of young men in Urumai, where the blues of the men's jackets jump provocatively to the surface (fig. 21).

(*fig. 21*) Young men, Urumai, Xinjiang, China, fall 1981

By this time, Kodak's development of a greatly simplified Ektacolor printing process had induced a new generation of artists, including Stephen Shore and Joel Meyerowitz, to take up color. Young nature photographers like Robert Glenn Ketchum also were following Porter's lead into the medium. Color finally was drawing serious critical attention. But as Ansel Adams's grand visions of a gloriously uninhabited West gave way to Robert Adams's (no relation) assertions of a human-inscribed terrain, Porter's idyllic visions of nature were likewise displaced by William Eggleston's laconic suburban views. Although Porter was given a 1979 exhibition at the Metropolitan Museum of Art in New York, even his new preoccupation with cultural history ran against the grain of contemporary curatorial tastes.[129] The situation was bittersweet. MoMA curator John Szarkowski had included nine of Porter's prints in his 1963 MoMA exhibition, *The Photographer in the American Landscape*. Yet as late as 1976, he insisted on labeling most color work created prior to the late 1960s as "puerile." Szarkowski was far from alone in his view. In 1984 the curator-critic Sally Euclaire likewise disparaged pre-1970s color as lacking "subtlety and complexity." That same year, photography historian Jonathan Green called 1950s–1960s color almost all either an arbitrary overlay on black-and-white or a poor imitation of painting.[130] Following this lead, most photography historians and curators still assume that color photography as a serious art form arrived after Porter. The artist's rich and vast archive provides a definitive retort.

I saw that the camera could be a powerful instrument for persuasion for other than exclusively aesthetic and creative purposes, without diminishing in the slightest degree the artistic integrity of photography. —E. P.

EVERY CORNER IS ALIVE

ELIOT PORTER AS AN ENVIRONMENTALIST AND AN ARTIST

REBECCA SOLNIT

BEHIND THE EYES

"As I became interested in photography in the realm of nature, I began to appreciate the complexity of the relationships that drew my attention," wrote Eliot Porter.[1] Complexity is a good foundational word for this artist, whose work synthesized many sources and quietly broke many rules, and whose greatest influence—an influence yet to be measured—was had outside the art world. Porter was one of the major environmentalists of the twentieth century, not because of his years on the board of the Sierra Club, but because of his role both in raising the public awareness of the natural world and shaping it in the popular imagination.

When Porter's first book, "*In Wildness Is the Preservation of the World," Selections & Photographs by Eliot Porter*, appeared in November of 1962, it came as a revelation. Nothing like it had been seen before, and while the subject was ancient, the technology to represent it so dazzlingly was new. Porter was one of the pioneers of color photography, and his editor, Sierra Club executive director David Brower, enlisted new printing technology to attain unprecedented sharpness and color fidelity. The essayist Guy Davenport wrote that the book "cannot be categorized: it is so distinguished among books of photography, among anthologies, among art books, that its transcendence is superlative."[2] A later reviewer recalled, "A kind of revolution was underway, for with the publication of this supremely well-crafted book, conservation ceased to be a boring chapter on agriculture in fifth grade textbooks, or the province of such as bird watchers."[3] Despite its $25 cover price, it became a best-seller in the San Francisco Bay Area and did well across the country. When a less expensive version was published in 1967, it became the best-selling trade paperback of the year. Porter's 1963 book, *The Place No One Knew: Glen Canyon on the Colorado,* a counterpoint to his first, was similarly well-received. Precisely because of the images's success, it is impossible now to see what they looked like when they first appeared.

There are two kinds of artistic success. One makes an artist's work distinctly recognizable to a large public in his or her time and afterwards—Picasso might be a case in point. The greater success is paradoxical: this work is so compelling that it eventually becomes *how* we see and imagine, rather than what we look at. Invisible most of the time, such art may look obvious or even hackneyed when we catch sight of it. Such success generates imitations not only by other artists, but throughout the culture. The ubiquitous Porter-imitations in advertisements, calendars, and posters are testimony to his success and fundamental effect on our perception. Such images tell hikers and tourists what to look for in the natural world; as a result, they may experience his aesthetic as nature itself rather than as art.

Color demanded different compositions and called attention to different aspects of nature than did black-and-white photography. Eliot Porter's aesthetic was born out of an individual talent and grew into a genre—"nature photography"—in which thousands of professionals and amateurs now toil (though most value beauty more and truth less than Porter did). His photographs have come to embody what we look for and value in the natural world, what the public often tries to photograph, and what a whole genre of photography imitates. Porter's pictures of nature look, so to speak, "natural" now, and this is the greatest cultural success any ideology or aesthetic can have.[4] We now live in a world Porter helped to invent. Because his pictures exist behind our eyes, it is sometimes hard to see the Porters in front of our eyes for what they were and are. Understanding Porter's photography means understanding the world in which it first appeared and the aesthetic and environmental impact it has had since.

David Brower chose to publish *In Wildness* in the centennial year of Henry David Thoreau's death; in the book, Porter paired his images with passages from Thoreau. But 1962 was making plenty of history of its own. In September of that year, Rachel Carson's *Silent Spring* was published, and this indictment of the pesticide industry quickly became a controversy and a bestseller. In October, President Kennedy announced that the Soviet Union had deployed nuclear missiles in Cuba and that the U.S. would attack unless they were removed: the world came closer to an all-out nuclear war than at any time before or since. "The very existence of mankind is in the balance," the secretary general of the United Nations declared.[5] The revelations of the atomic bomb and the concentration camps at the end of the Second World War had begun to erode faith in leaders, scientists, and the rhetoric of progress, and that faith had continued to crumble as the fifties wore on. *Silent Spring* and the Cuban Missile Crisis were crescendos of events that had been long building, and *"In Wildness Is the Preservation of the World"* may have succeeded in part as a response to these circumstances.

In the late 1950s and early 1960s, fear of a possible nuclear war was coupled with fear of what preparing for one entailed. The 1959 discovery that in many parts of the country milk, both bovine and human, was contaminated by atomic-testing fallout had prompted a national outcry. The appearance of man-made carcinogens in what ought to be the most natural and nurturing substance in the world meant that nature was no longer invulnerable to science and politics; it meant that the government was generating biological contamination in the name of political protection. Similarly disastrous pesticide-spray campaigns in the country's national forests had already provoked an uproar by the late 1950s. (Porter was among those decrying their abuse, with letters to his local newspaper.) Science and politics had invaded the private realms of biology, reproduction, and health as never before. Carson wrote of pesticides, "Their presence casts a shadow that is no less ominous because it is formless and obscure, no less frightening because it is simply impossible to predict the effects of lifetime exposure."[6] The world faced a new kind of fear, of nature itself altered, of mutations, extinctions, contaminations without precedent. Porter wrote in 1961, "Conservation has rather suddenly become a major issue in the country—that is, more people in higher and more influential places are aware of its importance and willing to do something about it."[7]

Pesticides and radiation were only part of the strange cocktail that fueled what gets called "the sixties." In November of 1961, Women Strike for Peace, the most effective of the early antinuclear groups, launched a nationwide protest that in many ways prefigured the feminist revolution. In 1962, the Civil Rights Movement was at its height, the United Farm Workers was founded, and Students for a Democratic Society (SDS) held its first national convention. The voiceless were acquiring voices and using them to question the legitimacy of those in power and the worldview they promulgated. Some of those with voices were speaking up for nature and wilderness with an urgency never before heard. During the late 1950s and early 1960s the epochal Wilderness Bill was being debated alongside pesticide and radiation issues; nature in its remotest reaches and most intimate details was at stake. It is in this context that the small American conservation movement became the broad-based environmental movement, and Porter played a role in its broadening.

Carson's and Porter's books refract the same ecological truth—that everything is connected—through very different prisms. What *In Wildness* depicts as a beatific vision, *Silent Spring* tells as a nightmare: our chemical sins will follow us down the decades and the waterways. Carson's book addressed a very specific history, that of the development of new toxins during World War II, their later application to civilian uses, and their effects on birds, roadside foliage, the human body, and the vast ecosystems within which these entities exist. "The world of systemic insecticides," she wrote, "is a weird world . . . where the enchanted forest of the fairy tales has become the poisonous forest in which an insect that chews a leaf or sucks the sap of a plant is doomed. It is a world where . . . a bee may carry poisonous nectar back to its hive and presently produce poisonous honey."[8] Porter's book showed the forest still enchanted, outside of historical time and within the cyclical time of the seasons (figure 22). (The photographs had earlier appeared in an exhibition titled *The Seasons*, and the images are sequenced to depict spring, summer, fall, and winter.) Only one image, of a mud swallow's nest built against raw planks, shows traces of human presence at all, and that presence is slight and

benign. The year before, in response to arguments that wilderness was an elitist value, Wallace Stegner had coined the phrase "the geography of hope," asserting that wilderness could instead be a place where everyone could locate their hopefulness, even if few actually entered it.[9] The Sierra Club's "Exhibit Format" photography books could be, as environmental historian Stephen Fox points out, a way to bring the wilderness to the people rather than the other way round, to show them the geography of hope and create a virtual access without impact.[10] *In Wildness* was in many ways a hopeful book, an intimate portrait of an apparently undamaged world of streams, blackberries, moths, saplings; a later Porter book would be titled *Baja California and the Geography of Hope*. These photographic books were in some sense documents, but in another, equally important sense, they were promises: the unspoiled nature they showed not only was confirmed still to exist, usually in remote places, but represented what the future could hold. It is a mark of profound change that in the time of the publication of these books, the best hope for the future was for one that resembles an untrammeled past. Industrialized civilization yearned not for the New Jerusalem, but for Eden.

Despite its lyrical celebration of the timeless and nonhuman, Porter's first book was widely recognized as a political book. Politics is ultimately about what we value and fear, and environmentalism is about what is worth protecting, as well as what threatens it; *In Wildness* spoke directly of these things. In a review of the 1967 edition, *Sports Illustrated* proclaimed, "Hundreds of books and articles have been written urging private citizens to do something ('Write your Congressman, now!') about the destruction of the nation's natural beauties, but the most persuasive volume of all contained not a word of impassioned argument, not a single polemic."[11] In fact, it did contain a few words of impassioned argument. At the end of his introduction, Joseph Wood Krutch stated, "If those who believe in progress and define it as they do continue to have their way, it will soon be impossible either to test his [Thoreau's] theory that Nature is the only proper context of human life or that in such a context we may ultimately learn the 'higher laws.' One important function of a book like this will have been performed if it persuades those who open it that some remnant of the beauties it calls to our attention is worth preserving."[12] Out of these two delicate sentences tumbles an avalanche of assertions: that progress, as conventionally imagined, was devastating the natural world, perhaps irreversibly; that Nature is a necessary but imperiled moral authority; that Porter portrays not only nature but its moral authority; that the purpose of Porter's book may be to help rally citizens to preserve this nature; that photographs of blackberries, birds, and streams can be politically and philosophically persuasive because a love of nature can be inculcated through beauty; and that such love can lead to political action on its behalf. Modernity had placed its faith in science, culture, and progress; the Rousseauian antimodernism that would be central both to the counterculture and the environmental movement put its faith in nature—usually nature as the embodiment of an ideal of the way things were before various interventions—before human contact, before the industrial revolution, before the arrival of the Europeans, before chemical contamination. Krutch, who had had a distinguished career as a literary critic before he left the East Coast intelli-

(*fig. 22*) Skunk cabbage, near Peekskill, New York, April 12, 1957

(*fig. 23*) Ferns, moss, dripping water, Redbud Canyon, San Juan River, Utah, May 25, 1962

gentsia for Arizona and naturewriting, embodies this shift—"an exile from modernism," curator John Rohrbach has called him, cast out of the city into the garden. Krutch was a major ally of Porter, and Porter supplied Americans with one definition of what that nature worth preserving was. (It is seldom acknowledged that this definition was made possible by a technologically advanced and aesthetically sophisticated art, an acknowledgment that would have greatly complicated the arguments.)

In his next book, Porter depicted a place that had been at least as pristine as anything shown in *In Wildness*, but which by the time of publication was irrevocably lost: the labyrinthine canyonlands drowned by Glen Canyon Dam. The book was an argument for preventing further dams in the Colorado River canyons, a struggle that continues today despite the loss of Glen Canyon. (The Sierra Club had done an earlier book in 1955, *This Is Dinosaur*, which campaigned against putting a dam in Dinosaur National Monument.) Porter portrayed Glen Canyon as a gallery of stone walls in reds, browns, and grays and of gravel-and-mud floors through which water flowed, occasionally interspersed with images of foliage and, much more rarely, the sky (fig. 23). Some found it claustrophobic and longed for more conventional distant views. It was much more radical than *In Wildness*—formally, in its compositions; politically, in the directness of its advocacy; and conceptually, in its depiction of an imminent catastrophe that would have been unimaginable only a century before. Beautiful images, particularly photographs, and most particularly landscape photographs, are usually invitations of a sort, but this one was the opposite: a survey of what could no longer be encountered, a portrait of the condemned before the execution. The beauty of the images was inflected by information from outside the frame; all this was being drowned. The environmental writer and photographer Stephen Trimble recalled, "When I explored the Colorado Plateau, I carried Eliot's pictures in my head and tried to let them guide my eye and then inspire me to see the same places and colors in my own way. My greatest sorrow is not having seen Glen Canyon. . . . It makes me sick at heart to look at the reservoir that drowned and destroyed the heart of the landscape that is my spiritual home. *The Place No One Knew: Glen Canyon on the Colorado* is the best book title of the second half of the 20th Century—and my first and best entry point into the lost basilica of my personal religion."[13] Elsewhere Trimble wrote, "The message was clear: go out into the land, stand up for it, fight its destruction—you lose forever when you fail to know the land well enough to speak for it."[14]

FLOW AND CONVERGENCE

Among the factors feeding Porter's vision were a socially conscious family whose influence contributed to his lifelong support of human rights and environmental causes; a boyhood passion for the natural world; an involvement with photography from late childhood onward; a medical and scientific education that gave him the skills to develop color-photography technology; the inherited funds to stand apart from fashions and pressures; and a sense of himself as an artist dating from Alfred Stieglitz's recognition of his work at the end of the 1930s. His education as a scientist can be regarded as a detour, but it can equally be portrayed as a necessary route, however roundabout. His training as a doctor and biomed-

(*fig. 24*) Little green heron, Kissimmee River, Florida, April 16, 1954

ical researcher refined his understanding of biology, chemistry, and laboratory work, which would stand him in good stead as a nature photographer, environmentalist, and innovator of color-photography processes. "I did not consider those years wasted," he once said. "Without those experiences it would be impossible to predict what course my life would have taken, least of all that it would be in photography. In retrospect, from my experience it appears highly desirable to order one's life in accord with inner yearnings no matter how impractical. . . ."[15] The yearnings began far earlier.

"As a child," he wrote elsewhere, "all living things were a source of delight to me. . . . I still remember clearly some of the small things—objects of nature—I found outdoors. Tiny potato-like tubers that I dug out of the ground in the woods behind the house where I lived, orange and black spiders sitting on silken ladders in their webs, sticky hickory buds in the spring, and yellow filamentous witch hazel flowers blooming improbably in November are a few that I recall. I did not think of them as beautiful, I am sure, or as wondrous phenomena of nature, although this second reaction would come closest to the effect they produced on me. As children do, I took it all for granted, but I believe it is not an exaggeration to say, judging from the feeling of satisfaction they gave me when I rediscovered them each year, that I loved them."[16] The absorption Porter describes in this passage goes deeper than aesthetic pleasure. Like William Wordsworth and many later nature writers, artists, and environmentalists, he retained this almost visionary childhood sense of wonder and transmuted it into something that could be communicated in the adult world. The items he names in this brief account—insects, buds, branches—are easily imaginable as subjects of his camera, and many of his photographs can be seen as childhood epiphanies of the minutiae of nature. As Stephen Trimble and Gary Paul Nabhan point out in their book, *The Geography of Childhood* (1995), children are usually far more engaged with the fellow creatures and tactile details of a place than with its overall scenic qualities. Thoreau, too, shared this passion for the near-at-hand and close observation, and it certainly explains part of Porter's affinity for him. "About this time I developed a capacity for observation that has lasted all my life," Porter continued. This capacity extended into both birdwatching and photography, and it provided the enormous patience with which he photographed birds (fig. 24).

"During my career as a photographer" Porter wrote, "I discovered that color was essential to my pursuit of beauty in nature. I believe that when photographers reject the significance of color, they are denying one of our most precious biological attributes—color vision—that we share with relatively few

other animal species."[17] The statement moves from aesthetics to science as though it were the most natural transition in the world, and for Porter it evidently was, though few others could or would deploy biology in arguing art. This mix made him something of a maverick and a misfit in photography circles—even the landscapists did not ground their work in science as he did. As a photographer he engaged with evidence of natural processes, biodiversity, the meeting of multiple systems, with growth, decay, and entropy. The book designer Eleanor Caponigro recalls, "Over the many years that I worked with him I became more and more aware of this complex composite of a man who was an extremely sensitive, articulate, visual artist, and who was a scientist and a naturalist. He was a doctor. So you'd be looking at photographs and they would have their own aesthetic beauty, and—it came up often in the Antarctica book—he'd say, 'But this is how this rift is formed, by these two land masses coming across. And this particular lichen occurs in this particular setup. And these are the dry valleys and the dessicated seals and this is how this happened and this is what happens when an iceberg rolls over and it's absorbed . . .' You know, so he was fascinated by all of that, and I think that's what drew him to photography instead of a different visual medium, because it solved, or it satisfied, this quality of scientific exploration for him. . . ."[18]

"At first," he once told a group of high school students, "My practice of photography was rather disperse; it had no direction; it was simply photography for photography's sake with the single exception of a long-established fascination with bird photography. . . . I [later] began to see photography associated with my other purposes, using it not simply as an art medium, but for its potential as an instrument of revelation to others, or propaganda, or to undermine accepted wrong points of view, in other words as a means of persuasion to make people change their beliefs and conduct."[19] Porter seldom spoke in books or lectures of his politics outside environmental issues, but his archives reveal an ideal citizen, informed about and involved in the activities of his government locally, nationally, and internationally. (In this, too, he has much in common with Thoreau, who is best known for his writing about nature, but who took strong stances on slavery, the Mexican-American war, and other issues of the time.) In 1924, while hopping freight trains in the West, Porter joined the I.W.W.—the International Workers of the World, better known as the Wobblies. Though he must have been influenced by the fact that I.W.W. members were less likely to be rolled by brakemen, his act reveals a sympathy with radicals perhaps not common among Harvard students from wealthy families. His tax records portray him as a staunch supporter of human rights and progressive causes: the American Civil Liberties Union was the one organization to which he donated year after year throughout his life, and in the 1930s he gave small sums to support the Republican side of the Spanish Civil War and the National Committee for the Defense of Political Prisoners. By 1946 the National Association for the Advancement of Colored People was on his list, and in 1948 he began giving to the Emergency Conservation Committee—a small, radical organization that began by reforming the Audubon Society and then issued prophetic warnings on what dams would do to salmon runs and cows to the public lands, among other environmental subjects. Documents in his archives show he was concerned about pesticides long before *Silent Spring* appeared, along with logging, grazing on public lands, and other subjects that environmental activists have since taken up. He often wrote letters to newspapers and politicians. In 1959, for example, he wrote the Santa Fe *New Mexican*, his local newspaper, to call attention to the centennial of abolitionist John Brown's execution. After quoting Thoreau on Brown, he wrote, "Not only are the bonds of the slaves he gave his life to free still not struck off, but we have since forged new bonds for ourselves. Is not this a fitting anniversary for us to rededicate ourselves to the cause of freedom, freedom from bigotry, freedom from prejudice, freedom from discrimination and freedom to stand up and be heard. . . . ?"[20] Later, he would write politicians and newspapers repeatedly about the war in Vietnam and the Watergate crisis, both of which outraged him; he also took an interest in Native American issues long before most of the non-native public was aware there were any. Though his principles involved him with many issues, his passion and his talent were dedicated to environmental causes, particularly the protection of wildlife and wilderness.

Early in his photographic career, Porter was making modernist photographs in the tradition of Paul Strand and Stieglitz, as well as pursuing ornithological photography in a genre that extends from scientists, illustrators, and hybrids such as John James Audubon (whom he cited in his two successful appli-

cations to the Guggenheim Foundation for funding to pursue this bird photography). Though he wanted to document birds for scientific-environmental purposes, he was committed to doing so aesthetically (as were, of course, Audubon and many others in that tradition). Thanks to Stieglitz's encouragement, he quit his day job as a biomedical researcher to devote himself full-time to photography. In 1939, Porter showed his bird photographs to Rachel Carson's editor, Paul Brooks, who was then the head of Houghton Mifflin. Brooks shared Porter's enthusiasm for natural phenomena—but not for the bird photographs. He told the artist that they would be far more valuable if they were in color. Thanks to his prodding, Porter became a pioneer of color photography. Eleven years later he approached Brooks again, only to be told that his jewel-like bird images would be too expensive to publish in color and would have a limited audience anyway. Fortunately, Porter garnered support from other quarters, including the Museum of Modern Art's David McAlpin, Ansel and Virginia Adams (who strove to find Porter a publisher early on), and Beaumont and Nancy Newhall. Even so, he toiled imperturbably with little public recognition for more than twenty years after resuming photography, and neither the lack of attention during those years nor the avalanche of it afterwards seems to have swayed his sense of purpose.

Throughout those twenty anonymous years he photographed birds in the spring and summer and other subjects the rest of the year. When his wife Aline said that this other work was evocative of Thoreau's writing, he began to read Thoreau with growing enthusiasm and to make pictures "of comparable sensibility . . . and for which I hoped to find a compatible description by Thoreau."[21] Like his scientific work, this work connected the images to something outside themselves, this time not to science but to a lyrical—and linguistic—encounter with nature from a hundred years prior. Like his bird photographs, his Thoreau photographs were admired and rejected by New York and Boston publishers. The story of his twenty years in obscurity usually ends with his meeting David Brower, and Porter himself let it be thought that it was not until his meeting with the Sierra Club director that he began putting his photography to political uses. In fact, he was already using it to lobby years before. In 1958 he wrote his middle son, Stephen, "The enclosed clipping is a letter I wrote to the paper about the Wilderness Bill which I hope very much will pass in the next Congress. To influence this legislation I made up an album of photographs of wildlife pictures showing what would be saved by the bill and sent them to [nature writer Joseph Wood] Krutch who agreed to write a short text to go with them. We will then send the whole work to the Senate committee that is considering the bill in hopes that it will influence them to recommend its passage."[22] Whether the album was ever assembled and sent out is not known, but it demonstrates that by the 1950s Porter was linking his art not only to science and literature but to politics, with hopes of influencing outcomes.

When *In Wildness* appeared, it was a convergence of childhood wonder, modernist art photography, breakthrough color-photography technology, scientific acumen, and political awareness—a convergence that would last and evolve through the subsequent books and years. Porter's most immediate contribution was his success in using aesthetic means for political ends. "Photography is a strong tool," he wrote, "a propaganda device, and a weapon for the defense of the environment . . . and therefore for the fostering of a healthy human race and even very likely for its survival. When used to its best advantage, dramatically, with uncompromising sharpness, it is a most powerful means for demonstrating the need for protecting and preserving the biota. This is so because photographs wield a great force of conviction. Photographs are believed more than words; thus they can be used persuasively to show people who have never taken the trouble to look what is there. They can point out beauties and relationships not previously believed or suspected to exist."[23]

DR. PORTER AND MR. BROWER

In David Brower and the Sierra Club, Porter met a man and an organization that had long put the aesthetic to political use in a way no other environmental group had. In 1939, long before Brower had become the Club's executive director, the photographer Ansel Adams had published *Sierra Nevada: The John Muir Trail* and sent it to Secretary of the Interior, Harold Ickes, to lobby—successfully—for the creation of King's Canyon National Park and expansion of Sequioa National Park. A Californian who spent much time in the Sierra Nevada and a board member of the Club from 1934 to 1971, Adams was far more deeply tied to the Club than the easterner Porter would ever be, and it was another of his

books that opened the door for Porter. Brower had published the Club's first Exhibit Format book, *This Is the American Earth*, in 1960; its black-and-white photographs were mostly by Adams and its Whitmanesque text by Nancy Newhall. Rather like the 1955 *The Family of Man*, this landscape photography book was more rhapsody than documentary survey, and it was a respectable financial success. Edgar Wayburn, who was the Club's president from 1961 to 1964, recalls that *This Is the American Earth* "changed Dave's whole way of looking at the conservation movement. He saw what a book could do."[24] It was the first of the Exhibit Format books the Club would publish, books that would introduce many Americans both to fine art photography and to their public lands. A few subsequent Exhibit Format books likewise lobbied for the protection of threatened places, though most, like *This Is the American Earth* and *In Wildness*, were less specific in their political aims.

Brower himself came out of publishing and publicity, and he naturally gravitated toward books—and later, newspaper ads and films—as means of educating the public and advocating on issues. A brilliant mountain climber and mercurial personality, he, more than anyone, changed the Club from its postwar role as a small regional outdoor society that did a little lobbying to the preeminent environmental organization of the 1960s. His book projects sometimes made money for the Sierra Club; more reliably, they brought in members and raised awareness. The Club had 7,000 members in 1952; 16,500 in 1961; 24,000 by 1964; and 55,000 by 1967. (In mid-2000, membership stood at 636,302.) But by the mid-1960s, the publications program had begun to lose money. As Stephen Fox writes in his history of the American environmental movement, "The conspicuous success of *Wildness* concealed the more typical commercial failure of other books in the series. Brower, believing the books a triumph in conservation, if not financial, terms, disregarded the warnings of his directors and plowed more money into the program. Once he asked the Publications Committee . . . for permission to go ahead with an Exhibit Format book. Turned down, he imperturbably replied: 'But I've already spent $10,000 on it.' Such collisions delayed the execution of contracts and the payment of royalties, poisoning relations between Brower and some of his most prominent authors, including Porter, Krutch, and Loren Eiseley. . . . From 1964 onward, the books program lost an average of $60,000 a year."[25] Brower and the Club published Porter's *Summer Island: Penebscot Country*, a portrait of his family's island in Maine, in 1966; *Baja California and the Geography of Hope*, with an extended essay by Joseph Wood Krutch, in 1967; and *Galápagos: The Flow of Wildness* in 1968. Though the books were not always related to immediate conservation objectives, they were often orchestrated to complement the campaigns Brower was working on. In his history of the Sierra Club, Michael P. Cohen points out that *The Place No One Knew* is a corollary to the "Should we also flood the Sistine Chapel so they can get closer to the ceiling?" ad, just as the Galápagos book was linked to Brower's infamous "Earth National Park" ad.[26] The Galápagos book helped fuel the controversy swirling around Brower in the late 1960s, by which time Porter was a member of the board of directors.

Porter had been elected in 1965 and served two terms during the great years of transition in the Sierra Club. In the 1950s, the Club had been fairly active in organizing outings and expeditions, less so in fighting environmental battles, and little involved in such battles outside California. Then, the Club took no stand on development and technology as such, only on their implementation in particularly beautiful or ecologically sensitive places. The Sierra Club had essentially told the U.S. government that, while they opposed a dam in Dinosaur, they would not oppose one in Glen Canyon—then found out too late what beauty the latter canyon of the Colorado held. In the 1960s the Club began to oppose many kinds of pesticide and herbicide use, and by the 1970s nuclear power and other major technologies were called into question; it had moved from preserving isolated places to protecting pervasive systems. As an outsider in the Club, Porter brought with him an independence from its traditional ties and limitations. The Club's directors were then mostly Californians, longtime members of the organization, and, more often than not, participants in its outings. Several had been great mountaineers in the days when the Sierra Club was a major force in American mountaineering, and many had ties within more powerful institutions in California—there were engineers, chemists, physicists, and executives involved with enterprises the Club would later target. "The idea of playing hardball with big corporations—Standard Oil or PG&E [Pacific Gas & Electric] and what have you—was a jarring thing to them," recalled board member Phil Berry.[27]

With Diablo Canyon Nuclear Power Plant, the drama of Dinosaur and Glen Canyon essentially replayed itself. The builder was Pacific Gas & Electric (PG&E), the same company that benefits from hydropower from Hetch-Hetchy Dam inside Yosemite National Park, the early-twentieth-century dam John Muir strove so hard to prevent and that first made the club into a forceful political organization. In 1963, members of the club discovered that PG&E was planning to build a plant at Nipomo Dunes on the central California coast, a site that had often been recommended for park status. After the Club's executive committee voted to try to preserve the dunes, board president Will Siri privately negotiated to have the plant moved to Diablo Canyon. Once again, too late, Sierra Club activists discovered that Diablo Canyon was too important to trade off. Many board members, including Ansel Adams, argued that if the Club had agreed to support the Diablo site, then they had an obligation to stick by the agreement. Porter thought differently. As Berry puts it, the uncompromising stand advocated by board member Martin Litton "was most eloquently stated, really, by Eliot Porter. Eliot said at that infamous September '68 board meeting that the Sierra Club should never be a party to a convention that lessens wilderness. That's the truth. We shouldn't be. I think we gained strength from the mess of Diablo."[28] Porter himself said in a letter published in the *Sierra Club Bulletin*, "Every acre that is lost diminishes our stake in the future. That is why a compromise is always a losing game. The wildness that we have set as our task to protect is finite, but the appetite of the developers is infinite. They never retreat, they only shift their place of attack and with tireless determination seek to control all that remains of unexploited wild lands."[29] Litton managed to get a narrow majority to vote to withdraw support and begin fighting against Diablo Canyon, and Porter's stand on it was his highest-profile act during his six years on the board. (The Club lost the Diablo fight, and by the 1980s the antinuclear movement had taken over the job of protesting the nuclear power plant there, which was built with many cost overruns, huge errors, and unanswered questions about safety.)

At least since the battle over Hetch-Hetchy early in the twentieth century, the Sierra Club had had a lot of internal dissent about tactics and mission, but the sixties battles were far more heated than their predecessors. Like the controversy over Diablo Canyon, the controversy over the publications program threatened to tear the Club apart in the late 1960s. Porter was later accused by conservative board member Alex Hildebrand of conflict of interest for voting to support the lavish publications program, a charge which Porter vehemently denied.[30] Brower, Porter, and some of the others on the board saw the publications as having far-reaching, if indirect, effects in promoting environmental awareness and raising the Club's profile. Others thought the program—particularly the picture books—a drain of time and money, and they felt that publications should be far more closely tied to specific campaigns and specifically endangered American places. Adams—who had mixed feelings about color photography anyway—was opposed to the lavishness and political indirectness of the publications program and to David Brower's direction in those years.[31] Porter's Galápagos book, which he had been thinking about since the early 1960s, joined Diablo as one of the conflicts that came to a head in 1968. "There was a great deal of opposition to the proposal within the board of directors," recalled Porter of the Galápagos project, "on the grounds that the islands were outside the continental United States, which, it was felt, put them outside the legitimate conservation concerns of the club [sic]; so the idea was rejected."[32] Then-President Edgar Wayburn argued, "other projects have higher conservation priority; for example a Mount McKinley book could make or break a great national park."[33]

Porter shared Brower's sense that the Club and the American conservation movement should expand to begin working globally, and he was passionate about the threats to the islands' unique species and ecosystem (fig.17). Brower reintroduced the project more successfully later, and "the publications committee of the Sierra Club had at last agreed to finance an expedition to the Galápagos Islands. Before it left, our party reached an almost unimaginable size."[34] Porter's son and daughter-in-law, along with Brower and his son Kenneth, had joined the expedition with several other parties playing roles of varying necessity. Growing impatient with the continual delays, Porter in 1966 approached Harper and Row about publishing the book, but it remained with the Sierra Club and grew into an unwieldy two-volume set, so that publication costs, like the expense of the expedition, became enormous. By 1968, as Cohen recounts, "Adams argued that Brower would not accept a position subordinate to the Club and demonstrated his thesis by detailing what he called the 'Galápagos Book venture,' wherein Brower

(*fig. 25*) Ferry, Chongqing, Sichuan, China, summer 1980

flagrantly disregarded decisions of the Publications and Executive committees."[35] Brower's waywardness pleased no one. As Porter recalled, "During a board meeting at the Sierra Club camp in 1968, Brower proudly presented me with the first copy off the press of *Galápagos: The Flow of Wildness* . . . My initial delight was soon dampened, however, by the discovery that my name appeared nowhere on either volume other than as photographer. . . . When I asked Brower why my name was not on either volume, he said it was because there were so many contributors that no one could be named. I was so shaken and speechless I left the meeting."[36] Despite this omission, reviewers and readers recognized it as Porter's book.

Porter would vote to keep Brower on the board of directors anyway, but the vote was ten to five against, and Brower left the job—though not the Club—in 1969. He founded Friends of the Earth and continued working to protect wilderness, nationally and globally. Porter served out his second term but, to his combined relief and chagrin, was not nominated to a third. He continued to support the Club's objectives and served on the New Mexico Nature Conservancy board and on the Chairman's Council of the Natural Resources Defense Council, gave images as donations and for reproduction to environmental organizations (and Planned Parenthood), and continued to donate money to a wide variety of causes. His books continued to be published, primarily by E. P. Dutton, which in 1972 finally put out the bird book that had prompted him to take up color photography more than thirty years earlier.

Porter himself roamed farther afield, completing books on Antarctica, Iceland, Egypt, Greece, Africa (with Peter Matthiessen) and China, as well as continuing to photograph North American places and phenomena. Many of the images made abroad incorporated evidence of human culture and portrayed human beings, as the American work generally did not (figs. 25 and 26). Perhaps it is that people were integrated into their landscapes in those places in a way they seldom are in the restless, rootless United States (though that process of integration has created some of the world's oldest environmental degradation in overgrazed Greece and topsoil-exhausted China). The African and Antarctica books were particularly concerned with environmental issues, though questions of extinction and habitat were present in most. From a modest initial definition of nature as birds and details of the New England landscape, Porter's photography grew into a global picture of natural systems and human participation—often benign—in those systems. His work evolved as the environmental movement did, from protecting particular species and places to rethinking the human place in the world, a world reimagined as an entity of interconnected systems rather than one of discrete objects.

(*fig. 26*) Abandoned farm, South Coast, Iceland, August 3, 1972

Porter remained a scientist as well as an environmentalist. When James Gleick's book, *Chaos: Making a New Science* was published in 1987, Porter read it with excitement and, with the help of his assistant Janet Russek, organized his own book around its themes, for which Gleick wrote an introduction. Porter was struck by the way the new scientific ideas seemed to describe nature as he had been attempting to describe it with his camera—for chaos theory might more accurately be called complexity theory: it describes the intricate patterns, interpenetrations, and repercussions of natural processes. For this last book, *Nature's Chaos*, which would be published posthumously in 1990, he collected existing images that suggested patterning and conjunctions of forces that overlapped and affected one another. In some ways these had always been his themes.

AN ECOLOGICAL AESTHETIC

Perhaps the central question about Porter's work is about the relationships between science, aesthetics, and environmental politics—about what an environmental aesthetic might be and to what extent Porter succeeded in creating one. His brother, the painter and critic Fairfield Porter, wrote in a 1960 review of the color photographs: "There is no subject and background, every corner is alive,"[37] suggesting what an ecological aesthetic might look like. The description prefigures Barry Commoner's 1971 declaration of the first principle of ecology, "Everything is connected to everything else," which ecofeminist Carolyn Merchant revised in 1981 as "All parts of a system have equal value." Merchant expanded, "Ecology assigns equal importance to all organic and inorganic components in the structure of an ecosystem. Healthy air, water, and soil—the abiotic components of the system—are as essential as the entire diverse range of biotic parts—plants, animals, and bacteria and fungi. Without each element in the structure, the system as a whole cannot function properly." A century before, John Muir had said the same thing with less science: "When we try to pick out anything in the universe, we find it connected to everything else."[38] Porter's most distinctive compositions are the close-ups in which the frame is filled with life and with stuff. Rather than portraits that isolate a single phenomenon, they are samples from the web of interrelated phenomena.

This close-up scale emphasizes the ordinary over the extraordinary. Plate 17 in *The Place No One Knew* is titled *Near Balanced Rock Canyon* (fig. 27), and Balanced Rock is a landmark, an outstanding and unusual feature of the landscape visible from a distance. But Porter's medium close-up shows large river-rounded rocks on a rock surface, the small rocks mostly grayish, the bedrock on which they lie more yellow—a quotidian scene near the unseen, exceptional one. Of course, this image was made to be viewed in the context of other, more spectacular images of Glen Canyon, and this serial approach changes the expectations for each photograph: they need not all be prima ballerinas, each straining for the spectacular, but together form a corps de ballet. But *Near Balanced Rock Canyon* also suggests that ordinary rocks are important enough, that we can love a place for its blackberries or its stream ripples, not just for its peaks, waterfalls, or charismatic macrofauna. All parts have equal value. These images make it clear why Porter was willing to fight for Diablo Canyon, a beautiful, pristine, but unexceptional landscape. In the exceptional places, Porter often homed in on the details. He wrote one of his sons, "I would like to go back to Death Valley sometime soon to photograph the details as well as the bigness of it. For me the dead seed stalks and whitened leaves of the plants that grew up quickly during the short rainy periods are as interesting as the erosions of rock and clay."[39] He wrote of what he saw aboard a ship sailing the open seas to Antarctica, "The monotony was only superficial, for each day was different from all that preceded it in many subtle variations of sea and sky—the colors of the waves and clouds, of the birds and the flying fish, and of the sequence of events. The variations engrossed my attention from dawn to dark."[40]

Porter came near to stating a credo when he wrote, "Much is missed if we have eyes only for the bright colors. Nature should be viewed without distinction. . . . She makes no choice herself; everything that happens has equal significance. Nothing can be dispensed with. This is a common mistake that many people make: they think that half of nature can be destroyed—the uncomfortable half—while still retaining the acceptable and the pleasing side."[41] This is what Merchant means by "All parts of a system have equal value," and Porter came of age artistically while a radical shift was taking place in the way Americans understood and managed nature. In the late-nineteenth through the mid-twentieth centuries, for example, predators were often depicted as "nuisance species" to be eradicated so that the useful species—game and domestic animals—might flourish. Aldo Leopold came out of this tradition and did an about-face in the thirties. One influence was the infamous Kaibab Plateau incident, in which the deer population, once humans had eliminated its predators, skyrocketed to twenty times its normal level, defoliated the region, and died of starvation en masse. Another was Leopold's encounter with a wolf he had shot: "I thought that because fewer wolves meant more deer, that no wolves would mean hunters' paradise. But after seeing the green fire die [from the wolf's eyes], I sensed that neither the wolf nor the mountain agreed with such a view."[42] In his final credo, "The Land Ethic," Leopold wrote, "It is only in recent years that we hear the more honest argument that predators are members of the community, and that no special interest has the right to exterminate them for the sake of a benefit, real or fancied, to itself."[43] Conservationists were evolving into ecologists as they came to understand that it was impossible to preserve a species or place apart from the complex systems of which they were part. In his overall pictures, Porter comes as close as any artist has to portraying ecology.

"Every corner is alive" suggests another important aspect of Porter's characteristic close-ups. Landscape photography generally depicts open space, usually defined by a horizon line, with the camera looking forward, much as a standing or striding human being might. It depicts, most often, an anthropomorphic space—anthropomorphic because its central subject is space, space that can be entered, at least in imagination. Moreover, it often shows things at such a distance that the entities themselves—the grass or trees or rocks—cannot be subjects, only compositional elements. The implication of many classic landscape photographs (and the paintings from which they derive) is that such space is essentially empty, waiting to be inhabited. This approach follows the evolution of landscape painting itself out of anthropocentric painting: the banditti or the Madonna got smaller, and the landscape behind the drama grew more complex, until eventually the actors left the stage. But the landscape was still composed as scenery, a backdrop, a description of habitable space. Porter, by contrast, often photographed flat surfaces up close—the surface of the earth, a stone or a tree trunk—and subtle tonal ranges. He looked directly at his subject, which was matter itself, rather than across

or through it to space. There is very little empty space in his images, and thus little or no room in which to place oneself imaginatively. The scale is not theatrical, or at least not anthropocentrically so. He once remarked, "Don't include the sky in the picture unless the sky has something to say," which seems to propose that the sky be a subject in its own right, rather than a provider of orienting horizon lines and habitable space above the surface of the earth.[44] His extensive series of cloud photographs bear out this notion, suggesting that clouds should be seen as autonomous scientific and aesthetic phenomena, rather than as part of a landscape scene. In fact, there are very few "scenes" in Porter's work. If the image is not a close-up, the camera may be tilted down or up to show things on their own terms, rather than as background to habitable space. Porter's favorite straight-ahead view depicts an impenetrable thicket of saplings, as in *Red osier, near Great Barrington, Massachusetts* (page 15). Where landscape photography has an empty center, in Porter's work nature itself fills that center, whether with leaves, stones, creatures, or clouds. Nature, not man, is the true inhabitant of Porter's places. This is not landscape photography, but nature photography, a wholly new genre Porter founded. If it has an ancestor, that ancestor is still-life painting and photography, though before Adams and Porter still-life subject matter was nearly always domestic items indoors, stuff that could be set up for the studio easel or camera—fruit, flowers, household objects, instruments, food—not wild stuff in its own place for its own sake.

(*fig. 27*) Near Balanced Rock Canyon, Glen Canyon, Utah, September 6, 1962

Something else is at play in many of these images: a passion for process. *Rose petals on beach, Great Spruce Head Island, Maine,* for example, seems at first about the visual pleasures of pink petals and slate-blue mussel shells, but it also contains the story of the tide that washed the shells ashore and the wind that blew the petals onto the beach, of the mortality of flowers and mollusks, of the overlapping of all these forces to make this small window into a large world not just of objects but of systems (page 33). An image titled *Hepaticas, near Sheffield, Massachusetts,* depicts the flowers named in the title, but it is the contrast of the three delicate lilac-colored flowers that have pushed up through grayish fallen leaves that makes the picture work both aesthetically and ecologically—it seems to show spring surging up amid the remains of fall, generation amid decay, the cycle of the year. As Caponigro notes, Porter was as motivated by ecological as by aesthetic aspects of a phenomenon. It may be that Porter appreciated lichen so much not only because it had wonderful color range and texture, but because it represented a unique symbiosis between a fungus and a mold, making its home on the seemingly inhospitable faces of rocks. Many of his pictures are meeting grounds between various forces and beings.

When Fairfield Porter wrote that "there is no foreground and background," he was probably less interested in ecological issues than in compositional ones. Fairfield Porter was a painter, as was Eliot Porter's wife Aline—and Aline Porter was a close friend of Betty Parsons, doyenne of the New York School of painting. It seems likely that, in the absence of a color photographic tradition to learn from, Porter learned from painting, and the painting of the 1940s and 1950s was mostly abstract. In his flat-to-the-picture-plane images, Porter seems to have learned from abstract expressionism, and some of his pictures are

(*fig. 28*) Lichens on beech at Hemlock Hall, Blue Mountain Lake, Adirondack Mountains, New York, May 17, 1964

impossible to look at without believing he was influenced by the movement (fig. 28). Abstract expressionism likewise emphasized what in Jackson Pollock's work was sometimes called "all-overness" and in the others' later on, "color-field painting." The painter Valerie Cohen suggests (in an e-mail to the essayist) that his ties are to earlier twentieth-century painters: "Porter's close-ups, and especially his flattening of space, follow developments in European and American painting (Milton Avery, Pierre Bonnard, Arthur Dove, Henri Matisse)." His photographs of birds and animals are an exception to Fairfield Porter's "no subject and background" observation. With the bird pictures Porter wanted a clear, useful image of each species—quite a different demand from the one he placed on images of flora. With the animals isolated in front of their surroundings, they serve as true portraits: the creature becomes the center of attention, and everything else becomes background, just as it does in, say, a Gainsborough portrait of a society beauty backed by feathery trees and verdure. (Of course, in both a Gainsborough and a Porter, the background is an important source of context as well as an aesthetic concern.) Elsewhere Porter's compositions show the strong influence of the great modernist photographers, though he adapted their lessons to color and to a very different kind of involvement with his subject. Porter rejected much of high modernism's philosophy in the way he tied his work to science, politics, and literature, but he never quarreled with its strategies or aesthetics.

Though childlike wonder has a role in Porter's work, so does dispassionate scientific observation, and the clarity and convincing color of many of his images convey a coolly objective view—perhaps not objective in the true sense, but with objectivity as an aesthetic and an ideal. Porter's personality—reserved, attentive, principled—comes across more in this withholding of drama and the personal than in any other aspect of his work save, perhaps, his choice of subjects and his deployment of those subjects for political purposes. In the 1980s, the editor and art critic William Peterson reflected, "The first photographic book I ever bought was Porter's *In Wildness*. . . . Now that I am older and more snobbish about art, I still find pleasure in Porter's prints, but their glassy beauty leaves me somewhat unsatisfied. They seem strangely cold to me, as if the world were caught in an ice crystal and preserved in glistening and over-sharp detail. Despite the close-up intimacy of many of the views, nature remains distant and the view feels somehow disembodied, as if they were sent back from a beautiful and remote planet where they were observed by some extremely sensitive surveillance device. Perhaps this distance is a measure of Porter's respect for the world and his wish to have it conserved in a pure state without marks of intervention, including his own. But, perhaps this is also the lesson—that nature truly is indifferent, independent, and autonomous."[45]

WILDERNESS AND STRATEGY

The golden age of the Sierra Club publication program can be seen to parallel the golden age of American landscape painting in the second half of the nineteenth century, when the American West was celebrated in paintings by Albert Bierstadt, Frederick Church, and Thomas Moran and photographs by Carleton Watkins, Eadweard Muybridge, William Henry Jackson, and others. In that time, it was the

West that was terra incognita to the majority; in the 1960s it was the remaining remote places, east and west. Both were eras in which the American public discovered their terrain through artistic representation, and in both cases American landscape was seen as the stage onto which no actors had yet entered, virgin wilderness before the first taint of civilization. Thomas Cole had written, "the most distinctive and perhaps the most impressive characteristic of American scenery is its wildness. It is the most distinctive, because in civilized Europe, the primitive features of scenery have long since been destroyed or modified. . . . "[46] For Cole the American landscape was a stage on which the principal acts had yet to take place, and this idea of wilderness as a place as yet affected by nothing but natural forces has been powerful ever since. Wilderness, as Wallace Stegner wrote of it in 1960 in the letter that coined the term "the geography of hope," meant a place apart from civilization, a place where humans had not yet and should not arrive on stage. Since that era, much has been written to revise this idea, most significantly by acknowledging that Native Americans spent millennia in places Euro-Americans dubbed "virginal," and that the supposed pristine quality of those places had been much affected by the Native presence—and sometimes damaged by their absence.[47] Out of the imagination of wilderness and the ignorance of indigenous presence came a false dichotomy: a wholly nonhuman nature and a wholly unnatural humanity. The latter was seen as a threat, meaning the former had to be protected as a place apart. Historian William Cronon writes, "The critique of modernity that is one of environmentalism's most important contributions to the moral and political discourse of our time more often than not appeals, explicitly or implicitly, to wilderness as the standard against which to measure the failings of our human world. Wilderness is the natural, unfallen antithesis of an unnatural civilization that has lost its soul."[48] Now that the critique of modernity is accomplished, we have entered upon the critique of wilderness—not of places themselves, but of the way they are imagined, described, and administrated.

One of the ironies of Porter's career is that he did much to give "the wilderness idea" a face, but that face exists not so much in the images he made as in the way people perceive them. *In Wildness* was seen—and successfully deployed—as a defense of wilderness. In their thank-you notes for the book most of the congressmen and senators to whom Brower had sent it called it "In Wilderness." In fact, most of the phenomena it portrays might readily be seen on the fringes of civilization—by a small-town New England schoolchild taking a detour through the woods on the way home, for example, or by Thoreau on the outskirts of long-settled Concord. The creatures are small—caterpillars, moths, songbirds; the bodies of water are brooks, not rivers; the trees are maples, not bristlecones. Guy Davenport commented, "Thoreau was shy before the grandiose and obvious. He looked beside his shoe for nature, at the bottom of creeks, deep into tall grass."[49] Porter himself recalled of his childhood near Chicago, "My unexplored and untamed West was the Skokie marsh."[50] The photographs could equally have been used to justify development, in that the flora and fauna they show could and do survive on the fringes of developed areas. In 1962, simply depicting the quiet splendors of the natural world was a powerful argument, in part because it had never been made as Porter made it. Success would wear out this argument's impact, setting a different task for a later generation of environmentally concerned photographers.

There are no human traces in *The Place No One Knew*, though the region abounds in petroglyphs and ruins and is partially within the huge Navajo reservation. Rainbow Bridge, which the Sierra Club defended as a great natural phenomenon whose setting would be damaged by Glen Canyon, has more recently been fought for as a sacred site by five Indian tribes in the area. But the book seems to postulate Glen Canyon as an untouched place and the dam as the first, devastating human trace that would be left on it. Now, wilderness can be seen as a useful fiction, a fiction constructed by John Muir and his heirs and deployed to keep places from being destroyed by resource extraction and wholesale development. In more recent years, it has become equally valuable to understand the ways that human presences can do other than destroy, the way wild places can be a homeland, rather than an exotic other. The wilderness idea may be peculiar to an immigrant industrial society. Porter and most of us have no trouble seeing traditional peasant and indigenous cultures, with their biodegradable, bioregional, often handmade artifacts, as part of their landscape, and in his Baja book Porter depicted a few religious sites amid the plants and rocks (and focused on Mexican churches in another book). Among one of Porter's most memorable later images is one of an apple tree, leafless, bearing withered golden fruit, on his prop-

erty in Tesuque, New Mexico—an image of nature, but hardly of wilderness. As he got older and went farther afield, more and more human traces began to appear: in his Iceland book, for example, there are abandoned houses nestled into their treeless slopes and weathered by the same forces as their surroundings. In Egypt and Greece, the stone buildings are treated much as the stone of Glen Canyon was—if Glen Canyon's nature was seen as art, this art is seen as nature in its materials, its erosion, its sense of place. One could argue that excluding human traces from Glen Canyon was necessary to present nature itself as art, so that Glen Canyon becomes a gallery being drowned; thus Brower was able to compare it to the Sistine Chapel—a very different argument from, say, proposing it as habitat. In China, people appeared as part of the place, and the majority of the photographs show people. How to show contemporary Americans as part of their landscape is a problem that subsequent generations took on: one could almost trace a lineage from the discordance of tourists, nudists, and developers in the 1960s and 1970s to more recent photographs—by Barbara Bosworth, Mark Klett, and Robert Dawson, among others—that show more complex, ambiguous, and sometimes even symbiotic relationships with the land.

Though he was often concerned with documenting diversity or the more endangered phenomena, Porter's selections did not always please fellow environmentalists. In a 1965 letter to Porter about the artist's Adirondacks project, George Marshall asserted, "What has troubled me is that few of them seem to represent or symbolize what seem to me to be the major characteristics of the Adirondacks which have made them for many of us a region unsurpassed in beauty. These unique characteristics are to be found, I believe, in its so-called High Peaks, its other mountains in places, its large lakes and ponds, its sphagnum marshes . . . and first growth forests. . . . Some of this is represented in your photographs, but frankly, as I recall them, very little." And to David Brower he wrote, "Most of the photographs as I recall them are of second growth forests which have been burnt or lumbered. I feel little in this book as it now stands . . . justifies the title 'Forever Wild.'"[51] That they represented the consequences of logging rather than of forest succession is evident only to the ecologically knowledgeable; human traces are not always so visible as petroglyphs or pavement. The same second-growth forests had been shown in *Wildness*; perhaps it was because the new photographs were meant as a portrait of a specific place, rather than a generalized evocation, that such details mattered. Marshall seems to think that the second-growth trees should have been left out or been photographed as something other than beautiful, since they represented something other than an ecosystem in its ideal state. Marshall raises the enduring conflict of environmental photography: that what is ecologically good is not necessarily beautiful, and vice-versa. For Porter, when art and nature came into conflict, art usually won out. His pictures were not always dispassionate surveys; he was motivated by what was worth looking at as well as by what was ecologically important.

Marshall wanted a more Ansel Adams treatment, with more majesty, more unusual features, less celebration of the quotidian. But Porter found the young trees beautiful, so he photographed them. The work of Ansel Adams and Eliot Porter generates instructive comparisons on many grounds: the two were nearly the same age, crossed paths both as artists and as activists, and became perhaps the most famous American photographers of the second half of the twentieth century (though Adams's reputation has not faded as Porter's has). The differences are obvious: Adams was a successful, confident artist in an established medium while Porter was still experimenting in relative isolation; Adams was ensconced in both artistic and environmental communities as Porter was not; Adams's work, with its taste for grandeur and spectacle, has ties to the great Western landscape photography of the nineteenth century, while Porter was exploring the new medium of dye transfer color photography as both a technical medium and a compositional challenge, echoing new developments in painting. Like Porter, Adams has suffered from becoming famous for a portion of his work now thought of as the whole: as the Yankee is to pristine close-ups, so the Californian is to majestic views, though he also made portraits and many close-up photographs of flora and other natural details, as well as series about entirely different subjects. Still, Adams did make the definitive majority of his pictures in the classic landscape-photographic tradition, emphasizing deep space, strong contrast, dramatic light, and crisp delineation—the near-sculptural qualities black-and-white was suited to portray—while Porter often flattened out a subject and sought a painterly subtlety of color range. Adams's pictures often depend on the drama of

(*fig. 29*) One of Scott's dogs,
Cape Evans, Ross Island,
Antarctica, winter 1975–1976

a revelatory light that appears almost divine, while Porter preferred cloudy days to make images that speak of slow, careful attention. Adams would usually photograph the balancing rock of Balancing Rock Canyon, while Porter would usually ignore it. Adams's work locates itself through landmarks—Half Dome, the Grand Tetons—while Porter's does so through representative specimens—the sandstone of the Southwest, the warblers of the Midwest, the maple leaves of New England. Another way to describe the difference between them is as the difference between the environmentalist and the conservationist. As a conservationist, Adams prized the most spectacular and unique aspects of a place; as an environmentalist, Porter focused on the representative and quotidian aspects even of the most exotic places he went. With Adams's monumental scenes, viewers at least felt they were remote from civilization (though cropping out the people and infrastructure in Yosemite Valley must have been a challenge at times); with Porter they could be a few feet from it—his close-ups might speak of an intact natural order, but not necessarily of an unviolated wilderness space.

Porter had his own restrictions about what should be represented and what should be found beautiful. In 1977, he saw the fashion and wildlife photographer Peter Beard's exhibition of African images, *The End of the Game*, at the International Center for Photography (ICP). Beard took a radically non-modernist tack in his book of the same name, writing on photographs, using his own work together with older images, and collaging them scrapbook-style with other material in the style of Victorian travel journals. Porter, who brought the Victorian texts of Thoreau together with his own images, could conceivably have been sympathetic, but he exclaimed in a letter that the project "was supposed to influence people for conservation but played to morbid curiosity and violence. It memorialized killing and death with dead animals, dying animals, a half eaten human body, and 100 elephant carcasses."[52] Porter had gone to the ICP to discuss an exhibition of his Antarctic photographs, which also included dead animals—dogs lost to the elements, seals that had become stranded and died inland, then been mummified and partially flayed by the arid winds (fig. 29). But Beard's images were not so gracious: elephants dying in a tropical zone were a far messier business, and he attempted to suggest the sheer scope of the disaster with copious images of elephant herds, corpses, and skeletons. He intended to shock and hoped to change minds by doing so. The huge die-off had been caused by an elephant population explosion that denuded the landscape. Ultimately, it was caused by unnatural game-protection laws born out of European-American ideas about wilderness as a place apart from humans (echoing the mistakes made by American game management in the Kaibab Plateau decades earlier).

Beard's work had little relationship to other nature and environmental photography, but much to both fashion and war photography—fashion in its flamboyant sense of design and drama, war in its sense of a crucial historical moment. It could be said that Porter photographed uneventful cyclical time, Adams an almost Biblical sense of revelatory time-suspension, and Beard the turbulent time of the news. Elsewhere Porter had argued that photography "almost always unintentionally softens rather than exaggerates the unpleasant aspects of the conditions it attempts to dramatize most forcefully. The same is true when photography is used to show the devastations produced by man's works. The utter desolation visible on the scene of operation is almost impossible to reveal in photographs."[53] While with Beard he argued that the photographs were not softened at all, but sensationalistic, the same principle remains— that photography can make the most reprehensible things fascinating, even pleasant, to behold. This assertion justified Porter's own strategy of showing what can be saved and what remains intact, rather than what has been ravaged; of photographing nature as existing in cyclical time rather than in history (though looming catastrophe had been the unseen subject of *The Place No One Knew*).

Porter and Adams functioned in a unique way at a unique time: their aesthetic work had a kind of political impact that is hard to imagine in any other arena. Even those who were not great supporters of the publications program of the Sierra Club acknowledged that it was the books—particularly the photographic books, and among those particularly Porter's—that first made the Sierra Club a visible force nationwide. It was a rare historical moment when art could achieve such profound political ends, when the mere sight of such images was a powerful motivating force, when a pair of artists admired in museum circles could do heroic work in environmental ones. No artist can ask for more than to live in a time when art can change the world.

LEGACY

Today's respected landscape photographers are making very different work, and few of them have the role within environmental organizations or the broad popular success Porter enjoyed. The terrain has changed. Almost two decades after *"In Wildness Is the Preservation of the World,"* the landscape photographer Robert Adams wrote, "More people currently know the appearance of Yosemite Valley and the Grand Canyon from having looked at photographic books than from having been to the places themselves; conservation publishing has defined for most of us the outstanding features of the American wilderness. Unfortunately, by perhaps an inevitable extension, the same spectacular pictures have also been widely accepted as a definition of nature, and the implication has been circulated that what is not wild is not natural. The extensive publishing of wilderness photographs by conservation organizations began in the mid-1950s, at the time of the struggle to save the canyons in Dinosaur National Monument. I remember the desperation of those who hoped to rescue that wilderness. . . . How were enough people to be informed of what they were about to lose? Photographs—the more extraordinary the better, because the place itself is so remarkable—were the logical answer. There are now far fewer unpublicized wilderness areas, and there are relatively few converts, with the exception of children, left to be won to the general idea of wilderness preservation." Adams argues here that the same images mean different things at different points in history. By this time, the popular imagination had reached a point where such imagery had achieved what success it could; a new generation of photographers ought instead to "teach us to love even vacant lots out of the same sense of wholeness that has inspired the wilderness photographers of the past twenty-five years."[54]

Of course it can be argued that Porter photographed backyards, if not vacant lots, along with people, ruins, and signs of rural life from Maine to Mexico, but this Adams has a point. Whatever images Porter made, the ones that proved most memorable and influential were of a pristine nature, a place apart. Though Porter's pictures may have been primarily of the timeless seasonal world of natural phenomena, they were subject to the passage of historical time, and their influence, even their appearance, has changed over the decades. Later in his career, Porter himself came to believe that his photographs were as likely to send hordes of tourists to an area as to send hordes of letters to Congress in defense of that area, countering Fox's argument that the books could substitute for visits to wilderness. Far more Americans had become familiar with the remote parts of the country, and recreational overuse as well as resource extraction and development threatened to disturb the pristine places. It may be precisely

because of Porter's spectacular success in promoting American awareness and appreciation for remote and pristine places that a different message may now be called for.

This invisible success is counterbalanced by a very visible one: thousands of professionals and countless amateurs now produce color nature photography more or less in the genre first delineated by Porter. Their work is not quite like his. For the most part, Porter seemed to value truth more and beauty—at least showy, bright beauty—less. He was concerned more with representing processes, systems, and connections than many of his followers. He often made photographs of reduced tonal range, and some of his images of bare trees in snow are not immediately recognizable as being in color: "Much is missed if we have eyes only for the bright colors."[55] The contemporary nature photography seen in calendars and advertisements tends to pump up the colors and portray a nature far more flawless and untouched than anything Porter found decades earlier (though the best defense for such images is that some of them continue to raise money for environmental causes). Their work tends to crop out anything flawed and to isolate a perfect bloom, a perfect bird, a perfect icicle, in compositions usually simpler than Porter's. Looking at these images, one has the sense that the genre Porter founded has become narrower rather than broader. Porter photographed dead animals and mating Galapagos turtles, but Barry Lopez, who himself once photographed animals, writes, "in the 1970s came, ironically, a more and more dazzling presentation of those creatures in incomplete and prejudicial ways. Photo editors made them look not like what they were but the way editors wanted them to appear—well-groomed, appropriate to stereotype, and living safely apart from the machinations of human enterprise."[56] A kind of inflationary process has raised the level of purity, of brightness, of showiness each image must have. Some of this may be about the continued evolution of technologies; with improvements in film and cameras and innovations like Photoshop, a greater degree of technical perfection is possible now than in Porter's time. And images that were relatively original in his work have now become staples, even clichés.

The thing least like an original is an imitation; the two look alike, but they are not akin at all in their function in the world. Porter's work is innovative, responding imaginatively to a new medium and the new way of representing the world that this medium made possible. Imitating Porter is not responding to the world but to a now-established definition of it. As the decades go by, these images tend to look more and more like each other and less and less like what we actually see most of the time when we go to natural places. The photographers who follow Porter most closely in their compositional innovations and their definitions of nature, the human place in it, and the role of photography in the preservation of the world may be those whose work looks least like his. They make work that responds to their time and their outdoor encounters with the same imaginative integrity as Porter did to his. Porter's primary legacy may not be photographic, but something far more pervasive: a transformation of what we see and what we pay attention to.

*The details of nature become more interesting,
and they become more beautiful too, as
one becomes more aware of them.* —E. P.

A MEMOIR
OF MY FATHER

JONATHAN PORTER

For the last week here in Okeechobee I have been photographing herons in a slough on the prairie. . . . These [sloughs] are favorite places for herons to build their nests in colonies probably because they are relatively safe from predators. Usually several kinds of herons get together to form these colonies. Not every slough becomes a heronry but those that do also team with other kinds of life. There will be alligators, water snakes, poisonous water moccasins, frogs and fish. There will also be other birds such as rails and gallinules. In the slough where I spent a week photographing there were five kinds of herons of which I took pictures of four. There were at least three alligators and probably more. And there were many moccasins. Since there was no dry land in this slough my blind stood in the water and I sat on two half submerged boxes. One time when I moved the blind to a new location a beautiful young water moccasin marked in rich browns swam out from under my seat when I lifted it up. In a place like this every living thing is out for itself and will eat the others if he can. Alligators eat everything. Snakes eat frogs and fish and the herons eat frogs and fish too but will peck one another to death when there is trespassing. Young birds especially get badly pecked by their elders when they don't watch out.

This letter from my father, written to me in May 1954, reflects the keen, observant style of a naturalist. He occasionally feared that I might become bored by his careful descriptions in his letters to me, but whether or not his intention was to teach, I was greatly influenced by his attitude toward nature.

"Naturalist" is a rather old-fashioned term now, evoking an image of a nineteenth-century amateur scientist. It resonates with the even earlier image of the natural philosopher. The term has been replaced by the more modern-sounding and politically charged "environmentalist" or "conservationist." But Eliot was above all a naturalist in the sense that his interest and fascination was with nature in its primordial sense—the natural world apart from the human world. He was interested in nature not as a philosophical construction, but in all its wonderful variety and detail. This fascination served him his entire life—everything else he did was incidental.

Although Eliot's fascination with natural history began with his discoveries of natural life around his boyhood home, it soon focused on birds, and, in my view, birds remained the core of my father's attachment to the natural world. He was always listening for their songs and looking for their nests. He took great satisfaction in finding them out, observing their behavior, enjoying their company. From Arizona, where he was photographing birds in May 1958, he wrote, "I have had a lot of luck this time finding nests: 10 hummingbirds, 8 Lucy's warblers, 4 vermillion flycatchers, 3 Arizona vireos, 2 Scott's orioles and many other common ones that I am not particularly interested in." Early on, photography became a way of capturing birds figuratively, at first in black-and-white, later in color. While his bird photographs reflected his most intimate feelings for nature, Eliot's affinity for birds transcended his photography. Later in life, as he was being overtaken by Lou Gehrig's disease (ALS), he complained that he could no longer hear the songs of birds. Soon, he was deprived of his mobility and also his ability to operate his camera. In an undated written statement discovered after his death, he wrote about suffering from the degenerative, fatal disease:

The winter birds that had been feeding on the seeds that I put out for them drifted north to their breeding grounds and were replaced by other species from the tropics whose warbling high-pitched songs I now only faintly hear. In past years I would have been out early to discover the secrets of

their domestic activities, and, although photographing birds has not been a principal occupation for many years, I would have discovered many of their nests.

My father's naturalist's curiosity extended from birds to plants, insects, and animals of every kind. All of these became subjects of his photography at one time or another. He went to elaborate lengths to photograph birds, including using blinds, scaffolds, strobe lights, and electric eyes to trigger the camera shutter. Equally challenging in a technical sense was his curiosity about insects, subjects he devised ingenious ways to photograph. He kept insects in terrariums and small cages in his studio, which was sometimes filled with thousands of baby black widow spiders or orb-weaving spiders—escaped hatchlings from egg cases left by the adults he had brought inside to observe. My father was always amused by this. Curious about the variety of life he found in a bird bath, he once made a tiny aquarium from microscope slides in order to photograph mosquito larvae hatching. Attempting to capture a picture of a grasshopper as it launched into flight was an extension of photographing hummingbirds or barn swallows in flight. The technical challenge was as exciting as any result he might achieve.

For any naturalist, there is an abiding temptation to bring the wild inside. But this impulse, even when born of compassion, is risky and oftentimes has sad consequences. Eliot once found a yellow-crowned kinglet in the snow where it had fallen, temporarily stunned, after hitting his studio window. He brought it inside the greenhouse, where it revived and began singing. But fearing for its fate in the winter climate, Eliot kept the bird inside too long, and it dashed itself against the window and died.

When my brothers and I were growing up in Tesuque, New Mexico, we had a blue jay that Eliot took from the nest as a baby and raised as a free-flying pet. It was very tame before it finally went wild and disappeared (or, more ominously—being fearless of any danger—it perhaps fell prey to a hawk). The jay was equally curious about people, poking seeds and small, found objects into one's ear as it sat perched on a shoulder. We kept snakes and lizards, often for several years at a time. I had a bull snake for many years. One summer we took it to our island in Maine, where it promptly escaped. Eliot thought that the alien, northern climate would be the end of it, but at the end of the summer, just before we left, we found it again, fat from the small animals it had found in the woods.

Eliot's commitment to conservation and environmentalism came from his proclivities as a naturalist, but it became more focused over time. The preservation of nature was a radical imperative for him, involving no compromise with human intervention, especially, of course, any kind of development or "improvement." Wildness itself possesses a spirituality upon which, he believed, humankind's welfare depended. "It is generally becoming recognized," he wrote in a letter to my brother Patrick in 1961, "that the happiness of people requires that they be able to live lives during which they can from time to time escape from civilization by going to remote, untouched primitive areas, and so these primitive areas must be set aside and maintained for them. In these areas there will be no roads, no automobiles, no hotels, no lumbering or mining."

Although wildness must be preserved for the sake of the human spirit, paradoxically humankind's approach to nature imperils this goal. To get close to nature, one has to have access to wild areas, which is bound to have negative consequences. Eliot was scornful of any developments, such as good roads, paths, campgrounds, or other amenities that made nature more accessible to the casual visitor who might be unwilling to make the effort to approach nature in the least intrusive way. On camping trips that my brothers and I took with him, we usually sought out the least developed camping sites and deplored the strange penchant of campers to gravitate to each other. Access to nature should be for the intrepid, demanding a physical effort that was a token of one's commitment to limiting the human impact to the irreducible minimum. The rather elitist implications of this wilderness ethic, one that perhaps reflected Eliot's own needs more than those of the general public, never seemed to bother him in the least.

Hunting, needless to say, was anathema to Eliot, and he had no sympathy for the viewpoint that hunters are conservationists at heart and potential allies in the environmental movement. An account he once read in a magazine about a man from Texas who, on a ten thousand dollar bet, killed an elephant with a bow and arrow enraged him. In a letter to me he wrote: "The man is supposed to be a nature lover, but his love for the elephant he killed was limited to the tail which he cut off in order to prove he had killed it. . . . For an adult man to do [this] is disgusting. How can the elephant's tail or

the dubious glory or the ten thousand dollars pay for the magnificence of a living elephant. I suppose it is too much to expect men not to kill elephants for fun when they continue to kill one another for little better reasons. Love seems to have become lost somewhere, but I send you mine."

Eliot was trained as a scientist, and even after he abandoned biochemistry as a profession to pursue photography full time, he never ceased to be a scientist. He had acquired much of his scientific orientation from his father, an amateur geologist. Besides his formal training in biochemistry, Eliot had an impressive knowledge of geology, geomorphology, paleontology, and botany. I never knew where he learned all these subjects, whether at college or from his own reading, and I regret now that I never questioned him about it. But even for subjects about which he knew much less, such as the astronomy I had studied in college and discussed with him from time to time, he showed a keen scientific curiosity. Eliot enjoyed the company of scientists, counted a number of them among his close friends, and often invited them to accompany him on photographic trips. I recall on a pack trip into the Escalante River canyons of southeastern Utah that we were accompanied by Jim Tuck and Paul Stein, a physicist and mathematician from Los Alamos. Around the evening campfires they all would enjoy elaborate theoretical discussions of possible explanations for the striations and whorls in the canyon's sandstone walls.

This scientific mentality served Eliot well as a photographer. Apart from the aesthetic appeal of the subjects he photographed, he was often quite aware of their scientific attributes: the geomorphic origins of rocks, the transforming effects of erosion on landscapes, the life cycles of insects, the taxonomy of birds, the optical qualities of reflected light. This almost clinical attitude protected him from becoming too sentimental about his subjects. He endeavored to remain a dispassionate observer.

Eliot's background as a scientist was no less evident in the laboratory regimen that he carried over from biomedical research to the darkroom and the technically demanding process of color print making. Making prints not only requires a high degree of skill and knowledge of chemistry, but it is also a methodical, repetitive process. He would spend weeks in his darkroom after a successful trip in the field. Although a succession of trained technical assistants later took over some of this work, Eliot always maintained a scientist's patience and discipline. Indeed, it always seemed to me that patience and a meticulous attention to detail were two of his strongest virtues.

My earliest memories of Eliot are of his craftsmanship. He derived an intense satisfaction from making things with his hands, mostly out of wood but also out of many other materials as well. This interest started when he was a boy and continued to develop throughout his life. He was a perfectionist, and the objects he made—whether furniture, cabinets, lamps, toys, model boats, or apparatus for his photography—all exhibited great precision and exacting attention to design. He loved good tools. When I was five years old he gave me a large, maple work bench and some basic tools. The bench was taller than I was, very heavy, and represented a formidable challenge to me. I still have it. My brothers, Stephen and Patrick, and I all have acquired in diverse ways our father's craftsmanship and love of tools.

During World War II Eliot worked in the Radiation Laboratory at MIT in Cambridge. The laboratory developed military radar, then a very new and critical technology. Eliot, who was beyond the age of conscription into the army, believed this was a way he could contribute to the war effort. Although he could use the machine shops there, his job was administrative. It was frustrating work that he did not particularly enjoy. However, in his spare time, perhaps to relieve the boredom, he made a brass model of an old-fashioned steam engine and tender. It was precisely and beautifully machined, with drive wheels and connecting rods, a cowcatcher, and even a small bell, which he had salvaged from a Christmas wrapping. When we were living in Winnetka, I remember him working for long hours on an elaborate doll house for my mother. It had two stories, a staircase with banister, and paned windows that opened. Later he made models of Maine lobster boats for Stephen and me, and he made a schooner for Patrick.

One of the most difficult symptoms at the onset of Lou Gehrig's disease is the loss of the ability to use one's hands in a precise and careful way. Almost more than anything else, Eliot took great satisfaction in the craftsmanship that had so informed his entire life. But ALS robbed him of that.

In the library of my house in Santa Fe is a small wooden box made of figured grain mahogany with dove-tailed corners perfectly fitted. The cover of the same wood is inlaid with an abstract design of a primitive sailing ship, the sails in white holly wood and the hull in ebony. And on the

desk in my studio I have a pair of rosewood bookends with figures of seahorses inlaid also in holly wood. When I examine these two creations of mine today I am affected by a feeling of wonder, of disbelief at the precision and delicacy of the workmanship and by a sense of sadness and loss in the realization that this kind of work is beyond what I could do now.

Eliot's photographic work habits reveal much about his character. His preferred equipment was a 4-by-5-inch view camera. Only when mobility or spontaneity demanded it would he abandon the view camera for a smaller and more convenient one, such as a 35mm single lens reflex. He practiced great economy in using film and counted it a good day when he took ten pictures.

Some days might pass when he had taken no pictures. The pressure to make a photograph would then build because he worried that his time and effort were wasted if no desirable subjects presented themselves. From Florida in 1954 he wrote me: "Photographing water birds is not an easy job, much harder than land birds. I have been out for many days in a blind and on many days I have taken no pictures. On one day, however, I went to a Wood Ibis rookery with a park ranger and took more pictures than I should have because it was so exciting to be taking pictures again."

Taking a picture was not a simple operation. After positioning the tripod and securely tightening its legs, Eliot would remove the camera from its case, mount it on the tripod, select the appropriate lens, and attach the cable release to the shutter. Next came the careful, and lengthy, process of composing the picture on the ground-glass viewing screen while huddled beneath a black viewing cloth. The image is inverted on the screen, which requires visualizing what the final print will look like properly oriented. At this point he sometimes would decide that the image was not what he had first envisioned, and, where someone else might have taken the picture for the sake of the effort that had been invested, he would dismantle everything and pack it away.

Once Eliot deemed an image worthy of a photograph, the exposure values had to be measured. This often involved measuring the light from various parts of the subject. When all was finally ready, it was time to load the film holder in the camera and take the picture. Rarely would he take another image at an alternative exposure. But if the light had changed, if the sun had come out from behind a cloud and spoiled the image he wanted, or if the exposure had been relatively long and the wind moved a blade of grass or a leaf, he would wait for the right conditions to return.

My brothers and I, when we went along on these trips, were at first impatient with this extremely deliberate and time-consuming process, but we came to understand it very well. We would often joke that we could predict when a potential photograph was imminent, because Eliot would become pensive and intent on a subject. He would begin to compose the image with his hands held in a rectangle before his eyes, a gesture we liked to mimic. We pretended that we could almost hear his mind pondering the photograph, and we would anticipate his decision by beginning to deploy the tripod and open the camera case. We got to know when an "Eliot Porter" was being conceived. Exposed over a long period of time to these work habits, I came to view Eliot's meticulous regimen of setting up the camera and composing and taking the picture as itself part of the artistic act, a kind of aesthetic ritual integral to the outcome of the process: the photograph itself. It was akin to the ceremony of the bull fighter dressing before his entrance into the arena.

Nothing about Eliot's methodical photographic process approached the notion of "shooting" or "snapping" a photograph—two words which, to the extent that they suggested rapid fire, Eliot regarded with contempt. Thus he was derisive, though also a little envious, of nature photographers with large film budgets who took thousands of exposures with 35mm cameras with motor drives. To Eliot's mind, this kind of "shoot everything" photographic approach involved little judgment and mostly luck, somewhat like the hypothetical monkeys with typewriters who, given enough time, would type the complete works of Shakespeare. Surely, by sheer chance, somewhere in all those pictures such a photographer would inevitably harvest a few good "shots." Although Eliot used a 35mm camera throughout his photographic career, to me, at least, his use of such a camera never carried for him the same artistic legitimacy as that of his view camera, and the results, to me at least, always lacked the latter's integrity.

Perhaps because he became so accustomed to viewing the world through a camera lens, Eliot found it difficult to look at things without reference to a potential photograph. His choice of subjects often

perplexed casual onlookers, especially when he avoided the conventional tourist sights. How could he choose not to take a picture of every waterfall in Iceland or every sentimental landscape in China, focusing instead on some nondescript detail off to the side? If a scene was not worth photographing, it was rarely worth investing the time to appreciate simply for its own sake.

While photography at first was simply Eliot's way of engaging nature, he came to represent his vision of the world through the medium. It was a world completely focused on nature. He possessed a tremendous empathy for both wildlife and the inanimate natural world, but he did not share the same feeling for people. While his images of people may be sympathetic, they lack the subtlety and sensitivity of his nature photographs. Pictures of people are best when they are spontaneous, an impossibility with a view camera. Eliot's photographs of nature were carefully composed, with attention to every part of the image. While his photographs are representations of his vision of nature, they are not narratives in any conventional sense. He disliked taking pictures with narrative content that forced the viewer to focus on what was happening, and except for his pictures with people as the explicit subject, he avoided pictures that possessed a literal human relevance. He often joked about the National Geographic cliché of putting a woman in a red sweater in a photograph to provide "human interest." Eliot's vision of nature did not depend on human interest.

As early as I can remember, though, Eliot avidly followed current events, listening to the evening news broadcasts on radio and television. It seemed almost an obsession at times, and he did not like to be interrupted. Influenced by his mother's liberal politics, he retained a similar point of view throughout his life, in contrast to the conservative shift that often comes with age. He relished discussions and arguments about political issues, and we often had vigorous discussions of current events around the dinner table, which my mother disliked because she mistook our vehemence for hostility. Politics was certainly one of his passions, but never in the sense of personal involvement. He was an observer, not a participant.

He was also highly self-directed, often reclusive, not easily swayed by the opinions of others, and confident in the rightness of his work. His passion for birds reinforced his rather solitary disposition. Birds are best observed and their nests sought out when one is alone, away from the distractions of other people; it was not an interest easily shared.

Eliot was a very private person. He was loath to exhibit his emotions, and except for his views on such topics as political affairs and conservation, he was reluctant to reveal much of his inner thoughts, even to members of his own family. One time in Santa Fe a small songbird flew headlong into the glass of his studio window and was partially paralyzed. After quietly examining it for awhile and realizing that it would not recover, he struck its head sharply against a tree branch to put it out of its suffering. Reluctantly, he later told me that he felt saddened by having to kill the bird, that it was such a waste. Though it was a passing incident, the memory of it has stayed with me because it was such an uncharacteristic expression of emotion from my father.

Eliot was not particularly at ease in public situations or with strangers, at least not until after he became famous as a photographer and a conservationist. Even then, he tended to shy away from public speaking engagements, for which he was increasingly in demand. Nevertheless, he enjoyed the celebrity that his photographic success finally brought him. His rather ambivalent and awkward relationship with the photographer Ansel Adams, who had achieved fame much earlier and basked in his own celebrity, reflected Eliot's sense of himself. He envied Adams's easy-going, extroverted sociability and admired his accomplishments in black-and-white photography. But while Eliot was stimulated by Adams's dynamism, he found his egotism insufferable and his dismissive attitude toward color photography annoying and frustrating. Adams was notoriously indifferent to color photography, an attitude that Eliot came to ascribe to Adams's own lack of ability with the medium. "It is a curious phenomenon," he once wrote to me, "that photographers on the whole do not like to look at color prints, whereas painters are usually very much interested."

My father was certainly no egotist. What he chose to photograph he chose for himself, according to his own vision of the world, not to please some imagined public audience. One of his great strengths of character was that he remained undaunted by the lack of public acclaim for his work for many years and steadily built his body of work. When celebrity finally did come in 1962 with the publication of *"In Wildness Is the Preservation of the World,"* he wore it with grace.

ELIOT PORTER
A CHRONOLOGY

This chronology presents an overview of Eliot Porter's life and accomplishments. It draws upon several sources, including the bibliography compiled by Milan Hughston in *Eliot Porter* (Boston: New York Graphic Society Books, Little Brown and Company, in association with the Amon Carter Museum, Fort Worth, Texas, 1987); the autobiographical material included in the same publication; the chronology included in *Eliot Porter: The Grand Canyon* (Munich: Prestel; New York: *ARTnews*, 1992); Nancy Barrett's chronology in *Intimate Landscapes* (New York: Metropolitan Museum of Art, 1979); and material from Porter's estate, housed at the Amon Carter Museum. Those interested in a fuller view of Porter's life are encouraged to consult these sources.

1901

Eliot Porter is born December 6 in Winnetka, Illinois, a suburb of Chicago, into an upper-middle-class household; his parents are James Foster Porter, a biologist, architect, and nature enthusiast, and Ruth Wadsworth Furness Porter, a social activist

Is the second child after sister Nancy; other siblings Edward, Fairfield, who later becomes an accomplished painter, and John

1905–11

Takes several trips with his family to Florida, New England, and the Grand Canyon

1910

Father purchases Great Spruce Head Island, Penobscot Bay, Maine; family summers there beginning in 1912

1912

Receives a Brownie box camera as a Christmas gift from his parents

1912–19

Photographs around Winnetka and on Great Spruce Head Island, first using his Brownie box camera and later a Graflex; takes his first photographs of birds

Becomes interested in chemistry while in high school

Enters Morristown School, a boarding school in New Jersey, and photographs athletic events there

1920

Enters Harvard University and studies chemical engineering; interests broaden to include biology and physiology

1924

Graduates from Harvard and enters Harvard Medical School

1926

Suspends studies at Harvard Medical School and enters University of Cambridge, England, to study biochemistry

1927

Leaves Cambridge and returns to Winnetka; resumes studies at Harvard Medical School

1928

Marries Marian Brown

First child, Meredith, born (exact date unknown)

1929

Receives M.D. from Harvard Medical School

1929–39

Researches and teaches bacteriology, biochemistry, and biophysics at Harvard Medical School

1930

Resumes photography after purchasing a Leica camera; photographs architectural and object close-ups around Boston

Meredith dies of meningitis

1931

Eliot, Jr. born January 21

1933

Charles Anthony born December 24

1934

Divorces Marian

Meets Alfred Stieglitz in New York City and Ansel Adams in Boston (ca. 1934)

Purchases a 9-by-12 cm Linhof camera

1935

Travel: Switzerland and Austria, summer

1936

Marries painter Aline Kilham

Exhibition: *Exhibition of Photographs by Eliot Porter* (Delphic Studios, New York, February 24–March 8; thirty-seven prints)

1937

Resumes bird photography

1938

Jonathan born March 25

Exhibition: *Eliot Porter—Exhibition of Photographs* (An American Place, New York, December 29–January 18, 1939; twenty-nine prints)

1939

Father dies, July 30

Resigns from teaching and research to pursue photography as a career

Begins photographing birds in color using Kodachrome film; continues photographing other nature and landscape subjects in black-and-white

Through the late 1950s contributes regularly to nature photography competitions presented at the American Museum of Natural History, New York; New England Museum of Natural History, Boston; Museum of Natural History, Chicago; and other venues

Through the early to mid-1960s, writes articles about bird and color photography and contributes photographs to publications focusing on American birds and nature

1940

Experiments with making color prints in his Chicago darkroom; settles on using Kodak's wash-off relief process

1941

Stephen born July 23

Receives a Guggenheim Fellowship to photograph birds in both black-and-white and color

1942

Mother dies, May 31

Exhibition: *Photographs by Eliot Porter* (New York Zoological Society, May 30–June 30; eighty prints)

1942–44

Suspends Guggenheim bird project and moves to Cambridge, Massachusetts, during World War II; works as a job scheduler in the Radiation Laboratory, Massachusetts Institute of Technology

1943

Exhibition: *Birds in Color: Flashlight Photographs by Eliot Porter* (Museum of Modern Art, New York, March 9–April 18, and other venues through 1944; fifty-four prints)

1944

Moves back to Winnetka and resumes photographing birds; occasionally makes color photographs of nature and landscape subjects

1946

Patrick born February 4

Moves to Tesuque, New Mexico, near Santa Fe; travels the U.S. photographing birds in color; continues to photograph other nature and landscape subjects in both black-and-white and color

Becomes Photographer-at-Large for *Audubon* magazine

Exhibition: *Leaders in Photography: Eliot Porter* (University of Virginia, Charlottesville, October 4–25, and other venues through 1949; organized and circulated by the Museum of Modern Art, New York; fifteen prints)

Renews Guggenheim Fellowship to continue bird project

1947

Refines color printing techniques; switches from wash-off relief printing to its successor, the dye transfer process

1951

Participates in Aspen Institute Conference on Photography, October

Travel: Mexico, with Aline, Georgia O'Keeffe, and Spud Johnson, February; photographs churches and pyramids in black-and-white and color

Exhibition: *Color Photographs by Eliot Porter* (George Eastman House, Rochester, New York, November–December)

1952

Photographs almost exclusively in color; has established routine of photographing birds at various U. S. locations in the spring of each year and spending the remaining months photographing nature subjects

Exhibition: *Diogenes with a Camera* (Museum of Modern Art, New York, May 20–September 20; group exhibition; twenty-one prints)

Exhibition: *Exhibition of Color Photographs* (Massachusetts Institute of Technology, Cambridge, May 21–June 10; fifty-seven prints)

1953

Exhibition: *Birds in Color: Photographs by Eliot Porter* (American Museum of Natural History, New York, October 1–22, and other venues through 1957; circulated by the Smithsonian Institution Traveling Exhibition Service; fifty prints)

Book: Robert C. Murphy and Dean Amadon, *Land Birds of America* (New York: McGraw-Hill Book Company; 104 illustrations)

Portfolio: *American Birds: Ten Photographs in Color* (New York: McGraw-Hill Book Company)

1955

Travel: Returns to Mexico with Ellen Auerbach, November–April 1956; together they photograph churches and other subjects in color

Exhibition: *Photographs by Eliot Porter* (Limelight Gallery, New York, March 21–April 17; sixty prints)

Exhibition: *This Is the American Earth* (LeConte Lodge, Yosemite Valley, California, n.d., and other venues through 1957; organized by Nancy Newhall and Ansel Adams and circulated by the Smithsonian Institution Traveling Exhibition Service; group exhibition; two prints)

1956

Book: Charles L. Sherman, ed., *Nature's Wonders in Full Color* (Garden City, New York: Hanover House; twenty-eight illustrations)

1957

Exhibition: *Madonnas and Marketplaces: Mexico in Color* (Limelight Gallery, New York, April 4–May 19; eighty-three prints by Porter and Ellen Auerbach)

1959

Exhibition: *The Seasons: A Photographic Essay* (Centerline General Store, Santa Fe, New Mexico, August 1–September 8, and other venues through 1960; organized and circulated by Porter; seventy-three prints)

1960

Travel: Glen Canyon, Utah, in the fall, for the first of eleven boat and raft trips on the Colorado River; returns in 1961–65, 1968, and 1971

Exhibition: *The Seasons: Color Photographs by Eliot Porter Accompanied by Quotes from Henry David Thoreau* (George Eastman House, Rochester, New York, August 12–October 1, and other venues through 1965; organized by George Eastman House and circulated by the Smithsonian Institution Traveling Exhibition Service; seventy-six prints)

1962

Book: *"In Wildness Is the Preservation of the World," Selections & Photographs by Eliot Porter* (San Francisco: Sierra Club; seventy-two illustrations); this book's unexpected success leads Porter to concentrate on place-oriented projects for the remainder of his career

1963

Travel: Returns to Great Spruce Head Island for the first time in eight summers

Travel: Adirondack Park, New York, in the fall; returns in the spring of 1964 and in winter, spring, and fall of 1965

Exhibition: *The Photographer and the American Landscape* (Museum of Modern Art, New York, September 24–November 28; group exhibition; nine prints)

Exhibition: *An Exhibition of Photographs: Eliot Porter* (Art Institute of Chicago, December 14–January 26, 1964; fifty-three prints)

Book: *The Place No One Knew: Glen Canyon on the Colorado* (San Francisco: Sierra Club; seventy-two illustrations; second revised edition published 1966, commemorative editions by Gibbs Smith Publishers in 1988 and 2000)

1964

Travel: Baja California, Mexico, February–April; returns in July and August of 1966

Exhibition: *Eliot Porter Photographs, Aline Porter Paintings, Stephen Porter Sculpture* (Manchester Gallery, Taos, New Mexico, September–October)

Portfolio: *The Seasons.* Portfolio One (San Francisco: Sierra Club). Twelve dye transfer prints, one page of text by Porter; edition: 105; one hundred for sale

1965

Elected to the Sierra Club board of directors; serves through 1971

Begins to exhibit regularly at universities and small museums

Exhibition: *Color Photographs by Eliot Porter* (M. H. deYoung Memorial Museum, San Francisco, March 26–April 25; fifty prints)

1966

Travel: Galápagos Islands, February–June

Exhibition: *An Exhibition of Work by The John Simon Guggenheim Memorial Foundation Fellows in Photography* (Philadelphia College of Art, April 15–May 13; group exhibition; one print)

Book: *Forever Wild: The Adirondacks* (Blue Mountain Lake, New York: The Adirondack Museum; New York: Harper & Row; eighty illustrations)

Book: *Summer Island: Penobscot Country* (San Francisco: Sierra Club; ninety-six illustrations)

1967

Receives the Conservation Service Award from the U.S. Department of the Interior

Travel: Greece and Turkey, March–May; returns March–April 1970 and March–April 1971

Travel: River trips through the Grand Canyon, June and September

Travel: Great Smoky Mountains National Park, October; returns March–May 1968 and February 1969

Book: Joseph Wood Krutch, *Baja California and the Geography of Hope* (San Francisco: Sierra Club; seventy-three illustrations)

1968

Travel: Red River Gorge, Kentucky, September, for *Audubon* magazine

Book: *Galápagos: The Flow of Wildness* (San Francisco: Sierra Club; two vols., 138 illustrations)— the last book Porter publishes with the Sierra Club

1969

Awarded Honorary Doctor of Fine Arts degree by Colby College, Waterville, Maine

Exhibition: *Photographs by Eliot Porter, Paintings by Fairfield Porter* (Colby College Art Museum, Waterville, Maine, May 6–June 24; forty-eight prints)

Book: John Wesley Powell, *Down the Colorado: Diary of the First Trip Through the Grand Canyon, 1869* (New York: E. P. Dutton and Company; London: Allen and Unwin; forty-four illustrations)

1970

Travel: Kenya, Tanzania, Uganda, February and June–November

Exhibition: *Eliot Porter: Nature's Photographer* (Museum of Fine Arts, St. Petersburg, Florida, March 15–April 15; seventy-five prints)

Book: *Appalachian Wilderness: The Great Smoky Mountains* (New York: E. P. Dutton and Company; forty-five illustrations)

1971

Becomes a Fellow of the American Academy of Arts and Sciences

Presents the Alfred Stieglitz Memorial Lecture at Princeton University

Exhibition: *Eliot Porter Photographs of Classical Greece and Asia Minor. Aline Porter Paintings* (St. John's College, Santa Fe, New Mexico, December 4–19; group exhibition; thirty-six prints)

1972

Travel: Iceland, July-August

Book: *Birds of North America: A Personal Selection* (New York: E. P. Dutton and Company; seventy-five illustrations)

Book: Peter Matthiessen, *The Tree Where Man Was Born*; Eliot Porter, *The African Experience* (New York: E. P. Dutton and Company; ninety-two illustrations)

Portfolio: *Iceland.* Portfolio Two (San Francisco: Sierra Club). Twelve dye transfer prints, one page of text by Porter; edition: 110; one hundred for sale

1973

Travel: Egypt, January–February, and September, to photograph ancient monuments for E. P. Dutton and Company

Exhibition: *Eliot Porter Retrospective* (University of New Mexico Art Museum, Albuquerque, March 20–April 15, and other venues through 1975; organized by Beaumont Newhall and circulated by the University of New Mexico Art Museum; 240 prints)

1974

Travel: Antarctica, December–January 1975; returns November 1975–March 1976

1975

Exhibition: *Color Photography Now* (Jewett Art Center, Wellesley College Museum, Wellesley, Massachusetts, September 29–October 27; group exhibition; 17 prints)

1976

Exhibition: *Eliot Porter Retrospective* (Santa Monica College, Santa Monica, Calif., September 22–October 20, and other venues through 1978; circulated by the Western Association of Art Museums Traveling Exhibition Service; seventy-five prints)

Exhibition: *Antarctica* (59th Street Gallery, St. Louis, January 31–February 29, and other venues through 1979; circulated by Smithsonian Institution Traveling Exhibition Service; forty-five prints, with 144 paintings by Daniel Lang

1977

Exhibition: *The Great West: Real/Ideal* (University of Colorado, Boulder, September 9–October 15, and other venues through 1981; circulated by the Smithsonian Institution Traveling Exhibition Service; group exhibition; twelve prints)

Book: *Moments of Discovery: Adventures with American Birds* (New York: E. P. Dutton and Company; sixty-four illustrations)

Portfolio: *Birds in Flight.* (Santa Fe and New York: Bell Editions), Eight dye transfer prints, nine pages of text; edition: twenty, plus six artist's copies

1978

Exhibition: *Mexican Church Interiors: Color Dye-Transfers by Eliot Porter and Ellen Auerbach* (Sander Gallery, Washington, D.C., September 30–October 28; one hundred prints)

Book: *Antarctica* (New York: E. P. Dutton and Company; eighty-seven illustrations)

1979

Begins to exhibit regularly at a variety of commercial galleries

Receives an honorary Doctor of Science degree from Dickinson College, Carlisle, Pennsylvania

Exhibition: *Intimate Landscapes* (Metropolitan Museum of Art, New York, November 14–January 20, 1980; fifty-five prints)

Exhibition: *Photographs of Maine by Eliot Porter* (University of Maine, Orono, July 15–September 30; one hundred prints)

Book: *Intimate Landscapes: Photographs by Eliot Porter* (New York: Metropolitan Museum of Art; fifty-five illustrations)

Portfolio: *Intimate Landscapes.* (New York: Daniel Wolf Press, Inc.). Ten dye transfer prints; edition: 250

1980

Travel: China and Macao, June–July; returns September–October 1981; travels to Macao and Hong Kong in May 1985

Exhibition: *Eliot Porter: Visual Explorations* (Art Center, Amarillo, Texas, December 10–January 18, 1981, and other venues through 1982; fifty prints)

Exhibition: *Color Photographs by Marie Cosindas and Eliot Porter* (Art Institute of Chicago, March 15–May 4; ninety-six prints)

Book: Peter Levi, *The Greek World* (New York: E. P. Dutton and Company; eighty-three illustrations)

Portfolio: *Eliot Porter, Glen Canyon* (New York: Daniel Wolf Press, Inc.). Ten dye transfer prints; edition: 250

1981

Exhibition: *1981 Festival of the Arts: Eliot Porter Retrospective* (Sweeney Center, Santa Fe, New Mexico, October 9–18; eighty-three prints)

Exhibition: *American Photographers and the National Parks* (Oakland Museum, Oakland, California, May 2–July 5, and other venues through 1983; organized and circulated by the National Park Foundation; group exhibition; ten prints)

Book: Wallace Stegner and Page Stegner, *American Places* (New York: E. P. Dutton and Company; eighty-nine illustrations)

Portfolio: *In Wildness* (New York: Daniel Wolf Press, Inc.). Ten dye transfer prints; edition: 300

1982

Portfolio: Santa Fe Center for Photography: Portfolio 1 (Santa Fe: Santa Fe Center for Photography). Five prints, one by Porter; edition: sixteen; ten for sale

1983

Book: *All Under Heaven: The Chinese World.* Text by Jonathan Porter (New York: Pantheon Books; 127 illustrations)

1984

Portfolio: *China* (New York: DEP Editions, Inc.). Seven dye transfer prints; introduction by Jonathan Porter; edition: fifty, plus ten artist's proofs

1985

Exhibition: *Eliot Porter and Richard Misrach: Landscape and Color* (Film in the Cities, St. Paul, Minnesota, June 5-26; twenty prints)

Book: *Eliot Porter's Southwest* (New York: Holt, Rinehart and Winston; ninety illustrations)

1986

Travel: Spends last summer on Great Spruce Head Island, Maine

Exhibition: *Eliot Porter's Southwest* (Museum of Natural History, Albuquerque, New Mexico, January 11–March 30, sixty prints)

Exhibition: *Retrospective: Eliot Porter and Beaumont Newhall* (Photo Gallery International, Tokyo, Japan, November 6–December 13; thirty prints)

Book: *Maine* (Boston: Little, Brown and Co.; A New York Graphic Society Book; eighty-six illustrations)

1987

Exhibition: *Eliot Porter* (Amon Carter Museum, Fort Worth, Texas, October 31–January 3, 1988, and other venues through 1988; 129 prints)

Book: *Mexican Churches* (Albuquerque: University of New Mexico Press; eighty-eight illustrations)

Book: *Eliot Porter* (Boston: New York Graphic Society Books and Little, Brown and Co. in association with the Amon Carter Museum; 156 illustrations)

1988

Book: *The West* (Boston: Little, Brown and Co., A New York Graphic Society Book; eighty-seven illustrations)

1989

Book: *Iceland*, text by Jonathan Porter (Boston: Bulfinch Press and Little, Brown and Co.; fifty-six illustrations)

1990

Dies in Santa Fe, November 2; estate bequeathed to the Amon Carter Museum, Fort Worth, Texas

Book: *Monuments of Egypt* (Albuquerque: University of New Mexico Press; 102 illustrations)

Book: *Nature's Chaos*, text by James Gleick (New York: Viking; 102 illustrations)

Book: *Mexican Celebrations*, with Ellen Auerbach (Albuquerque: University of New Mexico Press; ninety-two illustrations)

1992

Book: *The Grand Canyon* (Munich: Prestel; New York: *ARTnews*; sixty-four illustrations)

1996

Book: *Vanishing Songbirds: The Sixth Order: Wood Warblers and Other Passerine Birds* (Boston: Bulfinch Press and Little, Brown and Co.; 125 illustrations)

1997

Exhibition: *A Passion for Birds: Eliot Porter's Photography* (Amon Carter Museum, Fort Worth, Texas, November 8–January 18, 1998; ninety-eight prints)

Book: John Rohrbach, *A Passion for Birds: Eliot Porter's Photography* (Fort Worth: Amon Carter Museum; twenty-three illustrations)

2001

Book: *Eliot Porter: The Color of Wildness* (Fort Worth: Amon Carter Museum; 119 illustrations)

2002

Exhibition: *Eliot Porter: The Color of Wildness* (Amon Carter Museum, Fort Worth, Texas, December 21–March 23, 2003, and other venues through April 4, 2004; 162 prints)

ENVISIONING THE WORLD IN COLOR

1. Eliot Porter, *Eliot Porter* (Boston: New York Graphic Society Books, Little Brown and Company, in association with the Amon Carter Museum, Fort Worth, Texas, 1987), 29. Porter's autobiography in this exhibition catalog provides an important supplement to this essay.

2. Porter recounts his early years with the camera in Ibid, 20–27. See also Eliot Porter, *Summer Island: Penobscot Bay* (San Francisco: Sierra Club, 1966), 77–81, and John Rohrbach, *A Passion for Birds: Eliot Porter's Photography* (Fort Worth, Texas: Amon Carter Museum, 1998).

3. Porter was particularly proud of a close-up of blueberries so enlarged that the berries looked like tennis balls. *Eliot Porter,* 27. For one synopsis of the diverse avenues of "New Vision" photography, see Naomi Rosenblum, *A World History of Photography,* rev. ed. (New York: Abbeville Press, 1989), 393–419.

4. Porter offered conflicting explanations as to when exactly he first met both Stieglitz and Adams. Although he suggested that Adams was preparing for his 1936 exhibition at An American Place, their dinner meeting clearly occurred before Porter traveled to Austria in summer 1935. He placed his introduction to Stieglitz in 1934 in his lecture at the Amon Carter Museum, October 31, 1987 (Eliot Porter Archives, Amon Carter Museum (hereafter cited as EPA/ACM). See also *Eliot Porter,* 27–28; Paul Hill and Tom Cooper, "Camera Interview: Eliot Porter," *Camera* 57 (January 1978), 33–37, reprinted in their compilation *Dialogue with Photography* (New York: Farrar, Straus, Giroux, 1979), 238; Porter, *Summer Island,* 77–81.

5. Alfred Stieglitz to Eliot Porter, January 21, 1939, (EPA/ACM).

6. Overviews of the history of color photography are found in Louis Walton Sipley, *A Half Century of Color* (New York: The MacMillan Company, 1951); Manfred Heiting, *Fifty Years of Modern Color Photography,* 1936–1986 (Cologne: Messe-und Ausstellungs, Ges.m.b.H., 1986); Luis Nadeau, *Encyclopedia of Printing, Photographic, and Photomechanical Processes: A Comprehensive Reference to Reproduction Technologies, Containing Invaluable Information on Over 1500 Processes* (Fredericton, New Brunswick, Canada: Atelier Louis Nadeau, 1989); Jack H. Coote, *The Illustrated History of Colour Photography* (Surrey, England: Fountain Press Limited, 1993); and Keith Davis, *An American Century of Photography, From Dry-Plate to Digital,* 2nd ed., revised and enlarged (Kansas City, Missouri: Hallmark Cards, Inc., in association with Harry N. Abrams, Inc., 1999), 66–68, 158–162, 302–305.

7. Roy Stryker, chief of the New Deal's Farm Security Administration photographic project, had a difficult time convincing magazines to reproduce the color work because of the added difficulty of printing from 35mm slides. Historian Sally Stein discusses Stryker's enthusiasm for color in "FSA Color: The Forgotten Document," *Modern Photography* (January 1979), 90–98, 162–164, 166.

8. László Moholy-Nagy, "Paths to the Unleashed Color Camera," *The Penrose Annual: A Review of the Graphic Arts,* vol. 39, 1937, pp. 25–28. Leland Rice, *henry holmes smith, Photographs 1931–1986: A Retrospective* (New York: Howard Greenberg Gallery, 1992).

9. Porter's bird photography is discussed at length in Rohrbach, op. cit.

10. Kodak introduced Kodachrome sheet film in 1938.

11. Ambitious to make his mark, but not yet certain of his technical capabilities, Porter suggested in his Guggenheim application that he would photograph as many American bird species as possible in both black-and-white *and* color. He was awarded the Guggenheim in spring 1941.

12. David McAlpin to Eliot Porter, January 21, 1941, (EPA/ACM).

13. McAlpin to Porter, November 18, 1941 and July 14, 1942; Nancy Newhall to Porter, October 3, 1942 (EPA/ACM).

14. Nancy Newhall to Porter, October 17, 1942; March 11, 1943; April 9, 1943 (EPA/ACM).

15. For a direct comparison of Porter and Audubon see Rohrbach, op. cit., 8–10.

16. Eliot Porter, "Nesting Birds," *Life* 14 (May 17, 1943): 58–62.

17. To make dye transfer prints Porter had to make red, green, and blue color-separation negatives on black-and-white film from his original color transparency. He made a positive matrix enlarged to the size of the final print from each separation negative. He then soaked these positive matrices, now holding the complementary color information (cyan, magenta, and yellow) into dye baths corresponding to their color. Upon absorbing the dyes, the matrices were rolled in turn, and in exact register, onto a specially prepared receiving paper. The paper absorbed the dye from each matrix, producing a color print. Changing the acidity of the dye baths and rerolling the matrices offered the possibility of precise control over hue and contrast. The process's main advance over wash-off relief printing was that the dyes transferred to the receiving paper much more quickly.

18. Moholy-Nagy, op. cit. In taking this stance, Moholy-Nagy likely was reacting to mainstream currents, which took photography's descriptive capabilities for granted. Representative of that mainstream was the outlook of such commercial photographers as Ivan Dmitri and Victor Keppler, who, through the late 1930s and early 1940s, raced to press with "how to" books that called on photographers to overcome the "confusion of color" by constructing simple, naturalistic compositions organized around swatches of bright color like red and blue. See Victor Keppler, *The Eighth Art: A Life of Color Photography* (New York: William Morrow & Company, 1938); D. A. Spencer, *Colour Photography in Practice* (New York: Pittman Publishing Corporation, 1938); Ivan Dmitri, *Color in Photography* (Chicago: Ziff-Davis Publishing Company, ca. 1939); Jack H. Coote, *Making Colour Prints: Practical Photographic Methods* (London: The Focal Press, 1939); Ivan Dmitri, *Kodachrome and How to Use It* (New York: Simon and Schuster, 1940); and Fred Bond, *Kodachrome and Kodacolor from All Angles* (San Francisco: Camera Craft Publishing Company, 1942).

19. László Moholy-Nagy, *vision in motion* (Chicago: Paul Theobald, 1947), 170–176.

20. The Institute of Design was a hotbed of color experimentation. While Kepes and Smith were photographing light boxes or making photograms, Callahan and Siegel had taken Moholy-Nagy's ideas to Chicago's streets, photographing the patterns created by neon light and window reflections. Each of these photographers would become an influential teacher in his own right. See Leland Rice, op. cit.; Sally Stein, *Callahan: Works in Color* (Tucson: Center for Creative Photography, 1980); Robert Tow and Ricker Winsor, eds., *Harry Callahan: Color, 1941–1980* (Providence, Rhode Island: Matrix Publications, 1980); *Arthur Siegel: Retrospective: Vintage Photographs and Photograms, 1937–1973* (Chicago: Edwynn Houk Gallery, 1982).

21. Jacob Deschin, "The Future of Color," *Photography* 1, no.2 (Winter 1947), 35-37, 140–144. Nancy Newhall, wife of MoMA's photography curator, Beaumont Newhall, agreed with Weston. In early 1941 she bemoaned artists' lack of interest in color, but derided Dmitri's and Keppler's approach as founded on stereotype. To make color works of any emotional depth, she declared, photographers needed to learn how to move beyond bright hues and obvious color. She also had criticized as unnecessarily stylized the shadow-laden aesthetic promulgated by magazines like *Vogue.* Photography was more than a matter of recording the world, she had explained; it involved seeing. Nancy Newhall, "Painter or Color Photographer," *U. S. Camera* 14 (Spring 1941), 42.

22. Kodak's approach to artists in the mid-1940s is discussed in two sources. See *Edward Weston: Color Photography* (Tucson: Center for Creative Photography, University of Arizona, 1986) and Harry Callahan, ed., *Ansel Adams In Color* (Boston: Little, Brown and Company, 1993). Weston made his first color photographs in August 1946. See also Theodore Stebbins, Jr., and Norman Keyes, Jr., *Charles Sheeler: The Photographs* (Boston: Little Brown and Company, 1987), 162.

23. Kodak asked Adams to add color to his new Guggenheim Foundation-funded project to photograph America's National Parks. At Adams's urging, they approached Weston about making color transparencies at Point Lobos, California. The company convinced Paul Strand to slip color film into his camera while he photographed rural New England, and they induced Charles Sheeler to try out the film on his ongoing architectural studies. Strand was working on the book project that would be published in 1950 as *Time in New England*.

24. Peter Krause, "Fifty Years of Kodachrome," *Modern Photography* 9, no.11 (October 1985), 63.

25. "Color . . . Edward Weston's New Medium," *Kodak Photo* 2, no.2 (June/July 1947), 10, quoted by Terence Pitts in *Edward Weston: Color Photography*, 12.

26. *Edward Weston: Color Photography*, 13.

27. Ibid., 15.

28. Adams photographed in color in Yosemite, the Grand Canyon, Yellowstone, Death Valley, Zion, Bryce Canyon, and Acadia Parks. See Adams to Nancy Newhall, October 27, 1946; July 13, 1947; July 19, 1947, all quoted in Callahan, ed., *Ansel Adams in Color*. In 1948 he started making transparencies for Kodak's 16-by-60-foot Coloramas. He would continue to make color photographs for various commercial purposes throughout his career.

29. *In and Out of Focus: A Survey of Today's Photography*, MoMA, April 7–July 11, 1948. The show's title likely was a play on photographer Robert Capa's book, *Slightly Out of Focus* (New York: Henry Holt, 1947). It was Steichen's first major show since taking over as director of the photography department at MoMA.

30. Steichen also presented two of Weston's Point Lobos color transparencies and two of Adams's color views of Yosemite and Ranchos de Taos Church. Undated press release, *In and Out of Focus*; typescript of wall label, MoMA exhibition files.

31. Jacob Deschin, *The New York Times*, April 11, 1948, II, 13:1, cited by Sally Stein in *Callahan: Works in Color*.

32. Milton Brown, "Badly Out of Focus," *Photo Notes* (June 1948), 5–6.

33. Ansel Adams, "Some Thoughts on Color Photography," *Photo Notes* (Spring 1949), 10–11; Ansel Adams, "Some Thoughts on Color Photography," *Photo Notes* (Spring 1950), 14–15. Walker Evans agreed with Adams's assessment and also advocated that photographers stick to muted colors. See Walker Evans, "Test Exposures," *Fortune* 49. no.2 (July 1954), 77–80.

34. Ansel Adams, "Some Thoughts . . ." *Photo Notes* (Spring 1949), 10–11.

35. Porter accepted the proposition with the stipulation that the book include at least some color plates, and the two men started discussing design and even paper preferences. Ansel Adams to Eliot Porter, December 15, 1949; December 26, 1949; August 27, 1950; September 21, 1950; October 15, 1951; March 16, 1952; March 21, 1952 (EPA/ACM). When Edward Weston's series contribution, *My Camera at Point Lobos*, failed to find an audience, the Porter project was shut down.

36. Adams to Paul Brooks, January 18, 1950, quoted in Callahan, ed., *Ansel Adams In Color*, 120.

37 For those artists chagrinned at color's excessive "realism," in early 1950 Kodak even started trumpeting a new method of making color prints called "derivations." A variation on dye transfer printing, "derivations" transformed a naturally rendered scene to semi-abstract flattened planes of line and color by transposing and masking the color separation negatives used to make dye transfer prints. See "EK Creates Art with Color," *Kodakery* 8, no. 18 (May 4, 1950), 1, 4; "New Technique for Color Photos Shown in Exhibit," *Rochester Democrat and Chronicle*, May 10, 1950 (exhibition files, George Eastman House, Rochester, New York). Eastman House mirrored Kodak's publicity for the process. Newhall praised the process to Steichen and arranged to travel a forty-two-print "derivations" exhibition to institutions around the country. Steichen derided the process, yet included seven "derivations" in his mid-1950 summation of the field's expressive achievements, *All Color Photography*. Steichen to Newhall, February 24, 1950; Newhall to Steichen, March 27, 1950 (exhibition file, George Eastman House). Even Adams asked Kodak on several occasions to produce a "derivation" version of one of his color photographs. One of these prints, a close-up of leaves made in 1956, is owned by the Center for Creative Photography, University of Arizona, Tucson.

38. Beaumont Newhall, *The History of Photography from 1839 to the Present Day* (New York: Museum of Modern Art, 1949).

39. *All Color Photography*, MoMA, May 10–June 25, 1950. Sally Stein discusses this show as part of her analysis of Callahan's dealings with Steichen in *Callahan: Works in Color*.

40. See MoMA's installation photographs for *All Color Photography*. Ansel Adams, "Color and Control," undated typescript, Center for Creative Photography, University of Arizona, Tucson.

41. "Introductory Label," *All Color Photography*, typescript (exhibition file, MoMA).

42. Jacob Deschin, *The New York Times* (May 14, 1950) II, 13: 2–3. Bruce Downes, "Let's Talk Photography," *Popular Photography* (August 1950), 20–21. Willi Wolfradt, "Color Camera," *Aufbau* (May 26, 1950), typescript of English translation (exhibition file, MoMA).

43. Steichen included color photographs in a few early 1950s MoMA exhibitions, including *Abstraction in Photography* (May 2–July 4, 1951); *Diogenes with a Camera I* (1952), and *Always the Young Strangers* (February 1953). He also addressed color issues in his January 1952 presentation of experimental films. See the press release for "Why Experimental Films?" (exhibition file, MoMA).

44. Typescript of brochure copy for the exhibition, *Arthur Siegel, September 15–November 1, 1954* (artist files, Photography Study Center, Art Institute of Chicago). The exhibition was not a good experience for the artist. He had arranged for a local lab to custom-print the dye transfer prints for the show, but the costs were so high that it took him years to finish paying the bill. From then on, he generally presented his work in the format of slide lectures. John Grimes, "Arthur Siegel," *Arthur Siegel: a Retrospective*, n.p.

45. Adams to Nancy Newhall, December 13, 1952, quoted in *Ansel Adams In Color*, 122. The never-completed technical manual was to be volume six in Adams's Basic Photo series.

46. Adams, in particular, privately praised Porter's color work in the early 1950s. He purchased a number of Porter's prints and offered to help the photographer both to obtain an exhibition at the San Francisco Museum of Modern Art and to establish publishing contacts with *Arizona Highways*. Ansel Adams to Eliot Porter, October 15, 1951; March 16, 1952; March 21, 1952 (EPA/ACM). It remains unclear whether Adams followed through on his exhibition and publishing contact promises.

47. Beaumont Newhall, "The Aspen Photo Conference," *Aperture* 3, no.3 (1955), 3–10.

48. Although Porter would not get his full-length bird book into print until 1972, in 1953 he was able to convince McGraw-Hill to publish an offset portfolio of ten of his color bird studies. See Eliot Porter, *American Birds: Ten Photographs in Color* (New York: McGraw-Hill Book Company, 1953).

49. Porter regularly submitted prints to such annual exhibitions as the Chicago International Exhibition of Nature Photography. In 1953 the American Museum of Natural History sponsored an exhibition of fifty of his bird photographs. Robert C. Murphy and Dean Amadon, *Land Birds of North America* (New York: McGraw-Hill Book Company, 1953) presents 104 Porter images. Charles L. Sherman, ed., *Nature's Wonders In Full Color* (Garden City, New York: Hanover House, 1956) includes 28 Porter images.

50. Jeannette Klute, *Woodland Portraits* (Boston: Little, Brown and Company, 1954).

51. This concern came in the face of broad excitement over Kodak's introduction in 1956 of Type C (Ektacolor) color printing paper, which promised more darkroom control, and *Popular Photography*'s debut of *Color Annual*. "Color Photography Today: A Symposium," *Photography Annual 1955*, 144–170, 235–36. "Symposium on Color," *US Camera* 18 (May 1955), 58–63, 98–99; "Symposium on Color," *US Camera* 18 (June 1955), 85–91, 108–109. "Six Experts Discuss Color," *US Camera* 19 (October 1956), 53–54, 101, 110. "How Creative Is Color Photography?" *Popular Photography Color Annual 1957*, 14–25, 169–170.

52. Complaints in this vein were voiced into the 1960s. In *Popular Photography*'s *Color Photo Annual 1960*, Bruce Downes called color photography "undoubtedly the most complex and frustrating process ever invented by man." See his article, "Color Frustrations," 21.

53. "Color Photography Today," *Photography Annual 1955*, 169.

54. "Six Experts . . . ," *US Camera* 19 (October 1956), 53.

55. Alexander Liberman, ed., *The Art and Technique of Color Photography* (New York: Simon and Schuster, 1951). Years of working with color carbro prints (an even more complex predecessor to the dye transfer process), Liberman argued, had given fashion magazines and high-end commercial photographers a head start at exploring the expressive potential of color photography. He declared that the complexity and high cost of making good quality color reproductions had meant that only magazines had the material means to give photographers the freedom to experiment and be truly creative, along with the opportunity to share their results widely. Magazines, he claimed, had become "the meeting place of all new talents, a new salon where the whole world is on . . . exhibition" (xi). He illustrated his point with seventeen color portfolios and accompanying statements by distinguished Condé Nast photographers, including Irving Penn, Horst P. Horst, Cecil Beaton, John Rawlings, and Erwin Blumenfeld. While many of these practitioners also groused about the lack of consistency, slow speed, and high cost of color, they overwhelmingly reveled in the influence they wielded over the tastes of contemporary audiences.

56. Peter Pollack, *The Picture History of Photography, from the Earliest Beginnings to the Present Day* (New York: H. N. Abrams, 1958).

57. "Photography by Eliot Porter," Limelight Gallery, New York, March 21–April 17, 1955. The only color print in *The Family of Man* was a mural-sized enlargement of an exploding hydrogen bomb that closed the show.

58. In the spring of 1957, Gee exhibited Porter's and Auerbach's color photographs under the exhibition title *Madonnas and Marketplaces: Mexico in Color.*

59. Ansel Adams, "Color Photography as a Creative Medium," *Image* no. 9 (November 1957), 212. Curiously, Adams chose three of his own color photographs to illustrate this article—a portrait of a Navajo woman, a decorative barn facade, and a close-up of pine tree trunks.

60. Eliot Porter to Jonathan Porter, October 12, 1958 (ACM). Adams had spent a night with the Porters while on the road making color transparencies for Kodak. When Porter visited Adams the following January, Adams could not be bothered even to look at Porter's new color prints. Eliot Porter to Stephen Porter, February 3, 1959 (Stephen Porter Letters/ACM).

61. Ibid., Porter to Jonathan Porter.

62. "How Creative Is Color Photography?" *Popular Photography Color Annual 1957*, 14–25, 169–170.

63. This Haas work was not new. *Life* had published a two-part feature on it four years earlier: "Images of a Magic City," *Life* (September 14, 1953), 108–120, (September 21, 1953), 116–126.

64. The underlying approach may have been roughly similar to that explored in the 1940s by Callahan and Siegel, but the effect was much more accessible, built on beauty rather than intellect.

65. Nathan Lyons, Syl Labrot, and Walter Chappell, *Under the Sun: The Abstract Art of Camera Vision* (Honeoye Falls, New York: Glyph Press, 1960), "Artist's Statement," unpaginated. The Art Institute of Chicago presented a mixture of Labrot's black-and-white and color work in January 1961. Danish photographer Keld Helmer-Petersen and American Robert Sheehan had produced color photographs in the late 1940s and early 1950s that were precursors to Labrot's. By deliberately flattening the picture plane and drawing form and color to the surface, their works overtly mirrored the gestural paintings being exhibited in New York by young artists like Franz Kline and Mark Rothko. Keld Helmer-Petersen, *122 Colour Photographs* (Copenhagen: Schoenberg Publishers, 1949); Ellen G. D'Oench, Robert F. Sheehan: *Color Photography, 1948–1958* (Middletown, Connecticut: Davison Art Center, Wesleyan University, 1987).

66. See for example the blatantly unnatural human-made color produced by Scott Hyde and Francis Thompson during these years. Both were among the few photographers who made their own dye transfer prints.

67. *The Seasons: A Photographic Essay*, Centerline General Store, Santa Fe (August 1–September 8, 1959); Museum of Art, Baltimore (October 1959); Nelson-Atkins Museum of Art, Kansas City (February 6–March 27, 1960).

68. Grace Mayer to Eliot Porter, November 23, 1959; November 24, 1959; December 7, 1959; Eliot Porter to Grace Mayer, November 29, 1959 (EPA/ACM).

69. Fairfield Porter, "The Immediacy of Experience," *The Nation*, January 9, 1960, reprinted in Rackstraw Downes, ed., *Art In Its Own Terms: Selected Criticism 1935–1975 by Fairfield Porter* (Cambridge, Massachusetts: Zoland Books, 1979, 1993), 79–81.

70. *The Seasons: Color Photographs by Eliot Porter Accompanied by Quotes from Henry David Thoreau*, August 12–October 1, 1960. The Smithsonian Institution Traveling Exhibition Service traveled *The Seasons* over five years to twenty-four venues, ranging from the University of Delaware to the Art Institute of Chicago.

71. Porter and Adams would argue over whether leaves carried so much cyan. One Santa Fe associate of Porter's labeled the artist's choice of green "Porter's nervous greens." Jim Bones interview with author, typescript, 14–15 (ACM).

72. Beaumont Newhall lays out this preference in his review of Moholy-Nagy's book *vision in motion* in *Photo Notes* (March 1948), 9–11.

73. Nancy Newhall also was about to see her book, *Death of a Valley*, co-authored with Pirkle Jones, published as an issue of *Aperture* (see *Aperture* 8, no.3 [1960]), and was in the midst of writing a biography of Ansel Adams.

74. Brower may also have remembered that Porter had contributed several fine black-and-white photographs to *This Is the American Earth*. Porter retrieved the dummy of his proposed *Seasons* book from Knopf, who were still considering it, and mailed it along with one of his dye transfer prints, and even a sample press proof, to San Francisco. Eliot Porter to David Brower, August 20, 1960 (Carton 11: File 45, Sierra Club Members Papers: 71/295c, Bancroft Library, University of California, Berkeley, [hereafter UCB]).

75. David Brower, "Foreword," *"In Wildness Is the Preservation of the World," Selections & Photographs by Eliot Porter* (San Francisco: Sierra Club, 1962), 9.

76. Ibid., 10.

77. David Brower, untitled publisher's note, *"In Wildness Is the Preservation of the World," Selections & Photographs by Eliot Porter,"* n.p.

78. Eliot Porter, *Eliot Porter*, 49–50.

79. Ansel Adams to Eliot Porter, March 24, 1962 (EPA/ACM). Ansel Adams to John Irwin, December 13, 1962 quoted in Callahan, ed., *Ansel Adams in Color*, 24–25.

80. *In Wildness*'s Exhibit Format predecessors were Ansel Adams's and Nancy Newhall's *This Is the American Earth* (1960); *Words of the Earth* by Cedric Wright (1960); and Adams's *These We Inherit* (1962).

81. Porter and Brower oversaw the printing with press owner Hugh Barnes. David Brower with Steve Chapple, *Let the Mountains Talk, Let the Rivers Run: A Call to Those Who Would Save the Earth* (San Francisco: Harper-Collins West, 1995), 20–23. While Porter was surely pleased to see so much effort put into the publication, he subsequently suggested his continuing disappointment at the quality of some of the plates. Eliot Porter to David Brower, September 9, 1964 (File 30:1 Publ. Galapagos, 1964–67, Sierra Club Papers, Bancroft Library, UCB).

82. Porter took his first raft trip through Glen Canyon in September 1960. Eliot Porter to Stephen Porter, April 23, 1959 (Stephen Porter Letters/ACM). See Rebecca Solnit's essay in this catalogue for a further discussion of Porter's environmental sympathies and activities.

83. Eliot Porter, *Eliot Porter*, 46. Ironically, Porter's brother-in-law, Michael Straus, as commissioner of reclamation, had been instrumental in gaining Congressional funding for the dam.

84. Eliot Porter to Patrick, Stephen, and Jonathan Porter, October 16, 1960 (Stephen Porter Letters/ACM).

85. Porter later explained that he deliberately neglected the rim because it was important to those building the dam. Eliot Porter, "Photography and Nature," undated typescript (EPA/ACM). Eliot Porter, "Nature Photography," typescript of article published in the *Bulletin of the New England Camera Council* (Fall 1978), 13 (EPA/ACM).

86. Eliot Porter, "Nature Photography," undated typescript, 13 (EPA/ACM); Porter, *Eliot Porter*, 85.

87. Author's interview with Jorge Fick, February 1994; typescript, 3–4 (ACM).

88. David Brower, *For Earth's Sake: The Life and Times of David Brower* (Salt Lake City: Gibbs Smith, Peregrine Smith Books, 1990), 346.

89. Wallace Stegner, ed., *This Is Dinosaur, Echo Park Country and Its Magic Rivers* (New York: Alfred A. Knopf, 1955).

90. In 1958 Porter and Joseph Wood Krutch had lobbied together for the Wilderness Bill using a selection of Porter's photographs appended with a text by Krutch. Eliot Porter to Stephen Porter, November 29, 1958 (Stephen Porter Letters/ ACM). Wayne Aspinall, one of Brower's most vociferous opponents in the House, even sent him a note saying, "I wish you would let me have the photographer-artist, and I could take him into numerous canyon [sic] in my district where he could get similar pictures with like narrations." Wayne Aspinall to David Brower, July 1963 (Box 19, File 21: Glen Canyon-Place No One Knew, Sierra Club Papers, Bancroft Library, UCB).

91. In the early 1950s, Porter had shopped around an idea for a book on Great Spruce Head Island and had submitted an illustrated article to *National Geographic*. He received a $200 honorarium for the latter, but the article was shelved.

92. Porter, *Eliot Porter*, 48.

93. Porter, *Summer Island*, 19.

94. Ibid., 19.

95. Eliot Porter, *Forever Wild: the Adirondacks* (New York: Harper and Row, 1966).

96. David McAlpin finally stepped in on the Adirondack Museum's behalf to convince Porter to make a few broader views. McAlpin to Porter, July 9, 1965 (EPA/ACM). The resulting book thus only partially reflects Porter's vision of the park.

97. Joseph Wood Krutch, *The Forgotten Peninsula: A Naturalist in Baja California* (New York: W. Sloane Associates, 1961).

98. Author interview with Jorge Fick, February 22, 1994, typescript, 28–29 (ACM).

99. Eliot Porter, "Untitled," undated typescript, ca. 1985 (EPA/ACM). *Eliot Porter*, 46.

100. Eliot Porter to David Brower, January 5, 1965 (File 30:34, Sierra Club Members Papers, Bancroft Library, UCB). Porter also had not yet given up on his dream of publishing a book of his bird portraits. Porter's Baja project became *Baja California and the Geography of Hope* (San Francisco: Sierra Club, 1967). It carried an Introduction by Krutch, Porter's travelogue, and a pairing of Porter's photographs with text by Octavio Paz.

101. Ansel Adams, *Not Man Apart: Photographs of the Big Sur Coast* (San Francisco: Sierra Club, 1965); Ansel Adams to Dr. William Siri, August 12, 1965 (Carton 29, File 12, Sierra Club Members Papers: Publications, Bancroft Library, UCB). Rebecca Solnit reviews Brower's controversial management of the Sierra Club publishing program in her essay in this catalogue. See also Michael Cohen, *The History of the Sierra Club, 1892–1970* (San Francisco: Sierra Club Books, 1988).

102. Ibid., Adams to Siri.

103. Porter finally got to the islands as part of a large Sierra Club contingent in February 1966.

104. *Galápagos: The Flow of Wildness* (San Francisco: Sierra Club, 1968). The book includes introductions by the natural historian Loren Eiseley and head of the Conservation Foundation's Office of International Studies, John Milton. Kenneth Brower, David Brower's son and the book's editor, contributed excerpts from pertinent historical texts and textual sketches of the excursion.

105. Eliot Porter to Jonathan Porter, May 1, 1963 (ACM).

106. Untitled typescript reviewing the minutes of the publications committee meeting of November 9, 1966 (File 30:2 Galapagos, 1968, Sierra Club Members Papers, Bancroft Library, UCB).

107. Brower later claimed that printing Porter's Galápagos volumes in England saved $125,000. "David Brower: Environmental Activist, Publicist, and Prophet"; interview with Susan Schrepfer, 1974–8. Sierra Club History Series, Sierra Club Archive, Bancroft Library, UCB.

108. John Wesley Powell, *Down the Colorado: Diary of the First Trip Through the Grand Canyon, 1869* (New York: E. P. Dutton and Company, 1969).

109. Eliot Porter, *Appalachian Wilderness: The Great Smoky Mountains* (New York: E. P. Dutton and Company, 1970). This book pairs Porter's photographs with novelist Edward Abbey's "natural and human history" of the region.

110. Porter touches on the issue repeatedly in his essays, manuscripts, lectures, and interviews. See particularly "Statement by Eliot Porter," undated typescript (EPA/ACM); "In Support of Color Photography," undated typescript (EPA/ACM); untitled typescript of "Eyes West" lecture given at Squaw Valley conference, 1965 (EPA/ACM). Paul Hill and Tom Cooper, op. cit., 251

111. Eliot Porter, "On Color Photography," Stieglitz Lecture, Princeton (undated typescript, ca. 1970), 7 (EPA/ACM); "Statement by Eliot Porter" (EPA/ACM). One of the few critics to forcefully support Porter's color vision in the mid-1970s was Max Kozloff. See Kozloff's "The Coming Age of Color," *Artforum* 30 (January 1975), 34.

112. Adams, "Ansel Adams on Color," *Popular Photography* 61 no.1 (July 1967), 82–83.

113. Eliot Porter, "Eyes West, Squaw Valley," undated typescript, 3 (EPA/ACM).

114. Ibid., 8.

115. Porter, "In Support of Color Photography," typescript, 3 (EPA/ACM). Evans made his assertion about color photography's vulgarity on several occasions, including in his essay "Photography" in Louis Kronenberger, ed., *Quality: Its Image in the Arts* (New York: Athenaeum, 1969), 169–211.

116. Eliot Porter to Stephen Porter, September 27, 1960 (Stephen Porter Letters/ACM).

117. Peter Matthiessen, *The Tree Where Man Was Born*, Eliot Porter, *The African Experience* (New York: E. P. Dutton, 1972). The project was not helped by a customs agent's insistence on opening Porter's boxes of exposed transparency film on Porter's return to the United States from his first trip.

118. Author interview with David Rathbun, January 5, 1994, typescript, 1 (ACM).

119. Porter's early biochemical research was on thin film phenomena—what makes the membranes of cells.

120. Eliot Porter, *Iceland* (Boston: Bulfinch Press; Little Brown and Company, 1989). Porter's son Jonathan wrote the book's text.

121. Large expanses of a light color, such as white or light blue, are difficult to print in dye transfer because they show even the slightest amount of dirt or dust imbedded in the matrix film. The matrices tend to pick up such dirt quickly and permanently. Another point delighting Porter about his selections was that the National Science Foundation had chosen him over Ernst Haas.

122. Eliot Porter, *Eliot Porter*, 70–73.

123. Ibid., 70.

124. Ibid., 74.

125. Author interview with Jim Bones, November 15, 1993, types-cript, 1 (ACM).

126. The book fell prey to Kitchener's turgid prose and was never published.

127. Porter eventually turned his Greek and Egypt excursions into books. See Eliot Porter and Peter Levi, *The Greek World* (New York: E. P. Dutton, 1980) and Eliot Porter, *Monuments of Egypt* (Albuquerque: University of New Mexico Press, 1990).

128. Eliot Porter, *All Under Heaven: The Chinese World* (New York: Pantheon Books, 1983).

129. In the 1970s and 1980s Porter was given major retrospective exhibitions by the University of New Mexico Art Museum (1973), Santa Monica College (1976), and the Amon Carter Museum (1987). The artist's 1979 exhibition at the Metropolitan Museum of Art, entitled *Intimate Landscapes*, marked that institution's first all-color photography exhibition.

130. John Szarkowski, *William Eggleston's Guide* (New York: Museum of Modern Art, 1976), 8-9; Sally Eauclaire, *New Color/New Work: Eighteen Photographic Essays* (New York: Abbeville Press, 1984), 10; Jonathan Green, *American Photography: A Critical History*, 1945 to the Present (New York: Harry N. Abrams, Inc., 1984), 183–191. See also Stephen R. Milanowski, "The Biases Against Color in Photography," *Exposure* 23 no.2 (Summer 1985), 5–21.

1. Eliot Porter, *Eliot Porter* (Boston: New York Graphic Society Books, Little Brown and Company, in association with the Amon Carter museum, Fort Worth, Texas, 1987), 83.

2. Guy Davenport, *National Review*, December 18, 1962, Eliot Porter Archives, Amon Carter Museum (hereafter EPA/ACM).

3. Stephen Fox, *John Muir and His Legacy: The American Conservation Movement*, 317, quoting *Smithsonian* magazine, October 1974.

4. A historical parallel is the eighteenth-century English landscape garden, which imitated nature, then became what people looked for in nature—that is, they looked for landscapes whose features resembled those celebrated in the gardens. By the nineteenth century, the literal garden had evolved into a metaphorical way of looking at unaltered landscapes, from a constructed place into constructed frame of reference for looking at places. Yosemite Valley, for example, was often praised for resembling an "English park."

5. Spencer R. Weart, *Nuclear Fear* (Cambridge, Mass.: Harvard University Press, 1988), 258.

6. Rachel Carson, *Silent Spring* (New York: Houghton Mifflin, 1962), 188.

7. Porter, letter to Aline Porter, April 11, 1961, EPA/ACM.

8. Carson, *Silent Spring,* 32.

9. "The geography of hope" was the phrase that caught on from Wallace Stegner's letter to Dave Pesonen, originally titled "The Wilderness Idea." The letter was read by Secretary of the Interior Stewart Udall at the Sierra Club's 1961 wilderness conference as part of his presentation, "Conservation in the 1960s: Action or Stalemate?" The proceedings were published as *Wilderness: America's Living Heritage*, edited by David Brower (San Francisco: Sierra Club Books, 1961). "What I want to speak for is not so much the wilderness uses, valuable as those are, but the wilderness idea, which is a resource in itself. Being an intangible and spiritual resource, it will seem mystical to the practical-minded—but then anything that cannot be moved by a bulldozer is likely to seem mystical to them." (Brower, ed., *Wilderness*, 97; the phrase "the geography of hope" appears on page 102; the letter in its original version is printed in Stegner's anthology *The Sound of Mountain Water,* [New York: E. P. Dutton, 1980] 245–253.) Of course, in the very different times of the early twenty-first century, it can be argued hope is sometimes misplaced—that images like Porter's were and can be reassuring, when reassurance is far from what is needed. But on January 28, 1969, James W. Moorman of Washington, D.C., wrote to the Sierra Club, "I learned of the Club about four years ago when 'In Wildness' and 'These We Inherit' caught my eye in a New York bookstore. These wonderful, transcendent books touched me as few things have. I am not ashamed to say they restored hope. . . . If man created such books, then perhaps man could be persuaded to stop the destruction." (Ansel Adams Papers, folder 2:25, publications, Sierra Club Archives, Bancroft Library, Universtiy of California, Berkeley [hereafter UCB]). The books in this case worked exactly as intended.

10. Fox, *John Muir . . .* , 319: "The club's Exhibit Format books offered an ironic variation on Muir's old scheme of creating conservationists by depositing them in the Sierra. Instead of bringing people to the wilderness, Brower's publishing program brought the wilderness to people—with much the same conversion effect—through books that were hard to put down. Over the first four years, fifty thousand were sold, 80 percent through bookstores and mainly to nonmembers of the Sierra Club. The number of buyers was further increased by a distribution arrangement with Ballantine Books of New York. A less expensive edition of *In Wildness* was the best-selling trade paperback of 1967. By 1969 total sales amounted to ten million dollars."

11. *Sports Illustrated*, November 22, 1967.

12. Joseph Wood Krutch, introduction to "*In Wildness Is the Preservation of the World," Selections & Photographs by Eliot Porter* (San Francisco: Sierra Club Books, 1962), 13.

13. Stephen Trimble, letter to author, January 3, 2000.

14. Stephen Trimble in "Reinventing the West: Private Choices and Consequences in Photography," *Buzzworm*, November/December 1991, 46–54. Michael Cohen points out in a note to the author that the Glen Canyon book sent people in search of that sense of place throughout the Colorado Plateau, generating, among other things, a "plethora of Antelope Canyon pictures."

15. Porter, *Eliot Porter*, 29.

16. Eliot Porter, "An Explanation," *Harvard Alumni Bulletin*, 2–3, EPA/ACM. Michael P. Cohen points out another parallel to Carson in this delight; Carson wrote a book called *The Sense of Wonder*.

17. Porter, *Eliot Porter*, 83.

18. Eleanor Caponigro, interviewed by John Rohrbach, January 26, 1995, typescript, 3, EPA/ACM.

19. Porter, "Address to Los Alamos Honor Students," May 16, 1971, EPA/ACM.

20. Porter, letter to the Santa Fe *New Mexican*, 2 December 1959, EPA/ACM. Porter's interest in John Brown may have been whetted by Thoreau's support of Brown.

21. Porter, *Eliot Porter*, 45.

22. Eliot Porter to Stephen Porter, November 29, 1958 (Stephen Porter Letters/ACM).

23. Eliot Porter, "Photography and Conservation," mss. in "Notes on Conservation" file, pp. 5–6, EPA/ACM.

24. Edgar Wayburn cited by Michael P. Cohen, *The History of the Sierra Club, 1892–1970* (San Francisco: Sierra Club Books, 1988), 293.

25. Fox, *John Muir . . .* , 318–319.

26. Cohen, *The History of the Sierra Club*, 424–26. The "Earth National Park" ad was one of the last straws in Brower's relationship with the Sierra Club board, which perceived it as both an unauthorized expenditure and a far too vague and utopian idea for their commitment to concrete protections and realizable goals.

27. Philip Berry, oral-history interview, Sierra Club Archives, Bancroft Library, UCB. The Club was used to cordial relations with the sources of power; *"In Wildness Is the Preservation of the World"* was underwritten by a philanthropic arm of the giant Bechtel Corporation, which built Hoover Dam, countless oil pipelines around the world, and Glen Canyon Dam, and now manages the nuclear bomb testing program at the Nevada Test Site.

28. Philip Berry, oral-history interview, 27.

29. Porter, *Sierra Club Bulletin*, 1969, EPA/ACM.

30. Alex Hildebrand charged Porter in his oral-history interview in Sierra Club Leaders, 1950s–1970s, 21, Sierra Club Archives, Bancroft Library, UCB. Hildebrand was a Standard Oil executive and part of the Club's old guard.

31. Porter often depicted Ansel Adams as an intimidating and difficult figure, and certainly Adams made many disparaging comments about color photography over the years. But Virginia Adams apparently tried to get an early version of *In Wildness* published, and Adams's letter of congratulations to Porter for *The Place No One Knew* is generous. Perhaps because of his many years of involvement with the Club, Adams took a more pragmatic view on everything from publications to Diablo Canyon. In those years, Brower annoyed the two artists with his oft-repeated comment that "Porter is the Sierra Club's most valuable property" (in, for example, his letter of November 6, 1966 in the publications files of the Sierra Club Archives, Bancroft Library); Porter did not regard himself as property, and Adams felt slighted by the focus on Porter. During those years, the Sierra Club letterhead featured an Ansel Adams photograph.

32. Porter, *Eliot Porter*, 53.

33. Edgar Wayburn, letter of September 9, 1967, David Brower Papers, Sierra Club Archives, Bancroft Library, UCB. Many other Sierra Club board members felt that books should be tied to conservation objectives. Martin Litton tartly recalls, "Along came the Exhibit Format books. They were done in black and white which, of course, was cheap. In those days not too much color was done anyway. That was the perfect stage for Ansel Adams's material. You had these terrific books, most of which did not pinpoint any subject. They were just all over the place, like *This Is the American Earth*. Pretty pictures of America with a little message by Nancy Newhall or whoever under each one about how lovely it is we still have Mount Whitney there. It didn't do anything political. It showed the Sierra Club could publish books, and books like that weren't all that common then as they are now." Litton, oral history, 79, Sierra Club Archives, Bancroft Library, UCB. Board member August Fruge agreed with Adams and Wayburn when he wrote to Brower, on 2 February 1969, "We have little need for coffee table books on the Alps and the Scottish Highlands (planned for 1969), but we desperately need books that will help us save Lake Tahoe, San Francisco Bay, the

Everglades, Lake Superior, and many other places" (Ansel Adams Papers, Sierra Club Archives, Bancroft Library UCB).

34. Porter, *Eliot Porter*, 54.

35. Cohen, *The History of the Sierra Club*, 421.

36. Porter, *Eliot Porter*, 56. In a letter to Brower of March 4, 1968, Porter wrote, "I am getting a little weary of being told one day that I am a valuable property of the Sierra Club and the next day lectured on my responsibilities to the Sierra Club and conservation. Sometimes I think that you would like me to feel guilty for making any money at all from Sierra Club publications. . . . My contribution to conservation may not be enough in your eyes but after all this is a matter that each of us has to decide for himself. My contribution is considerably different from yours and may be judged considerably less, but whatever the judgment is I resent its being down-graded. And this happens when my books are publicized as Sierra Club publications without credit going to me or my name mentioned" (EPA/ACM).

37. Fairfield Porter, *The Nation*, January 1960, 39. In a review of Fairfield Porter's paintings, art critic Peter Schjeldahl writes, "Porter was born real-estate rich in a suburb of Chicago to a family that had deep roots in New England. His gloomy father was a frustrated architect, his mother a life-long amateur in social causes and cultural uplift. . . . In 1927, he traveled to Moscow, where he had his first exposure to the paintings of Vuillard and Bonnard, and an audience with Leon Trotsky, who allowed Porter to sketch him. . . . Settling in New York, he became embroiled in radical politics and painted a mural, now lost, entitled, 'Turn Imperialist War Into Civil War'" (*New Yorker*, April 17, 2000; in an interesting coincidence, the activism of the author's brother David is celebrated on page 45 of the same issue). Among the differences between the Porter brothers is that Fairfield found his metier early on, and eventually the painting became quite separate from the politics, while older brother Eliot struggled to define a new medium that eventually allowed him to bring politics and aesthetics together.

38. Carolyn Merchant, "Feminism and Ecology," in Bill Devall and George Sessions, *Deep Ecology: Living As if Nature Mattered* (Layton, Utah: Gibbs Smith, Inc., 1985), Appendix B, 229.

39. Eliot Porter to Stephen Porter, February 10, 1959 (Stephen Porter Letters/ACM).

40. Porter, *Eliot Porter*, 69.

41. Porter, *Eliot Porter*, 44.

42. Aldo Leopold, *Sand County Almanac with Essays on Conservation from Round River* (New York and San Francisco: Ballantine Books and Sierra Club, 1970), 138–139, 247. Background on predator philosophies from Donald Worster, *Nature's Economy* (San Francisco: Sierra Club Books, 1977).

43. Aldo Leopold, *A Sand County Almanac and Sketches Here and There* (New York: Oxford University Press, 1949, 1952[3rd printing]) 211–212.

44. David Brower quoting Porter in a letter to John Rohrbach, September 16, 1999, ACM.

45. William Peterson, *Artspace*, Winter 1987–88, EPA/ACM.

46. Thomas Cole, "Essay on American Scenery," in John McCoubrey, ed., *American Art, 1700–1960*, Sources and Documents in the History of Art series (Englewood Cliffs, NJ: Prentice-Hall, 1965), 92.

47. My own 1994 book *Savage Dreams: A Journey into the Landscape Wars of the American West* documents the cost—to the Euro-American imagination, Native American rights, and the place's ecology—of imagining Yosemite Valley as virgin wilderness. Ethnobotanists such as Kat Anderson and books ranging from William Cronon's *Changes in the Land* to Jonathan S. Adams's *The Myth of Wild Africa: Conservation Without Illusion* to Alston Chase's *Playing God in Yellowstone* have done more to complicate our understanding of the ecosystems we sometimes call wilderness and of the human presence in them. Recently, the Native American writer Elizabeth Cook-Lynn published *Why I Can't Read Wallace Stegner and Other Essays.*

48. William Cronon, "The Trouble with Wilderness," in William Cronon, ed., *Uncommon Ground: Rethinking the Human Place in Nature* (New York: W. W. Norton, 1995), 480.

49. Davenport, 480

50. Eliot Porter, "An Early View of the Southwest," *Eliot Porter's Southwest* (New York: Holt, Rinehart and Winston, 1985), 9.

51. George Marshall, letter to Eliot Porter, 11 May 1965, and letter to David Brower, May 6, 1965, David Brower Papers, Sierra Club Archive, Bancroft Library, UCB.

52. Eliot Porter to Marcie and Stephen Porter, 17 December 1977, Stephen Porter Letters/ACM.

53. Eliot Porter, "Address to Los Alamos Honor Students," EPA/ACM. Other color photographers—notably Richard Misrach and John Pfahl—have explored the moral quandary implicit in the fact that a color photograph likely to attract attention is also likely to endow its subject with beauties of color or composition, and these two artists have intentionally deployed this flaw to test ethics against aesthetics (a subject I have addressed at length in *Crimes and Splendors: The Desert Cantos of Richard Misrach*, Museum of Fine Arts, Houston, and Bulfinch Press, Boston, 1996).

54. Robert Adams, "C. A. Hickman," in *Beauty in Photography: Essays in Defense of Traditional Values* (New York: Aperture, 1981), 103. As Michael Cohen points out, Adams's assertion that there are "few converts . . . to be won to the general idea of wilderness preservation" is open to debate now, with the spread of corporate-financed, anti-environmentalist groups (such as the Wise Use Movement and People for the West) contributing to a widespread rural, conservative, and working-class suspicion and hostility toward environmentalists.

55. Porter, *Eliot Porter*, 44.

56. Barry Lopez, "Learning to See," in *About This Life: Journeys on the Threshhold of Memory* (New York: Random House, 1998), 233.

Eliot Porter, March 28, 1952

ACKNOWLEDGMENTS

A number of people and several institutions have generously contributed in ways large and small to make this project a reality. Most important is Eliot Porter, who so graciously bequeathed his personal collection of prints, transparencies, negatives, and manuscripts to the Amon Carter Museum. His family, particularly his sons, Jonathan, Patrick, and Stephen, and grandson Matthew, provided invaluable counsel and support. His associates, including Jim Bones, David and Kenneth Brower, Eleanor Caponigro, W. Powell Cottrille, Jorge Fick, David Rathbun, Janet Russek, David Scheinbaum, and Robert Widdicombe, shared their knowledge and advice without hesitation.

For their assistance with research, loans, and reproductions I thank Leslie Calmes, Lisa D'Acquisto, Nicole Finzer, Tod Gangler, Alex Haas, Bonnie Hardwick, Sarah Hermanson, Jeannette Klute, Nathan Lyons, Frank McLaughlin, Kristin Nagel Merrill, Dianne Nilsen, Jeff Rosenheim, Amy Rule, Joseph Struble, Rachael Stuhlman, John Szarkowski, and Marsha Tiede. I benefited invaluably from the support and input of my fellow authors and colleagues David Brower, Michael Cohen, Terry Evans, Edward T. Hall, Clay Lewis, Jonathan Porter, Rebecca Solnit, and Sally Stein.

The staff of the Amon Carter Museum contributed greatly to this project, especially Fran Baas, Libby Cluett, Courtney DeAngelis, Pam Graham, Wendy Haynes, Barbara McCandless, Tim McElroy, Jane Myers, Tricia Pentecost, Helen Plummer, Jane Posey, Paula Stewart, Rick Stewart, Karin Strohbeck, Melissa Thompson, and Bob Workman. Mark Mortensen, Amy Reed, Alonso Sanchez, and John Young provided invaluable assistance on the exhibition's interpretive programming. Sam Duncan astutely assembled the chronology, and Will Gillham ably shepherded the catalogue through production and edited its contents. Steven Watson provided high-quality transparencies and oversaw the printing of the publication in concert with Stevan Baron. Wendy Byrne created a remarkable design, while Phyllis Thompson Reid oversaw every detail of the project from Aperture's perspective.

This catalogue would not have come into being without the tremendous support of Michael E. Hoffman, executive director of Aperture Foundation, and Ruth Carter Stevenson, president of the Amon Carter Museum board of trustees. I am deeply grateful for the unstinting support and patience of Joan Massy and our son, Ethan. The Andrew W. Mellon Foundation supported my first three years of immersion in Porter's remarkable collection. This catalogue and its accompanying exhibition have been supported by the National Endowment for the Humanities: expanding our understanding of the world. Further support has been provided by American Airlines and The Cabot Family Charitable Trust.

The Staff at Aperture for *THE COLOR OF WILDNESS*:
Michael E. Hoffman, *Executive Director*
Phyllis Thompson Reid, *Editor*
Wendy Byrne, *Designer*
Stevan A. Baron, *V.P., Production*
Lisa A. Farmer, *Production Director*
Eileen Connor, *Editorial Assistant*

Aperture Foundation publishes a periodical, books, and portfolios of fine photography and presents world-class exhibitions to communicate with serious photographers and creative people everywhere. A complete catalog is available upon request.

Aperture Customer Service: 20 East 23rd Street, New York, New York 10010. Phone: (212) 598-4205. Fax: (212) 598-4015. Toll-free: (800) 929-2323. E-mail: customerservice@aperture.org

Aperture Foundation, including Book Center and Burden Gallery: 20 East 23rd Street, New York, New York 10010. Phone: (212) 505-5555, ext. 300. Fax: (212) 979-7759. E-mail: info@aperture.org

Aperture Millerton Book Center: Route 22 North, Millerton, NY 12546. Phone: (518) 789-9003

Visit Aperture's website: www.aperture.org

Aperture Foundation books are distributed internationally through:

Canada: General/Irwin Publishing Co., Ltd., 325 Humber College Blvd., Etobicoke, Ontario, M9W 7C3. Fax: (416) 213-1917.

United Kingdom, Scandanavia, and Continental Europe: Aperture c/o Robert Hale, Ltd., Clerkenwell House, 45-47 Clerkenwell Green, London, United Kingdom, EC1R OHT. Fax: (44) 171-490-4958.

Netherland, Belgium, Luxemburg: Nilsson & Lamm, BV, Pampuslaan 212-214, P.O. Box 195, 1382 JS Weesp, Netherlands. Fax: (31) 29-441-5054.

Australia: Tower Books Pty. Ltd., Unit 9/19 Rodborough Road, Frenchs Forest, Sydney, New South Wales, Australia. Fax: (61) 2-9975-5599.

New Zealand: Southern Publishers Group, 22 Burleigh Street, Grafton, Auckland, New Zealand. Fax: (64) 9-309-6170.

India: TBI Publishers, 46, Housing Project, South Extension Part-I, New Delhi 110049, India. Fax: (91) 11-461-0576.

To subscribe to the periodical *Aperture* write Aperture, P.O. Box 3000, Denville, New Jersey 07834. Toll-free: (866) 457-4603. Inernational orders: (973) 627-2427. One year: $40.00. Two years: $66.00. Add $10.00 per year for international orders.

First Edition
10 9 8 7 6 5 4 3 2 1

Grasses and tamarisk, Music Temple Bar, Glen Canyon, Utah September 23,1961 (endsheets)

THIS PUBLICATION IS GENEROUSLY SUPPORTED BY

THE CABOT FAMILY CHARITABLE TRUST

AMBROSE MONELL FOUNDATION

THE NATIONAL ENDOWMENT FOR THE HUMANITIES
EXPANDING OUR UNDERSTANDING OF THE WORLD

ADDITIONAL SUPPORT IS PROVIDED BY

AMERICAN AIRLINES